Advance praise for **SNATCHED**

"Scholars and students interested in moral panics, cultural narratives, and news will find a fascinating read in *Snatched*. Spring-Serenity Duvall and Leigh Moscowitz effectively weave together theory and textual analysis, taking us into the mediated world of abducted children, their families, and kidnappers. The book highlights the racial, gendered, and classed disparities in news coverage as it questions the ethics of journalism that sensationalizes and capitalizes upon missing children."

—*Carol M. Liebler, Professor, Department of Communications,*
S. I. Newhouse School of Public Communications,
Syracuse University

"Spring-Serenity Duvall and Leigh Moscowitz provide a sophisticated and accessible analysis of news coverage concerning 'every parent's worst nightmare'—and in doing so expose the myths and moral panics rooted in gender, race, class, sexuality, and nation that shape U.S. cultural views of innocence, family and childhood, as well as deviance and crime. Their book goes well beyond the common criticism of news organizations that they afford outsized coverage to white, middle- and upper-class girls who are abducted, thereby ignoring children of color and those who do not fit the preferred profile. Instead, *Snatched* provides nuanced readings of the news to generate fresh insights into this horrific crime."

—*Marian Meyers, Professor, Department of Communication and the Institute of*
Women's, Gender, and Sexuality Studies, Georgia State University

SNATCHED

mediated youth

Sharon R. Mazzarella
General Editor

Vol. 25

The Mediated Youth series is part of the
Peter Lang Media and Communication list.
Every volume is peer reviewed and meets
the highest quality standards for content and production.

PETER LANG
New York • Bern • Frankfurt • Berlin
Brussels • Vienna • Oxford • Warsaw

Spring-Serenity Duvall & Leigh Moscowitz

SNATCHED

Child Abductions in U.S. News Media

PETER LANG
New York • Bern • Frankfurt • Berlin
Brussels • Vienna • Oxford • Warsaw

Library of Congress Cataloging-in-Publication Data
Duvall, Spring-Serenity.
Snatched: child abductions in U.S. news media /
Spring-Serenity Duvall, Leigh Moscowitz.
pages cm. — (Mediated youth; vol. 25)
Includes bibliographical references and index.
1. Kidnapping—Press coverage—United States.
2. Crime and the press—United States.
I. Moscowitz, Leigh. II. Title.
HV6598.D88 070.4′493641540973—dc23 2015010726
ISBN 978-1-4331-2716-8 (hardcover)
ISBN 978-1-4331-2715-1 (paperback)
ISBN 978-1-4539-1618-6 (e-book)
ISSN 1555-1814 (print)
ISSN 2378-2935 (online)

Bibliographic information published by **Die Deutsche Nationalbibliothek**.
Die Deutsche Nationalbibliothek lists this publication in the "Deutsche
Nationalbibliografie"; detailed bibliographic data are available
on the Internet at http://dnb.d-nb.de/.

Cover photo ©iStock.com/shaunl

The paper in this book meets the guidelines for permanence and durability
of the Committee on Production Guidelines for Book Longevity
of the Council of Library Resources.

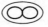

Contents

Acknowledgments vii

Chapter 1: Introduction: Every Parent's Worst Nightmare 1

Chapter 2: The Summer of Child Abductions 21

Chapter 3: When Boys Go Missing 51

Chapter 4: Why Didn't They Leave? 75

Chapter 5: The Ones Who Got Away: "Unlikely"
 Heroes and Brave Survivors 99

Chapter 6: Conclusion: Innocence Lost 127

Media Examples Cited 143
Timeline of Major Cases Prominently Featured
in U.S. News Media 153
References 161
Index 169

Acknowledgments

We are indebted to the many individuals whose support, insights and guidance made this book possible, from its imperfect origins as a class project through to its final publication. This project originated as part of our graduate work nearly a decade ago at the Indiana University School of Journalism, and we remain forever indebted to Radhika Parameswaran and Betsi Grabe, true teacher-scholars whose scholarship and mentorship provided us with the foundational tools that inspired and informed this work. We are also incredibly appreciative of the careful and attentive work of Sharon Mazzarella, our series editor, whose own scholarship shaped our thinking about this project. In addition, she devoted countless hours to reading, commenting on and critiquing various versions of this manuscript, providing critical insights that helped us refine our arguments. This book project would not have been possible without the work of Mary Savigar, our fantastic editor, as well as Sophie Appel and the entire Peter Lang production team.

Spring is indebted to Salem College for generously providing funding to support the production of this book. She is fortunate beyond measure to have friends and colleagues whose kindness sustained

her during the writing of this book, especially Jessica Birthisel, Lindita Camaj, Lori Henson, Stacie Jankowski, Ammina Kothari, and Rosemary Pennington. She would like to thank her sister, Robyn Dey O'Neal, for listening and understanding.

Finally, she is profoundly grateful for the love of her family—her daughters, Lilian and Rowan, whose smiles made writing this book more heartbreaking and urgent, and her husband, Court, for the patience and unwavering encouragement that made difficult days bearable.

Leigh is also indebted to two wonderful institutions whose support made this publication possible: The College of Charleston for granting her sabbatical leave to research and draft the manuscript, and the University of South Carolina for supporting the publication of the book, including securing funding to support its production. She is grateful to her colleagues, friends and family members from across the country who have sustained her throughout the writing process, people like Andy Billings, April Bisner, Erin Benson Lee, Janis Cakars and Melissa Cakars, Christy and Mike Conway, Suz Enck, Erica and Chip Gray, Tamara Leech, Mike Lee, David Parisi, Ryan Milner, John and Stephanie Stickler, Kristen Swenson and Mary-Tina Vrehas. She is eternally grateful to her parents for their continued dedication to her academic pursuits, Beverly and Rick Mehrlich, Ray and Barbara Moscowitz and James Stickler.

Finally, she owes her greatest debt to her family, those she held a little bit tighter through researching and writing this difficult book—her children, Amelia and Eli, and her partner, David Moscowitz, whose own passion for scholarship and writing inspire her to continue on.

We would also like to acknowledge our own friendship, which is what allowed us to write a book that neither of us could have tackled alone. Spending countless hours researching a topic as devastating as child abductions was at times grueling and we leaned on each other when the project became difficult. We are grateful to each other for the friendship and shared dedication to research that carried us through.

Chapter 1

Introduction

Every Parent's Worst Nightmare

> Kidnapping is a modern morality play, the innocence of the child in stark contrast to the corruption of the criminal, all played out by a media industry eager to feed the worst fears of every parent.
> —Paula Fass, *Kidnapped: Child Abduction in America* (1997)

Few crimes provoke the kind of collective fear, outrage, and fascination that child abductions do. Over the last decade, American media has obsessively covered the individual disappearances, and in some cases, reappearances, of missing children like Elizabeth Smart, Samantha Runnion, Danielle van Dam, Carlie Brucia, Jaycee Lee Dugard, Shawn Hornbeck, Amanda Berry, Gina DeJesus and Michelle Knight, among others. The international abduction cases of Elisabeth Fritzl and Natascha Kampusch, both from Austria, and Madeleine McCann from the U.K., were also highly publicized in the U.S. These often gruesome and gut-wrenching stories have struck fear in American families, captured the public's imagination, impacted law and public policy, and shaped cultural discourses about childhood.

Moreover, the abductions that dominated media headlines in the 2000s were not random or representative cases. Clear patterns emerged

in the kidnappings that attracted the most media attention. Though statistically rare, U.S. news media disproportionally covered stories of young Caucasian girls being snatched from their middle-to upper class homes by male strangers, constructing a nationwide epidemic of "every parent's worst nightmare" (Murr, 2002, p. 38). These kidnapping stories, covered obsessively by mainstream news organizations, perpetuate powerful social myths about vulnerability in girlhood, hypersexuality and violence in masculinity, and criminality and deviance from "strangers" and "othered" groups. Pervasive images of missing little girls have served as a metaphor for a vulnerable, fragile nation suffering from a weakened economy, political instability, and the cultural aftershocks of terrorist attacks (Faludi, 2007).

The kidnapping, torture and murder of children are certainly not new crimes, and the journalistic captivation with child snatchings has a long history. Historians mark the first headline-grabbing case as the 1874 kidnapping of four-year-old Charley Ross, who was held for ransom (Fass, 1997). But as childhood historian Paula Fass (1997) points out, while the actual *social experience* of child abductions is not a new problem, it has been laden with new *meanings*. For example, in stark contrast to the images of young girls who captured headlines in the 2000s, the missing children's movement actually arose around the disappearance of young *boys* who dominated headlines in the early 1980s, namely the 1979 disappearance of six-year-old Etan Patz and the 1981 abduction and murder of six-year-old Adam Walsh. The last decade has seen a renewed media fascination with and increased cultural anxieties over child abductions in American public life. And since the 2000s, media coverage has centered on a particular *type* of child abduction: the face of the young, white, telegenic and oftentimes affluent girl-victim has taken center stage.

According to media reports, the contemporary child abduction victim meets a specific racial and class profile: a young Caucasian girl from a middle- to upper-class family. While these cases make dramatic news stories, the National Center for Missing and Exploited Children as well as the National Criminal Justice Reference Service verify that in reality this type of kidnapping by strangers is statistically rare and constitutes on average fewer than 100 cases per year (NCJRS, 2015; NCMEC, 2015;

Crary, 2002). Meanwhile, the more than 350,000 children who are kidnapped by a parent each year go virtually unreported in mainstream news. National U.S. media also tend to ignore cases of missing minority children, especially if they are taken from lower income urban neighborhoods where crime is assumed "normal."

This lopsided coverage that highlights particular child abduction cases over others is the central concern of this book. *Snatched* interrogates the predominant myths centered on gender, race and class that shaped mainstream U.S. news coverage of kidnappings in the 2000s. We showcase how the major news media relied upon problematic assumptions about racial, gender and class identities to construct the "epidemic" of child kidnappings during this time period. Through an analysis of hundreds of media reports from mainstream U.S. television broadcasts and web stories, as well as newspapers and news magazines, *Snatched* critically analyzes how news narratives constructed the phenomenon of child abductions, the young girls and boys who fell prey, the male perpetrators of the horrific crimes, and the adult victims of long-term abductions who escaped or were rescued years later. We argue that the deferential treatment of victims and perpetrators in news narratives in turn constructs and feeds moral panics—and ones that fit a specific script—a powerful and consistent storyline largely based on race, class and gender.

This book thus contributes to evolving academic and popular conversations about how crime news both shapes and polices the boundaries of gender, sexuality, race, class, and deviance. *Snatched* also speaks to a growing body of work on the cultural myths that influence news coverage of girlhood as vulnerable and fragile, contrasted with the constructions of violent and sadistic male predators who symbolize threats to nation and family structures. By examining both young male and female victims, this project offers a uniquely comparative case study of how boy and girl crime victims are treated in news narratives. *Snatched* examines news stories and representations as a critical but understudied source of information about how crime, victims and perpetrators are understood.

Beyond its academic contributions, this analysis is especially important because the disproportionate coverage of child victims has

real consequences for families of missing children. Kidnapped children who receive widespread publicity in the mass media are much more likely to be returned home safely and quickly, whereas those whose kidnappings go unreported are rarely found (NCJRS, 2015; NCMEC, 2015; Crary, 2002; Fass, 1997).

Our time frame, beginning in the early 2000s, is particularly ripe for critical scholarly interrogation as we trace this increased media and public attention on missing children, in particular on missing girls. As Paula Fass (1997) reminds us, stories of child abductions in the news constitute much more than the mere reporting of a crime. As we relay in more detail, America's post-9/11 milieu set a backdrop for amplified cultural anxieties over hypersexuality and violence in masculinity, as well as deviance from strangers and "othered" groups (Berlant, 1997; Faludi, 2007; Grewal, 2005; Zgoba, 2004). These fears collided with, on the other hand, cultural fantasies of "the innocent," idealized child, in particular constructions of vulnerability in girlhood.

To begin our interrogation, we outline the cultural circumstances and theoretical foundations that underpin our analysis. We start by positioning the media coverage of child abductions within the larger context of moral panics about childhood and pedophilia. Next, we identify the major intellectual frameworks for the study of child abductions in the news and why it matters. In particular, we draw upon our understandings of the cyclical nature of crime news, how crime reporting relies on cultural myths to police boundaries of nation, gender, sexuality, race, class, and deviance during times of turmoil. Subsequently, we explore the myths that influence news coverage of girls as vulnerable and fragile contrasted with myths about male predators who symbolize threats to national and family structures. Finally, we explain what was included in our media analysis, how these news stories were selected and analyzed, and lastly, we lay out the organization of the book.

Framing and Myth in News Narratives

This book about child abductions in the U.S. news has to be understood within the larger body of scholarship about media, gender and

crime (Bissler & Conners, 2012; Benedict, 1992; Chermak, 1995; Meyers, 1997; Potter & Kappeler, 2006; Steeves, 1997; Wanzo, 2008; Williams, 2012; Wykes, 2001). News does much more than merely report events; like other cultural forms news tells stories and teaches important social lessons. News is a narrative, literary form that "provides the guiding myths which shape our conception of the world and serve as important instruments of social control" (Cohen & Young, 1981, p. 12).

Our project here joins other cultural studies and feminist theorists who understand news as a part of larger hegemonic power structures (Althusser, 1971; Gramsci, 1971; Hall, 1973; Meyers, 1997; Parameswaran, 1996; Rakow, 2006; Steeves, 1987). Media corporations are ideological institutions that work with other interrelated social entities, such as state governments, religious organizations, and education institutions, to maintain and sustain dominant social norms. Cultural studies scholars understand hegemony as a process in power relations that establishes and reinforces "common sense" cultural values and beliefs, making the interests of elites seem not only reasonable but inevitable (Lull, 2014). Commercial media forms can serve as powerful tools for dominant groups to popularize a particular set of values, moralities, norms and ways of seeing the world that serve elite interests. Importantly, these ideologies are not compulsory. Dominant groups remain in power by acquiring and inviting consent from subordinate groups, thereby creating a "common ground, or a degree of collective consciousness" (Steeves, 1997, p. 2).

Therefore, constructions of gendered, raced, classed and sexual identities in the news and popular culture are a part of historically rooted hegemonic power relations that privilege patriarchy and heterosexuality. For example, feminist media scholars (Steeves, 1997; van Zoonen, 1994; Meyers, 1997; Parameswaran, 1996; Rakow, 2006; Steeves, 1987) have shown how news reflects patriarchal hegemonic perspectives by excluding women from news stories, both as a topic of news and as sources in news (a practice known as "symbolic annihilation;" see Gerbner, et al., 1978; Tuchman & Benet, 1978), denigrating women and their concerns, sexualizing women, confining women to narrow and traditional roles, and constructing women as victims of violence.

Of course, we cannot expect news to accurately represent reality or everyday life. News organizations, like the broader media industries, are profit-seeking corporations within larger capitalist economic structures. Professional norms, i.e., "new values," dictate that the most extraordinary, dramatic and tragic elements of stories will be emphasized. However, in order for abnormal occurrences to make sense, they must be given meaning; otherwise, they remain random, isolated events. As Tuchman (1976) notes, reporters organize events around major societal themes or conflicts through a process of framing that offers "definitions of social reality" (p. 94). Newsmakers use societal myths to structure stories in order to "give meaning to incredible events, to explain that which cannot be explained and to reaffirm values and beliefs, especially when those values and beliefs are challenged" (Lule, 2002, p. 276).

Societies rely on negotiations of stability and crisis to survive, so myths function to simplify and maintain social boundaries (Barthes, 1972). Myth is a powerful cultural force that "has turned reality inside out, it has emptied it of history and has filled it with nature, so it is in a literal sense 'depoliticized speech'" (pp. 142–143). Myth cannot simply sustain itself by replaying the past, as new meanings arise from converged discourses. As Bignell points out, "myth is not an innocent language, but one that picks up existing signs and their connotations, and orders them purposefully to play a particular social role" (Bignell, 1997, pp. 16–17).

Crime Waves and Moral Panics

As the adage "If it bleeds, it leads" illustrates, no topic dominates broadcast, web and print news media—and increasingly entertainment media—more than crime. Put simply, crime news is both popular and highly profitable. Since the vast majority of Americans will not be victimized by crime, media become the major source of the public's imagination about crime and criminals (Potter and Kappeler, 2006). A body of scholarly work (Bissler & Conners, 2012; Denham, 2008; Mazzarella, 2010; Potter & Kappeler, 2006; Williams, 2012; Wykes,

2001) has illustrated how stories about crime and deviance are especially instructive because they mark "the transgression of normative boundaries" between the acceptable and the unacceptable in society (Hall et al., 1981, p. 352). Crime news both captures and reflects the prevalent societal, political and economic tensions of the time.

Because news dramatizes, distorts and exaggerates, crime coverage is out of sync with actual police statistics, both in terms of the *amount* of crime reported and the *types* of crimes reported (Bissler & Conners, 2012; Gorelick, 1992; Potter & Kappeler, 2006; Pritchard & Hughes, 1997; Sheley & Ashkins, 1981). Both print and television news media over represent the relative frequency of violent crime, and public perceptions more closely mirror media representations than police statistics (Potter & Kappeler, 2006; Sheley & Ashkins, 1981). The most unusual crimes, especially homicides, are over represented (Gorelick, 1992; Potter & Kappeler, 2006), and the most newsworthy murders are those involving whites (either as suspects or victims) where the suspect is male and the victim is a woman, child or elderly person (Carter, 1998; Pritchard & Hughes, 1997). Therefore, news coverage not only "over exaggerates the crime risks faced by economically privileged white people," but also "overwhelming focuses on ethnic minorities as perpetrators and suspects from the lowest socio-economic groups" (Potter & Kappeler, 2006, p. 5).

The differential treatment of crime reporting based on race, gender, class and age is not random (Bissler & Conners, 2012; Potter & Kappeler, 2006, Liebler, 2002). By highlighting particular cases, victims and perpetrators over others, crime news works to maintain hierarchies of class (Grabe, 1996), race (Benedict, 1992), sexuality (Buckingham & Bragg, 2007), and gender (Meyers, 1997). The "recurring pattern of news that highlights certain kinds of criminals and victims while downplaying others transmits daily messages about whose behavior matters most in society" (Pritchard & Hughes, 1997, p. 50). For example, tabloid news magazine shows, which target working class audiences, are more likely to cover crimes that illustrate middle and upper class deviance, while traditional news magazine programs more often show the upper class as victims of crime by lower class criminals (Grabe, 1996). News coverage amplifies crime allegedly committed by young, poor, urban, nonwhite

males and in turn frames these particular crimes as "social problems" like drug abuse and gang violence (Kappeler and Potter, 2005).

By over-publicizing the rarest types of crimes—whether it be rape, murder or kidnapping—the media construct epidemics which can serve as false warnings to women and young girls. For example, Cynthia Carter (1998) has argued that an unwarranted amount of attention is focused on the rarest crimes such as stranger rape, while the more common incidents of familial abuse and domestic violence are downplayed. While the murder of females is reported more often, men are most likely to be the victims of homicide (Carter, 1998). As a result, "the daily diet of representations of the most brutal forms of sexual violence constructs the world outside as well as inside the front door as highly dangerous places for women and girls, one in which sex crimes have become an ordinary, taken-for-granted feature of everyday life" (Carter, 1998, p. 231).

Snatched draws from scholarly understandings of mediated "moral panics" (Cohen, 1972; Hall et al., 1981; Goode and Ben-Yehuda, 1994; Mazzarella, 2010) in particular how alleged crime waves and youth crises are situated within larger cultural tensions. Crime "epidemics" and "moral panics" have throughout history been well-established as cyclical and intertwined with socio-economic conditions. Moral panics are defined as a "group or type of activity that is perceived as a threat to the stability and well-being of society" (Potter and Kappeler, 2006, p. 7). Media coverage focuses attention and organizes public fear about those particular groups or activities, typically targeting immigrant and minority populations as well as inner-city youth. Researchers have shown how moral panics have historically served important ideological functions, whether the panic revolved around "sex fiends" in the 1920s and 1930s (McCaghy & Capron, 1997), youth "gangs" in the 1960s (Cohen, 1980), mugging in the 1970s (Hall et al., 1981), or crack "mamas" and babies in the 1980s (Reinarman & Levine, 1989). In each of these cases, media portrayals of the crime or problem were disproportionate to the actual incidences and severity of the offenses. Crime statistics are often manipulated to serve specific political agendas. For example, the ensuing "War on Drugs" that emerged from the media-hyped crack panic in the 1980s targeted inner-city blacks, while both

the state and the media largely ignored cocaine use by affluent whites in the 1970s (Potter and Kappeler, 2006; Reinarman & Levine, 1989). The process of framing, or in this case assignment of meaning to seemingly isolated incidences, also helps explain how independent crimes take on the illusion of a "crime wave." Journalists and editors organize individual cases around themes as a way to synthesize large amounts of raw materials (Fishman, 1981, p. 103). The interactions among news organizations reporting on the same crimes, and the consistency with which the crimes are reported, gives the illusion of a crime wave. Furthermore, journalists feel pressure to seek out and "discover" new types of unusual crimes, at which point the news media become saturated with stories about these rare occurrences (Carter, 1998). It is this process of developing journalistic "story shorthand" or "branding stories" which results in the type of labeling (i.e., "the summer of child abductions") that frames isolated incidents as cultural phenomena or "epidemics" (Kitzinger, 2004).

By amplifying either trivial (vandalism) or serious (kidnapping) crimes, news media manufacture sensationalized coverage that prompts audience engagement and incites public outrage (Hall et al., 1981). As McRobbie and Thornton note, "Moral panics, once the unintended outcome of journalistic practice, seem to have become a goal" (1995, p. 560). In particular, moral panics about child sexual abuse signal "new forms of neo-liberal governmentality that have emerged to reconcile the rift between the sexual commodification of girls, public morality, and heterosexual paedophilic desire" that play out in news media (Bray, 2009, p. 173). The influence of moral panics, particularly involving children, on policies, laws, and organizations has been significant (Zgoba, 2004). Two specific groups—child victims and sexual predators—have long been at the heart of moral panics, governmental legislation, and media narratives.

The "Modern Morality Play" in Context

As this larger scholarly body of work demonstrates, crime involves both a real human experience and a mediated cultural representation.

Kidnapping stories in particular represent "how our culture views children, parenthood, and sexuality and how it defines strangers, community and crime" (Fass, 1997, p. 8). And while there has been a great deal of research published on media coverage of crimes like rape, child abuse and domestic violence, very little has been written about the news coverage of child abductions or of violence against children more broadly.

As previously cited, Paula Fass, author of *Kidnapped: Child Abduction in America* (1997), offers the only book-length study of kidnappings in the news, historically tracing coverage of abduction cases from the mid-19th Century through the 1990s. Fass (1997) approaches the topic as a historian of childhood, arguing that stories about child theft, molestation, and the torture and killing of children mark boundaries of deviance and dramatize larger social tensions. For example, in the 1920s, major newspapers were fascinated with the sexual torture of a fourteen-year-old boy in the infamous Loeb-Leopold case, indicative of an intense fear of sexuality during that time period. In the 1930s, ransom kidnappings such as the highly publicized 1932 abduction of Charles Lindbergh's toddler son came to symbolize the civic decay of that period, the fear of gang and mafia crime, and the threat of economic disparity brought on by the Depression.

As notions of the "nuclear family" came under siege in the 1970s and 80s, media reporting centered on parental kidnappings. With the rise of divorce rates and subsequent custody battles, parental abductions came to symbolize "the most extreme instance of individual family disorder" and became a powerful "sign of erosion of contemporary family life" (Fass, 1997, p. 145). The civil rights, feminist, and LGBT movements that arose in the 1960s had by then forged a more open critique not only of the "nuclear family" but also of its partners-in-crime, white male patriarchy and compulsory heterosexuality. Therefore, the heavily publicized disappearances of young white boys like Etan Patz and Adam Walsh in the late early 1980s "took on symbolic salience as threats to the future of the white American male" (Mokrzyckil, 2013/2014). These cases also fueled anti-gay cultural anxieties about predatory male homosexuality. In the 1990s, stories about parental kidnappings took on

new meanings, focusing on issues of familial abuse, as well as distrust of the state in regulating family relationships (Fass, 1997).

Child kidnappings in our contemporary media have evolved from a social problem into something of a national pastime, a source for "daily sensationalism" (Fass, 1997, p. 19). In the 2000s, the "new wave" of child abductions centered around missing white girls served as a catalyst for a modern moral panic (Mokrzyckil, 2013/2014). Moreover, with the rise of digital media technologies, stories of child abductions are highly malleable and adaptable across a wide variety of media platforms, from hard news reporting to tabloid infotainment to best-selling memoirs to television dramas and made-for-TV movies. The same stories that headline the evening news transition seamlessly to reality series like *America's Most Wanted* and "ripped-from-the-headlines" television dramas like *Law & Order*. These highly market-able and profitable stories symbolize a "painful contradiction of child sexual exploitation" (Fass, 2011). The commercial mass media system commodifies childhood and profits from child victims just as popular media forms eroticize youth culture.

In *Snatched*, then, we seek to extend Fass's impactful work by focusing on the coverage of the major cases in the 2000s, a time when "stranger danger" abductions dominated media headlines and were framed as alarming epidemics and as national tragedies. We situate the study of child kidnappings within the realm of girlhood studies, as we explain in the following section, because the victims who head-lined the news media in the 2000s held significant symbolic power. As Mokrzyckil writes, the increased interest in this specific type of child disappearance, that of the young girl victim, "confirmed Americans' desire to *reaffirm* the national value of innocence" (2013/2014).

Vulnerable Victims and Temptress Vamps: Girlhood in Context

Our work joins an ongoing conversation about contemporary represen-tations of girls in media and popular culture. Childhood and girlhood

are highly contested social constructs that shift throughout time (Aries, 1962; Jenks, 1992; Lee, 2001; Postman, 1994; Prout, 2005; Wyness, 2006). Since the turn of the 21st century, girls media studies has emerged as a dynamic and interdisciplinary area of inquiry that has critically examined the production and growth of girl-themed media (Durham 2004; Schor 2004; Vargas 2009), how girlhood is constructed through popular media forms (Arthurs, 2003; Banet-Weiser, 2004; Gonick, 2004; Mazzarella and Pecora, 2007; McRobbie, 1991), and how girls negotiate and make use of the messages and images in media content (Acosta-Alzuru and Kreshel, 2002; Mazzarella, 2005). Collectively, this scholarship provides insights into the construction of "crises" in girlhood; identity formation through the use media culture; the commodification of girlhood; the relationship among diasporas, migration and popular culture; and the tensions among media, post-feminism and consumer culture.

Girls studies scholars have demonstrated how narratives surrounding girlhood in news and popular culture mark boundaries of deviance and social control (Harper et al., 2013; Kearney, 2006). Coverage of children is especially instructive; young Americans have historically "shouldered broader national anxieties about race, class, sex, and crime" (Mokrzyckil, 2013/2014). Girlhood in particular elicits our collective "protective response" toward childhood, symbolizing desires to guard family life, community, and national identity more broadly. Our examination of child abductions in the 2000s looks at the ways in which news stories sensationalize girlhood sexuality even as they attempt to deny and protect it.

Studies of mediated constructions of girlhood find that news media serve the contradictory function of celebrating innocence and sexualizing girlhood while at the same time policing youth sexuality (Fass, 1997; Hartley, 1998; Levine, 2002; Mokrzyckil, 2013/2014). According to Holland, "The visible sexuality of young girls has had immense consequences for the imagery of childhood" (2004, p. 180).

The young girl has emerged as an important figure in mainstream mass media in an effort to attract young female audiences, a phenomenon John Hartley (1998) terms "juvenation." The juvenation of the modern news media, and specifically the reporting on people ages

eight to eighteen, has become "the most intense site of media concern, especially for girls" (Hartley, 1998, p. 53). The modern news media are extremely concerned about girls, as they have become the subject of an unprecedented amount of hard news reporting on youth sexuality, teenage pregnancy, pedophilia, child pornography, anorexia, and crime committed by children (Hartley, 1998; Mazzarella and Pecora 2007).

Problems arise when media narratives work to mark the often-illusive boundary between childhood and adulthood. In policing juvenile behavior and defining what is appropriate for pre-pubescents, the media casts juveniles as outsiders, in the separate world of "Theydom." At the same time, however, their innocence and even attractiveness are celebrated by adults as part of the adult world of "Wedom" (Hartley, 1996). These problematic distinctions complicate coverage of child victims like JonBenet Ramsey, the highly publicized case of the six-year-old girl who was found murdered in her parents' basement in 1996. JonBenet's participation in child beauty contests, and the pervasive images of the child in full make-up with meticulously coiffed pageant hairdos, became highly scrutinized by media outlets. As Hartley describes,

> Children who are destroyed or shamed by their adult-like characteristics mark the boundary of adulthood, and put children firmly outside of it, but the same children are celebrated as the very essence of Wedom in their attractiveness, which cannot avoid eroticisation, since it seems equally a "law" that photographs of child-victims receive the widest and most sustained coverage, and are printed in the largest format, when they show the most attractive girls. (1998, p. 57)

The focus on young, white, telegenic girl victims like JonBenet is indicative of a larger media phenomenon known as Missing White Woman Syndrome, or MWWS (Berlant, 1997; Liebler, 2010; Stillman, 2007). Coined in 2005 by PBS anchor Gwen Ifil, Missing White Woman Syndrome is a contemporary illustration of a longstanding cultural obsession with white female victimhood.[1] Armstrong (2013), Robinson (2005) and Wanzo (2008) argue that missing persons coverage acts

out a "Damsel in Distress" trope, one that guides coverage of young abduction victims like Elizabeth Smart and Madeleine McCann as well as older missing person cases like eighteen-year-old Natalie Holloway, who disappeared on a high-school trip to Aruba. Media critics and Internet bloggers juxtaposed the media exposure of Holloway's case next to the scant coverage of LaToyia Figueroa, a twenty-four-year-old pregnant Latina woman who disappeared from Philadelphia, and was later found strangled to death. National news media initially neglected to cover the Figueroa case despite attempts by her family to capture media attention (Leibler, 2010).

The disproportionate focus on female victims who line up with "historically rooted conceptions of beauty and innocence" (Mokrzyckil, 2013/2014), namely young white, privileged, physically "attractive" girls and women, works to further marginalize the poor and working class, minority/nonwhite families, and older victims. In defining who is considered a "worthy" or "innocent" victim, media storytellers by extension demarcate those who count as citizens and those who are cast as "lost citizens" (Wanzo, 2008, p. 101). As Rachel Wanzo argues, the "lost (white) girl body is reconfigured and imbued with more meaning than she can possibly hold, becoming a powerful symbol through the carefully crafted representation of her disappearance or death" (Wanzo, 2008, p. 100.)

Threats to Child, Family and Nation: Masculinity in Context

Just as young white girls came to symbolize virginity and purity, media narratives also perpetuate myths of violent male predators. As such, this project, with its focus on male suspects and its inclusion of the rare cases of young boy abductions victims, also contributes to understandings of how masculinities are constructed though popular media forms (Malin, 2005; Watson, 2009; Wannamaker, 2011). News media routinely perpetuate stereotypes of men being "naturally" more violent than women, casting women as nurturers of children and men as threats towards them (Meyers, 1997; Silverman & Wilson, 2002).

Judith Levine (2002) argues that media exaggerate teenage sexuality and the "epidemic" of pedophilia specifically. News organizations virtually construct widespread panic and hysteria about childhood sexual deviance by reporting on topics such as teen sex, teen pregnancy, pedophilia and kiddie porn. However, there is little evidence to support an increase in any of these "problems"; there has been no increase in child sexual abuse, and teen sex rates have remained fairly stable since the 1950s (p. xxiv).

Scholars have demonstrated how the recurring "pedophile panic" is a cultural construction carried out by media narratives, symbolic of cultural fears about adolescent sexuality. Far from being a static, ever-present figure, the pedophile emerges as a modern character during times of economic and social upheaval (Brongerson, 1984; Foucault, 1977; Levine, 2002; Silverman & Wilson, 2002). For example, the trope of the pedophile lay dormant during much of the twentieth century, but emerged during the Depression when economic hardship challenged masculinity, and again after WWII with the need to restore gender roles and family life (see Bromley, 1991; Doyle & Lacombe, 2000; Levine, 2002).

The mythic figure of the pedophile serves as a popular construct in a culture that paradoxically sexualizes youth and at the same time seeks to police and protect them. As Levine writes, "we relish our erotic attraction to children" in that we celebrate child beauty pageants and the sexiness of the teenage body, but "we also find that attraction abhorrent" (Levine, 2002, p. 26). The pedophile thus serves as a convenient societal scapegoat: "a monster to hate, hunt down and punish" (Levine, 2002, p. 27).

As with the depiction of girlhood innocence, the early 2000s in the U.S. was ripe for representations of the mythical violent male pedophile, as the nation struggled to metaphorically protect its "global dominance" and place blame on the "other" for its unraveling national and economic security (Grewal, 2005). These central concerns make this analysis of boy and girl victims, as well as male perpetrators, a critical and timely contribution. In the following section, we describe the process of artifact selection, how we chose the news texts that were included for investigation in this study.

Research Approach

Employing qualitative analysis of U.S. mainstream news texts over the last decade—with a specific focus on broadcast television news, large circulation national newspapers and newsmagazines, and news websites, this book project addresses the following research questions: What types of kidnapping crimes attracted the most media attention during this time period? What were the characteristics of the cases that reached national prominence? What were the dominant framing devices used by journalists to construct kidnapping stories and myths? How did these frames shift over time? How were gender, race, class and sexuality used by storytellers to construct both victim and suspect? How were boy kidnapping victims treated differently from girl victims?

To explore these questions, we relied primarily on textual analysis to "discern latent meaning" and interrogate the myths that influence framing of child abductions in news discourses (Fursich, 2009, p. 243). Our theoretical grounding in media studies, gender studies, and cultural studies serves as the foundation for a broad and nuanced feminist textual analysis of news media framing of child abductions. We deconstructed subtexts through "a radical questioning of underlying assumptions of a text by exposing internal inconsistencies" such as the simultaneous celebration of girls' innocence and toughness (Fursich, 2009, p. 240). Parameswaran (2005) notes that middlebrow culture—including cable news, Internet stories, talk shows and news magazines—has been a neglected area of cultural studies research (p. 199).

We targeted prominent, mainstream national media outlets to capture the stories that reached the widest audiences. As our focus was on *child* abductions, we excluded cases in which the abductee was in his or her late teens or early adult years. The exception here was in cases in which the abductee was found or returned as an adult, but had been a child at the time of abduction (for example, the cases of Jaycee Dugard, Tanya Kach and Michelle Knight). In addition, our focus was on U.S. media and thus tended to focus on cases involving American children. However, as we discuss throughout the book, several prominent international cases attracted U.S. media attention, in particular when these

cases "fit the frame" of the Missing White Woman Syndrome perpetuated by the national media. As such, we offer a comparative study of how U.S. media covered these prominent international cases.

Using the Lexis-Nexis database, we searched major U.S. media sources for stories that included the terms "abduct!" or "kidnap!" as well as other relevant search terms depending upon the focus of the scholarly investigation (i.e., "escape!" for stories of escaped victims).[2] We further searched for the names of people involved in prominent abduction cases. Adult kidnapping cases were excluded from the study, as were other stories irrelevant to the study (i.e. sports stories, movie reviews, letters to the editor, etc.).

This book was limited to a systematic textual analysis of U.S. news coverage across a ten-year time span, 2002–2012, in which coverage of child abductions saturated U.S. news media and captured the public imagination. We included prominent broadcast, online and print media forms with a particular focus on how visual representations of victim and suspect (especially gender, race and class) frame the story in important ways that textual forms alone could not. As such, this book offers a significant contribution to the study of U.S. press coverage of age-and-gender-related crimes in hopes of fueling additional research on coverage of gender, children, and crime news.

Plan of the Book

Our analysis begins with the highly publicized "summer of child abductions" during the summer of 2002, the cases that launched the contemporary moral panics over kidnappings in the U.S. The cases of Danielle Van Dam, Samantha Runnion and Elizabeth Smart were horrific yet isolated; nevertheless the U.S. news media referred to these kidnappings as "national tragedies," discussed "a nation in mourning," and dubbed child abductions a "national epidemic," although actually kidnapping cases were at a decade-long low. Our analysis reveals how gender and class were used to construct vulnerable girl victims and predatory male perpetrators. News narratives organized kidnapping stories using frames of family values, community cohesion

and patriotism, while also disproportionally stressing the "stranger danger" myth.

On the contrary, male abduction victims are virtually invisible in mainstream news narratives that made national headlines in the 2000s. When boy victims do achieve national prominence, it is usually in the context of cases of pedophilia, in which the overarching narrative focuses on male perpetrators of sexual assault on young boys. Thus, Chapter 3 situates the cases of missing boys in a historical context and offers an analysis of contemporary male abduction victims such as Shawn Hornbeck and Ben Ownby as well as a series of cases which gained regional news attention but whose stories failed to reach national audiences. This chapter offers a comparative case study of how boy victims and girl victims are treated in news discourses, exploring how journalistic constructions of girls "in crisis" and boys as "proper citizens" simultaneously reinforced the idealized innocent child while mapping moral panics onto girls' bodies.

The past decade has also seen intense media scrutiny focused on several recoveries of teenagers and adults who were victims of long-term abductions. Crime coverage has a long history of victim blaming, employing incarnations of the virgin/vamp myth. In Chapter 4, our analysis turns to the news treatment of these prominent "recovered victim" cases of Elizabeth Smart, Shawn Hornbeck, Jaycee Dugard, Amanda Berry, Gina DeJesus, and Michelle Knight.

These cases of long-term abduction and captivity spawned journalistic narratives in which cultural notions of the idealized child were contrasted with fears about youth agency and teenage sexuality. As in the case of rape and domestic violence, victims of long-term child abduction and sexual assault garnered speculation by journalists and "experts" about what the abductees could have done to escape. As previously discussed, victims must adhere to gender norms in order to be granted legitimacy as victims (Greer, 2003). In the case of child abductions involving teenagers such as Elizabeth Smart, speculations about whether she invited sexual attention from her attacker or chose to stay with him rather than escape build on myths that girls are "asking for it" when they are kidnapped.

In contrast to the representations of vulnerable girls as victims, news narratives also highlighted "tough girls" who were able to thwart kidnapping attempts or escape their abductors. In Chapter 5, we interrogate how news media deployed the characteristic of toughness to construct narratives of victims who fought back against their abductor, attacked their abductor in any way, tried to escape or were able to free themselves. The uniquely American myth of the rugged individual was deployed to exalt some young girls who show "masculine" bravery, while other victims are blamed and sensationalized for having been abducted and "failing" to escape.

As researchers, journalists and citizens, we must consider the implications of when notions of childhood, and girlhood specifically, become symptomatic of cultural anxieties about nation, gender and family. When youth culture is celebrated and sexualized, we are inundated with news stories, billboards, milk cartons and Amber Alerts containing the faces of our lost children "which serve as both cautions and come-ons, provoking anxiety and defining a cultural indulgence that exploits the very children we seek to protect" (Fass, 1997, p. 7). In our concluding chapter, we consider the ways in which news stories about child abductions sensationalize certain child victims as symbols of protection while at the same time marginalizing others as threats to family and nation. Employing theoretical perspectives from girls studies, cultural studies, feminist scholarship and media studies, we use abduction coverage as a lens to demonstrate how media narratives of girlhood "signify the endangered purity of the nation," particularly during times of national crisis and economic upheaval (Mankekar, 1997, p. 29).

Notes

1. These "Damsels in Distress" myths have their roots in enduring parables and fairy tales such as Little Red Riding Hood, Sleeping Beauty and Snow White.
2. The exclamation mark at the end of the search terms covers derivations of the word. For example, "abduct!" would return stories with the words "abduction," "abducted," "abductor" and so on.

Chapter 2

The Summer of Child Abductions

I turn on the TV and hear about dead little girls.
—Sheila Joyner of Baton Rouge, La., explaining to *Newsweek* magazine why she could no longer let her 11-year-old daughter ride her bike in the daytime.

—(Murr, 2002, July 2, p. 38)

It was the summer of 2002. While media reports circulated images of military air strikes and on-the-ground combat missions in Afghanistan as part of America's "War on Terror," another series of news events dominated headlines that summer. Perpetuated by a barrage of stories about several terrifying child abduction cases, many Americans began to feel, as Sheila Joyner did, that she couldn't let her daughter out of sight.

Joyner wasn't alone in what she saw splashed across the evening news. During the media-dubbed "summer of child abductions" (SOCA) (Alter, 2002), news coverage of American children being snatched from their homes and neighborhoods skyrocketed. Beginning with a string of high-profile cases in 2002, this "new wave" of child abductions captured national headlines and dominated public discourses about crime

and deviance, child safety, parenting, the American family, and gender and sexuality in the new millennium.

The prominent cases in the U.S. that dominated national headlines during this time period include the abduction and murder of seven-year-old Danielle van Dam from San Diego in February 2002, the abduction and eventual return of fourteen-year-old Elizabeth Smart from Salt Lake City in June 2002, and the abduction and murder of five-year-old Samantha Runnion from Stanton, California, in July 2002. In each instance, the missing child was a young Caucasian girl from a middle- to upper-class family who was taken from her home by a male stranger. As we explore in this chapter, the abductions that made the news in the summer of 2002 were not representative cases. The cases which garnered national media attention centered around a young female from a middle- to upper-class neighborhood who was abducted from her home by a lower- to working-class male "stranger."

The primary purpose of this chapter is to uncover the patterns that emerged in the journalistic prioritization of which victims are deemed worthy of concern, attention, resources, and protection, as well as the suspects who were vilified as responsible for these heinous crimes. To begin, this chapter will first uncover the dominant narratives that were used to construct mainstream U.S. news coverage of the Summer of Child Abductions. In doing so, we unpack the larger cultural myths that influence news coverage of girls as vulnerable and fragile. Next, we contrast how myths of girlhood were juxtaposed with those of violent male predators who were cast as threats to nation and family structures. Finally, we examine the evolution and lingering deployment of the Summer of Child Abduction narratives and framing devices in more recent domestic and international cases. For example, in 2005, eight-year-old Shasta Groene was abducted, along with her nine-year-old brother Dylan, from their Idaho home, and in 2007, three-year-old Madeleine McCann disappeared from her vacation home in Portugal. In both cases, the frames established in 2002 evolved, but remained largely intact, as intense news coverage continued to privilege a particular script, that of the young Caucasian girl snatched from her family.

Race, Class and Gender Define Victim and Suspect in the New Millennium

Before we describe the mythic framing devices employed in news reporting during the Summer of Child Abductions, it is first important to provide background information on the major abduction cases that dominated headlines from May through August of that year. On February 1, 2002, Danielle van Dam disappeared from her San Diego bedroom around 10 p.m. Her body was found on February 27. A fifty-year-old neighbor, David Westerfield, was convicted of her kidnapping and murder on August 22. Initially, this case seems to fall outside of the "summer" time period. However, Danielle's case received increased coverage in the summer months since most reports tied her case to the disappearance of the other two girls who went missing, Elizabeth Smart and Samantha Runnion. Additionally, the case received increased attention that summer since her kidnapper's trial took place in August, situating her case within that news cycle.

The second "headline" girl victim to go missing, and the one to receive the most media attention across the entire time period of our study, was fourteen-year-old Elizabeth Smart from Salt Lake City, Utah. Elizabeth was abducted from her bedroom at gunpoint on June 5, 2002 in the middle of the night. The Smarts live in 7-bedroom mansion in an affluent suburb. Elizabeth's nine-year-old sister was sleeping beside her when Elizabeth was taken. Out of fear, her sister complied with the gunman's request and did not wake her parents until two hours later. In July, police arrested suspect Richard Albert Ricci, a forty-eight-year-old handyman who had worked for the Smarts. Ricci suffered a cerebral hemorrhage and died in August while in jail.

In March 2002, in a rare and "shocking" turn of events, Elizabeth was discovered nearly nine months after her abduction when several tips sent police to the home of Brian Mitchell and Wanda Barzee. As we analyze in Chapter 4, initial police reports suggested that Elizabeth was "brainwashed" by her abductors since she failed to try to escape despite her supposed several opportunities to (*The New York Times*, March 13, 2003). Mitchell, forty-nine, had been a handyman for the Smarts, and allegedly kidnapped Elizabeth in hopes of making her the first of seven new brides.

The third case during the SOCA was the abduction of five-year-old Samantha Runnion from Stanton, California. Samantha disappeared on July 15, 2002, while she was playing a game of Clue with a friend outside her home. She left with a man who said he needed help finding his dog. Her body was discovered the next day by two hang gliders who stumbled upon her in the national forest by Riverside. Her body was found bruised and naked, laid out in a provocative way by a major highway, as if daring FBI profilers to find him (Murr, 2002). Police later charged Alejandro Avila, twenty-seven, with murder.

We argue that these cases, while tragic, are not symbolic nor typical of the majority of cases of missing children, but they do meet similar "newsworthy" prerequisites, namely, all victims were middle-upper class young girls. We thus interrogate the patterns that emerged in news coverage during this time period of intense focus on abducted girl victims, with a particular analytical lens toward how gender, class and race were used to construct victims and suspects. We also investigate dominant framing devices used by national media outlets to construct kidnapping stories and myths, and how these framing devises shifted over time as new cases emerged in the later part of the decade.

As clearly identified in the introduction, the emphasis on victims as female and suspects as male across national media outlets suggests that the stories achieving national prominence are those that successfully perpetuate the myth of predatory males abducting young girls (Moscowitz & Duvall, 2011; Levine, 2002). However, it is not only the *selection* of these particular cases as "newsworthy," but also the *emphasis* on particular identity categories within news narratives that highlight this specific script. Of course, not all young girls who disappear have the same degree of "newsworthiness" media workers grant that images of "cute teenage girls" are part of the marketing strategy used by news organization to attract audiences and garner higher ratings (Kurtz, 2002, p. 2).

The emphasis on socioeconomic class within national coverage also worked to exaggerate the myth across class lines, highlighting low-class male vagrants snatching girls from upper-middle class suburban

homes (Moscowitz & Duvall, 2011). The socio-economic class of the victims and suspects was usually included in news reports through descriptions of neighborhoods, homes or occupations. For example, in the coverage of Elizabeth Smart, whose case received the most prominent coverage, the press routinely described her "million dollar home" as a "seven-bedroom hillside mansion," and stressed her father's employment as a "real estate broker." On the opposite side of the spectrum, the initial suspect in the case was assumed to be a homeless man: "The hunt continues for Bret Michael Edmunds, 26, a transient whom police think may have been in the neighborhood before the disappearance" (McMahon, 2002, June 17). Another example shows how class was used to demarcate victim and predator:

> The two neighborhoods couldn't be more different. Almost four weeks after 14-year-old Elizabeth Smart was kidnapped from her home in the wealthy foothills of Salt Lake City, the spotlight had shifted across town to a modest trailer park in the southwest suburbs. The focal point: the home of Richard Albert Ricci, a 48-year-old ex-con and handyman who had worked at the Smart's million-dollar mansion more than a year ago. (Peraino, 2002, p. 41)

Media reports stressed class to clearly define suspects as "other"—different from the families being tormented by child abductors, priming audiences to imagine predatory culprits as low class vagrants or blue-collar workers. Class distinctions are also present in tips for parents about how to keep your children safe and *avoid* abductions by male strangers. Reports urged parents to have the child's bedroom on the second floor, not to advertise family finances, and avoid personalized clothing and bags that have the child's name imprinted on them. Warnings such as these presume a higher socio-economic status, and clearly play to an audience of predominately middle-to upper-class viewers and readers.

The deployment of these class distinctions in media narratives of crime reporting is significant. As Grabe (1996) points out in her work with television news magazine programs of crime reporting, the class of the suspect is directly related to the class of the target audience.

Mainstream news outlets tend to reach an audience of older, middle- to upper-class Caucasian consumers, while the content perpetuates the image of low-class criminals victimizing the middle class. As Meyers (2004) points out, "the news supports the values, beliefs and norms of a ruling elite that wields social, economic and political power within a hierarchy of social formations" (p. 96).

Thus, child abduction narratives help to maintain class boundaries by "othering" members of the lower/working classes such as bus drivers, construction workers and handymen. Class distinctions are used to show how kidnappers come from a "different world" than that of victimized families. By stressing these "differences," U.S. media reports may create perceptions that abductors are from the underclass, when in reality most kidnappings are committed by a family member or someone within the family's social circle.

Closely related to depictions of socio-economic class, racial identity was a common marker used to further differentiate victims and suspects. National and even local media often ignore reports of missing minority children, in particular if they disappear from lower income neighborhoods and/or are considered "runaways." During this same time period, several children with diverse class and non-white racial identities disappeared across the U.S., but did not receive the same media attention. For example, two-year-old Jahi Turner was kidnapped from a park in San Diego, and seven-year-old Alexis Patterson was abducted when walking home from school in her Milwaukee neighborhood. Both kids were black. While their cases generated some local media attention, they did not rise to the level of national media prominence like the cases of Smart, Van Dam and Runnion, the middle-to upper class Caucasian girls (Murr, 2002) (See Chapters 3 and 4 for further discussion of how class and race were used to mark some victims of worthy of media attention while other cases were ignored).

The lopsided coverage of child abductions in the early 2000s was influenced by other factors than the race, class and gender of the victim, however. As we will explore in the following sections, news coverage highlighted cases in which specific frames of community and national cohesion, contrasted with narratives of stranger danger, were employed as dominant story-telling devices.

Mythic Narratives Dominate in a Post 9–11 Cultural Climate

By emphasizing family values, community engagement, nationalistic ideologies, stranger danger, and childhood innocence, journalists wove tales that reinforced dominant notions of citizenship. Young white girls, their families, and the U.S. were cast as idealized victims under attacks by foreign, lower class, and unknown assailants.

For example, the dominant framing of "family values" was deployed through mentions of grieving families, parental efforts to find their abducted children, and the idealized American family and home. These

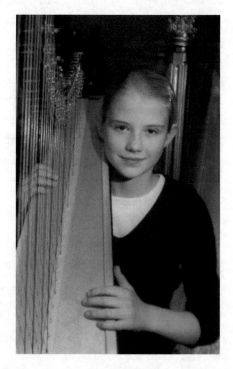

Figure 2.1. Elizabeth Smart family photo (Elizabeth with Harp).
A family photo of 14-year-old Elizabeth Smart who was abducted at gunpoint from her Salt Lake City home on June 5, 2002 was widely circulated throughout national news media. Her disappearance dominated media headlines and became one of the most notorious missing children cases of the last decade. Smart was recovered and returned to her family in March 2003 after 9 months of captivity.
(George Frey/Getty Images News/Getty Images)

depictions dominated in the coverage of the most prominent child abduction of 2002, that of Elizabeth Smart. Details about the family's devout religious practices, loving home and the opportunities afforded Elizabeth, such as music lessons, portrayed the Smarts as a loving and intact idealized family.

Stories that contained the "family values" frame broadly used kidnapping stories to reflect upon how the American (nuclear) family was in need of protection or salvation. Stories that used the "family values" theme sometimes centered on how the suburbs/small towns are "supposed to be safe," expressing disbelief that child abductions could happen "here, in our neighborhood." Other stories described how the streets and parks, once filled with childhood laughter, are empty now as a result of fear. A key component of this theme was the need for the family unit to be kept intact, thus focusing on the grieving family members, or the need for the family to be protected from scrutiny by police and media. Remembrances and family interactions also idealized familial intimacy. As the search for Smart continued, her family became the story. This interchange between reporter Jane Clayson and the Smart family on *CBS Evening News* featured footage of the Smarts's other children and demonstrates the journalistic focus on the idealized American family:

> Jane Clayson, reporter, *CBS News*: They may not know where Elizabeth is now, but her family knows exactly where she would have wanted to be on the day she turned 15. You took them to Disneyland and Knott's Berry Farm for Elizabeth's birthday because that was her favorite place.
> Mrs. Lois Smart: We felt that she would have loved to have been there with us. And each of the children has said that, "I wish Elizabeth could be here," cause she loved those big, scary rides, and we don't.
> Mary Katherine Smart: Well, once you've been on it, it's not that scary.
> Andrew Smart: It's not scary once you've been on it.
> Clayson: No?
> Clayson: The Smarts refuse to allow what happened on June 5th to stop them from being a family. (*CBS News*, January 10, 2003)

Idealized families were represented as being strong, resilient and bonded by the search for their missing child, and, in the rare case of Elizabeth Smart, rewarded for their steadfastness with her return:

Doratha Smart, Elizabeth's grandmother: And I'm so proud of the family for holding together and giving so much time and effort, and this is just Thanksgiving in March for us. That's it. All the way home we were driving home and—and thanking God, and I couldn't help but think of those families who still have their children missing, and who have gone through the tragedy of also finding that they will never come back; instead, that they were killed. And we know what the grief is. We've been through a lot of grief, and we're gonna pray for you, and we are anxious to see this Amber Alert go through immediately, and we're just grateful for all of the help, and today is a—just a day of thanksgiving. (*CBS News*, March 13, 2003)

By situating child abduction as a family crisis, narratives both reified families such as the Smarts, but by extension, also scrutinized other families for their seeming failures to fulfill the expectations of the archetypal family. As we explore further in Chapter 3 as well as in the book's conclusion, these distinctions were used to create hierarchies of "good families" (secure, responsible) and "bad families" (negligent, irresponsible). When families became suspect or blameworthy for their missing child, it was characterized as a lack of "responsible" parenting.

For example, in the aftermath of Danielle van Dam's disappearance, news reports centered on her parents' recreational drug use, their number of sexual partners, and the party they hosted the night of Danielle's disappearance. By the time Danielle's murder went to trial, these claims became indictments of failed parenting and were entered into evidence:

With intense cross-examination Wednesday and again today in San Diego Superior Court, the defense lawyer tried to show that the parents, Damon and Brenda van Dam, engaged in such bawdy behavior the night their daughter, Danielle, disappeared that anybody might have abducted the girl and killed her. In so doing, the lawyer, Steven Feldman, turned the spotlight almost entirely away from his client, David A. Westerfield, 50, an engineer and neighbor of the van Dams who is accused of kidnapping and murdering the girl, largely based on traces of her hair, blood and fingerprints that the authorities say they found in his motor home. (Janofsky, *New York Times*, June 7, 2002)

Alleged drug use was wielded as further evidence to demean Danielle's family:

The father of 7-year-old Danielle van Dam Wednesday admitted he smoked marijuana on the night his daughter disappeared. (CNN, June 6, 2002)

In a similar way that family values were deployed to demarcate virtuous, respectable, stable families from "bawdy" irresponsible parents, news coverage also frequently focused on "good" neighborhoods and communities that banded together to search for child victims, issued or promoted Amber Alert efforts, organized community prevention efforts, or held neighborhood vigils. Stories containing the "community" theme focused on the neighbors and local community members coming together to organize search efforts, wear ribbons of support, erect shrines, attend vigils, and mourn the victim if found murdered. Stories also contained information about local efforts to raise money to assist in searches, offer a reward, organize an Amber Alert, or establish community prevention and warning systems. Throughout the months that Elizabeth Smart was missing, for example, reports typically described her Salt Lake City neighborhood as "a close-knit community" where "the family is getting plenty of support. Neighbors attended a prayer service last night, after spending much of the day helping in the search" (CNN, June 6, 2002).

Figure 2.2. Seven-Year-Old Missing in California.
Marla Huott and her son Aaron sign a book wishing for the safe return of missing seven-year-old Danielle van Dam, who disappeared from her home in Sabre Springs, CA, on February 1, 2002. Her body was recovered on February 27. Images and narratives emphasizing organized community support—including search efforts, vigils, and prevention programs—became an important story-telling device in coverage of missing children. (Tom Kurtz/Getty News Images/Getty Images)

Closely related to framing kidnapping stories through the lens of "community support," the frame of nationalism emerged as a consistent storytelling device during the Summer of Child Abductions. As the U.S. reeled during the aftermath of the terror attacks of September 11, 2001, stories of child abductions took on the significance of representing both citizen and nation. The patriotism theme of U.S. nationalism brought kidnapping cases into the context of the whole nation, "a nation in mourning," framing the crime as a national problem that required a state-run solution. This narrative stressed political and governmental settings, mentions of Americana, the use of patriotic symbols such as flags, and linked unrelated cases to cast child abductions as a social problem that demanded a united citizenry response.

For example, when President Bush announced in the fall of 2002 additional federal resources to improve the nation's Amber Alert system, mainstream newspaper accounts discussed "federal efforts" and "national standards" to end what Bush dubbed "this nightmare across America" (*The New York Times*, October 2, 2002). Stories containing the nationalism theme specifically mentioned America being "under attack," sometimes alluding to the events of September 11, 2001, by referring to abductions as another "homeland security threat" and "a different, and much older, sort of terrorism" (*USA Today*, August 26, 2002).

Stories containing this theme also cast child abductions as America's problem; described the victim, victim's family, or town as "All-American" and/or included national symbols like the flag. For example, stories included descriptive details like a returned victim dressed in a t-shirt with the American flag on it, described the child as a Girl Scout (or alternately, a Boy Scout, as we discuss in Chapter 3) who sold cookies door to door or mentioned the presence of American flags at a victim's funeral or of small flags dotting the yard from where the child went missing. Perhaps not surprisingly, the patriotism theme was employed most frequently in nationally targeted newspapers like *USA Today*, which was also more likely to frame news of child abductions in a national context, perhaps stimulating solidarity among nationwide readers.

The cases that dominated national news also rose to prominence in large part because they deployed the powerful "stranger danger" myth, perpetuating the focus on the stranger-as-suspect or on the "anonymous predatory" nature of the kidnapping crime (i.e. strangers

"lurking" outside homes). The theme of "stranger danger" appeared frequently in headline coverage even though this particular type of kidnapping is statistically rare, constituting fewer than 100 cases per year. This theme stressed the outsider status of suspects and the randomness of kidnapping crimes.

In the "stranger danger" theme, the suspect was identified as a stranger to the family or "unknown" to the family, most often in cases of home invasions where young girls were snatched from their bedrooms or yards. In some cases, even if the suspect was known to the family, such as the handyman in the Smart case, he was still framed as a "stranger." In cases in which police had no leads, the suspect was still often framed as an anonymous stranger. Even when the suspect turned out to be an acquaintance of the family, initial reports presumed the suspect to be a stranger. For example, in reporting on Brian Mitchell, who the Smarts met while he was panhandling and invited to work at their home, news organizations focused on him being a "drifter," using an assumed name, and reported that he had only worked at the Smart house "once." News outlets used the descriptors to mark Smart's abductor as a "stranger":

> Now law enforcement apparently had received two calls, two calls from two separate women saying they saw a subject that they recognized as "Emmanuel." Emmanuel's real name is David Brian—I'm sorry. Brian David Mitchell. He is a drifter and apparently had done some work at the Smart home, only apparently one time. (CNN, March 12, 2003)

In other cases, stories relied upon the "stranger danger" narrative even when initial evidence pointed to a family member as the prime suspect. For example, stories indicated that when family members were interviewed by police, as in the case of Elizabeth Smart's uncle Tom Smart, it was only a part of customary routine to "rule out" relatives. In fact, when the local paper reported a police theory that the culprit may be an extended family member, the Salt Lake City community and the Smarts's Mormon congregation became enraged (McMahon, 2002, June 10; McMahon, 2002, June 17).

Despite the fact that crime statistics show that a child is much more likely to be taken by a parent or someone close to the family, in the summer of 2002, news organizations went to great lengths to exaggerate

threats of stranger abduction and at the same time downplay the possibility that the perpetrator was known to the child or victim's family. While a few families were blamed for poor or neglectful parenting, as we discussed above in the case of Danielle van Dam, nonetheless the image of the lurking predatory male stranger was framed as the constant threat to young children, namely girls. Stranger danger stories included instructive warnings to parents, such as a list of "stranger traps" children should avoid (Preventing Child Abductions, 2002, p. 10A).

Linking unrelated cases was inconsistent with the journalistic tendency toward integration—to amalgamate individual cases into a "trend" or "social phenomenon"—in particular in crime reporting. In the case of abduction reporting, integrating disparate cases into a single report worked to increase the perception of a "kidnapping" epidemic and fed fears surrounding predatory "stranger danger." Paradoxically, news reports also used crime statistics to highlight how "rare" stranger abductions are. In some cases, this pattern resulted in conflicting messages within new stories themselves. On the one hand, coverage claimed that stranger abductions were statistically rare but also included warnings to parents about how to keep children safe from strangers.

While information about preventing abductions is certainly vital to parents even when the crime is rare, the sensationalized language and framing of a manufactured kidnapping epidemic escalates fears in news audiences and then place responsibility on caregivers to take actions (typically those rooted in the consumerist child safety industry) to protect children as a means of assuaging those fears. Thus, the framing both constructs the epidemic and prescribes the cure for the symptoms of fear and uncertainty.

Related to anxieties centered on stranger abductions, the theme of the innocent, asexual child in need of protection, and the loss of innocence suffered by victims, parents, and the nation, further served to reify certain victims as worthy of national concern. For example, on *Larry King Live*, John Walsh described fourteen-year-old Elizabeth Smart as a "little girl" (*Larry King Live*, CNN, June 26, 2002), contrasted to reporting on male abduction victims like Shawn Hornbeck, who when discovered at the age of fifteen was cast as a "teenager" or a "young man" (See Chapter 3 for an analysis of boy abduction victims).

Reporters such as Charlie Gibson also addressed the lost innocence of all children and, indeed, the implications of a nation under threat:

> It's a dangerous balance. Widespread coverage of a missing child might help her and it might scar a generation. Elizabeth Smart's story tells over and over one of childhood's deepest fears, an innocent child, taken in the middle of the night from the safety of her own home. Experts say news, particularly news about a child, hits home and hits hard when you're just a child yourself. (*Good Morning America, ABC News*, June 25, 2002)

While the number of stranger abductions is statistically low, the news outlets in this study played up the theme of "stranger danger," linked together individual yet unrelated cases which implied a broader stranger kidnapping "trend" or epidemic, and were ambiguous about reporting the relationship of the suspect to the victim (implying stranger). As is the case for crimes like rape and domestic violence, family members perpetrate most violence against women and girls, even as media reports stress the "extraordinary" crimes where the stranger is the culprit.

U.S. media continued to sustain narratives of idealized girls as fragile victims, objects in need of protection by and from men. The mythic framing devices and journalistic selection of young female victims "snatched" from their homes were juxtaposed with the "othering" of kidnappers/pedophiles as low-class and/or strangers to the American family. These framing devices worked to reinscribe family values, community cohesion and nationalism, reflecting a post-9/11 American culture struggling to protect its families and its nation.

Fitting the Frame: The Legacy of the Summer of Child Abductions

The legacy of the 2002 Summer of Child Abduction lingers in reporting of child abductions in the later half of the decade as well. In this section, we demonstrate the ways in which the prominent abductions of young, white girls have sustained the media themes of family, community, patriotism, and innocence shattered. The abductions of Shasta Groene in Idaho and Madeleine McCann in Portugal were distinct

cases, yet they share similarities with the 2002 cases that catapulted them to headline news stories. In both cases, the victims were young white girls abducted at night from their bedrooms by presumed male strangers. As we will explore below with each case, the narratives about their abductions were classed as well as raced and gendered, as news media speculated about innocence and culpability in each crime. Furthermore, the themes of family, community, nation, stranger danger, and innocence continued to structure reports about the two girls.

In 2005, a convicted violent sexual predator entered the Groene home after stalking the family for several days, and then murdered the children's older brother, mother, and her boyfriend, before abducting Shasta and Dylan. After almost two months, Shasta was recovered alive; her abductor was arrested, and Dylan's body was found in a remote wooded area where Duncan had sexually assaulted and murdered him. Although there were two abduction victims, news coverage of the case tended to foreground Shasta in comparison to Dylan (See Chapter 3 for a discussion of boy victims). Commenters subtly, but consistently, mentioned Shasta first or included more detailed and subjective descriptions of her:

> Family members have also released new photos of 8-year-old Shasta Groene. She is a beautiful little girl, as you know, Carol, waist length auburn hair, green eyes, slight build, just 40 pounds and 3'10" tall. Her brother Dylan, 9 years old, also missing of course, blond hair, crewcut, blue eyes, 60 pounds and four feet tall. The two children have not been seen for exactly a week. (*Live Sunday*, CNN, May 22, 2005)

> A grieving community awoke to a heartbreaking video filmed just days before eight-year-old Shasta Groene vanished. At the time, just another home video of a second-grader's science project. Today authorities say it's more than that. (*NBC Nightly News*, May 21, 2005)

As with the cases of 2002, socioeconomic class became central to the reporting. Several commenters focused on the rural, working class identity of the Groene family, as well as the presence of unnamed illegal substances in the toxicology reports of the two adult murder victims, depicting the parents as degenerate and potentially blameworthy for bringing the crimes upon the family. By including details of the

police searching pawn shops, using the crimes as a jumping off point for lengthy discussion of drug-related crime, and reporting that the oldest Groene child was in jail at the time of the abductions, the overall narrative that dominated coverage of this case was that the family unit had failed:

> Nancy Grace: But first, 8- and 9-year-old Shasta and Dylan Groene still missing tonight after a massive search effort in Idaho like no other. Their mom, brother and the mom's boyfriend slain in their own home nine long days ago. Toxicology reports show the two adults, the mom and the boyfriend, both had used illegal drugs before the kids were kidnapped. (*Nancy Grace*, CNN, May 24, 2005)

> Opri: You know, Nancy, what did you and I discuss the first night this show came out? It's crystal methamphetamine county over there. It's very high usage. And if they were bound, and tortured, and beaten, and bludgeoned to death, what do you think it was? It was an interrogation style. And that's the drug world. And I'm sticking ...
> Grace: Well, I can tell you this much, Debra. If it were pot, believe me, they would not have bludgeoned the victims up ... They'd all be laying on a sofa right now watching reruns of TV Land. All right? Not what happens with meth. (*Nancy Grace*, CNN, May 24, 2005)

> Bill O'Reilly: This Idaho situation, we're going to let this unfold without conjecture. We'll let the others do—because I don't know what happened here, but it has the look with the bound people, you know, shot down as a drug execution, which goes on all the time in this country, does it not? (FOX News, May 18, 2005)

Just as Danielle van Dam's parents' behavior prior to her abduction was cited in order to blame their negligence and inattentiveness, so speculation by news commentators was used to fault elicit drug use for Shasta and Dylan's disappearance. In addition, the Groenes' biological father was also initially suspected of wrongdoing because he had been absent from the home. The Groenes were not granted the privilege of being "ruled out" as suspects that occurred in the Smart case. After being seen as blameworthy when the story broke, they continued to be treated as criminals when their history with the law was seen as an impediment to the investigation:

Pat Brown, criminal profiler: Right. Well, we—it's an interesting case and the police had a lot of problems with this case for a very important reason. A lot of bad behavior was going on. Now, when you work—when you work with a case where everybody is law abiding and, therefore, when you talk to the witnesses they're all willing to help out and you don't have a lot of squirrelly backgrounds, you don't have as many directions to look. But when you deal with a case where a lot of the people have connections to the people who were murdered and the children taken, they have criminal backgrounds, they have drug issues. They don't really like law enforcement, they don't want to talk to law enforcement themselves, you are dealing with so many possible suspects, so many possible scenarios and so many uncooperative people, it doesn't make your investigation very easy.

Fredricka Whitfield, reporter: And in an investigation like this, as you said, you know, they're looking internally before widening the net. They asked that people who are a part of that party that had taken place at the home of these kids to step forward, to cooperate. (*CNN Live Event*, July 2, 2005)

Although various family members, including cousins, grandparents, their father, and their aunts worked to portray the family in news reports as close-knit, happy, and loving, journalistic labels and framing still delineated the Groenes as a rural, working-class family with divorced parents who did not fit the frame of the "ideal family" such as the Smarts.

In contrast to the suspicion cast on the Groene family, the community was overwhelmingly described in positive terms.

Rocky Watson, Sheriff, Kootenai County: It is a small community, and there's great concern, because this touches every corner of a community. (*American Morning*, CNN, May 18, 2005)

Jennifer Inwood, cousin of missing children: Driving into town and seeing their faces up on billboards, seeing Amber Alerts and having the people in the community just reach out to us has meant so much. And it's just, you know—that's the most important thing. We just ask America to stick with us. (*CNN Live Event Sunday*, May 21, 2005)

Privileging narratives of close-knit community cohesion continued when Shasta was found alive by an "astute waitress" who recognized the girl from media coverage. Although the recovery sparked renewed attention that pushed the case back into national headlines and became

the subject of near constant coverage in cable news, the lack of detailed information to report led to several patterns that fit previous themes. First, the waitress took center stage and over the course of a couple of days morphed into the heroine of the story. Second, the broader community and local media were lauded for saving Shasta.

> Robin Roberts, host: Captain, when you hear the story of what Amber Deahn did, how does that—as a law enforcement official, how does that make you feel to know that she had the presence of mind to recognize her and to stay calm and to call the police?

> Captain Ben Wolfinger, Kootenai County, ID, Sheriff's Department: You know, we're not surprised. The people in Coeur D'Alene are caring and their hearts have gone out to the family in this case right from the get go. And it's heart warming and we're proud of her but we're not surprised.

> Robin Roberts: I bet. It's a wonderful community. I know you are very proud. Captain and Amber Deahn, thank you very, very much, we appreciate your time. (*Good Morning America, ABC News*, July 4, 2005)

During the Summer of Child Abductions, the patriotism theme played out as a narrative of individual abductions constituting an assault on a nation under threat. By 2005, the national landscape was one in which the U.S. was at war in both Afghanistan and Iraq and the mediasphere was dominated by stories of war and uncertainty. The Groene case was often juxtaposed immediately before, after, or even in the same broadcast as stories of war and terror. Segments featured reports of war in Iraq and Afghanistan, the Abu Ghraib prisoner tortures, and the war on terror in general. The Groene kidnappings became one element in a larger conversation about vulnerable families under threat during a time of national anxiety, similar to the Summer of Child Abductions.

More explicitly, the July 4th Independence Day holiday was used to frame renewed coverage of the missing Groene children after attention to the case had waned almost two months after their disappearance.

> Sue Torres, great aunt of Dylan and Shasta Groene: Nancy, we're handing out our flyers. We're hoping there`s going to be a lot of gatherings this weekend. We're just hoping that people will keep these kids' picture in their mind. Look for them at the Fourth of July displays. (*Nancy Grace*, CNN, June 28, 2005)

Journalists were able to rely upon established symbolism of nationalism to discuss the search for the Groenes as galvanizing the community as well as touching the nation at a time of war during the Independence Day celebrations.

Once Shasta was recovered alive, journalists and commentators acknowledged their lack of information about the arrested suspect and the ordeal the children had suffered, so the coverage turned to rehashing speculation about motive and culpability, as well as sensationalizing possible experiences of the children in order to fill airtime. The lack of information and the sensitive nature of the case led to conjecture and innuendo that primed viewers to imagine unspoken graphic details and fears of unverified threats. When journalists rely on hypotheticals and speculations, the facts concerning the crime being reported are blurred and fears of children being under constant threat are highlighted.

> Michael Okwu, reporter: Wide speculation of a vengeful or desperate killer, or killers, who authorities say bound and bludgeoned the children's mother, brother and a family friend sometime before Shasta and Dylan disappeared. (*NBC Nightly News*, May 21, 2005)

> Ann Curry, reporter: She's only eight years old, but already she's known enough horror for several lifetimes.
> John Larson, reporter: (Voiceover) But an arrest would bring even more heartbreak and more questions. Why was this one family targeted? The investigation would soon open the door into the terrifying mind of a sex offender and find a road map for a descent into madness. (*Dateline*, July 8, 2005)

The sensationalized coverage also insinuates details about sexual assaults against abduction victims that both sexualizes the child and may conjure up images in viewers' minds of little girls being brutalized.

> Neal Karlinsky, reporter: A steady stream of stuffed animals at this north Idaho hospital from the children of Coeur D'Alene to eight-year-old Shasta Groene. She spent the night here with her father by her side after six weeks alone with this man, 42-year-old Joseph Edward Duncan, a notorious sex offender. (*ABC News*, July 3, 2005)

> Wow. I mean, this may be a dumb question, but how is a child who's lost her
> brothers, lost her mother, been raped, how is she doing at this point? (*Nancy
> Grace*, CNN, July 5, 2005)

As with coverage of the 2002 cases, the emphasis on Shasta's appearance both sexualized her body and was used to speculate about her possible emotional state. Statements that she "looked healthy" seemed to indicate a desire to declare her "well" and her innocence recovered in the service of closure. Yet, as more information emerged about her recovery, video surveillance footage of Shasta and Duncan in a convenience store was dissected on air to establish her emotional state.

> Captain Ben Wolfinger, Kootenai County Sheriff's Department:
> Well, I—looked at just parts of the video late last night and, and saw a little
> girl who's wandering around, looks like she's wanting to be recognized by the
> patrons there in the store. But unfortunately, isn't at that time.
> Diane Sawyer, host: She has her arms crossed and, what, she seems to be look-
> ing at each customer?
> Captain Ben Wolfinger: She really does. In the, in the small takes I saw out of
> that surveillance video, she's walking around, stopping, looking right at the
> faces of, of the different patrons there. (*Good Morning America*, July 5, 2005)

Competing interpretations of the surveillance video either faulted Shasta for not explicitly calling out for help, or instead found hopeful signs that she was indeed seeking help. Her supposed lack of fear or her state of paralysis was also used to speculate in the first days of her return that perhaps the suspect was not the same person who murdered her family and that she hadn't even been abducted. This harkened back to theories in the early days of her disappearance that Shasta and Dylan may not have been abducted but rather escaped the murderer in their home and ran off to survive in the woods.

The clearly heinous nature of the crimes against the Groene family meant that news media could simply report "the facts" of the case and still convey horror, but the use of overtly sensationalized language and speculation seemed calculated to evoke maximum fear in audiences.

Pat Brown, investigative profiler: As they said, he was in jail for 18 years. And he wrote on his own blog on the web, he said, "All I could think about was getting out and getting even. And when I got out, I got even again and again and again. And I did not get caught." (*CNN Saturday Night*, July 2, 2005)

The sensationalized coverage perpetuated the stranger danger myth by casting the suspect as an "idiot" who was "evil" and had traveled the country committing unsolved violent sexual crimes. Of course, the crimes committed against the Groene family were reprehensible and the perpetrator deserved being denounced in the strongest terms. Yet, it is important to note how the coverage followed the 2002 pattern of describing the crimes against minor children in graphic, titillating detail while linking unrelated cases to perpetuate the myth of child abductions as a seemingly widespread national epidemic of violent and predatory pedophiles threatening vulnerable children.

Neal Karlinsky, reporter: Today in Idaho, it is Joseph Duncan, accused of raping eight-year-old Shasta Groene, and suspected of killing her nine-year-old brother, Dylan. Earlier this year, in Florida, John Couey was charged with raping and murdering Jessica Lunsford. Again and again, cases of known sex offenders on the loose, not monitored, accused of the most horrific crimes. (*World News Tonight with Peter Jennings*, July 6, 2005)

These fears of uncontrolled predatory male sexuality led to calls for tougher laws, harsher penalties, and even vigilante justice (*American Morning*, CNN, May 18, 2005). The need for new legislation, a focus on repeat offenders who "get away" with attacking children, and offering tips on prevention techniques to parents all rehashed patterns of coverage from 2002. Sensationalizing the criminals and the crimes, as well as fixating on a perceived lack of adequate laws and enforcement of sexual offenders registries to track convicted molesters, perpetuated "stranger danger" fear mongering—conjuring in the public imagination a world in which predators are lurking everywhere and law enforcement is powerless to find or stop them. Connecting Duncan, the perpetrator in the Groene case, to other unrelated cases stoked fears of wide-spread

stranger abductions and crime epidemic. As longtime victim advocate John Walsh told *ABC News*:

> The loopholes state to state are unimaginable, unacceptable. It is an absolute nightmare. We can't cure these guys, we can't put them on a penal colony, they get out and beat the system. I think every American has the right to know, especially parents, where these convicted sex offenders are. It is the least we can do for our children, because they are predators. I have been hunting them for years. They know what they're doing, they know how to beat the system. (*ABC News*, July 21, 2005)

The Groene case exemplifies the lingering deployment of themes from the 2002 summer of child abductions, yet coverage diverges in important ways. For example, while coverage of both cases emphasized the theme of community, representations of the communities that supported the Smart family and the Groene family were classed in unique ways. As we revisit in our conclusion, conceptions of family and community are constructed hierarchically, often along class lines.

Building National Solidarity through International Abduction Cases

No international case more powerfully exemplifies the continued deployment of the abducted "missing white girl" frame than that of Madeleine McCann. As one of the most heavily reported child abduction cases of the last decade, Madeleine's disappearance continues to make headline news around the globe. Reported missing by her parents in 2007, Madeleine was three years old when she disappeared from the British family's resort in Portugal. Amid reports that her parents were eating dinner at a restaurant while Madeleine slept in their rental across the street, eyewitnesses claimed to have seen a "dark skinned" man walking away from the area carrying a sleeping little girl. International media attention and inquiries by the Portuguese police have waffled between blaming the parents as negligent for leaving Madeleine unattended while they dined and stoking fear of "foreign" strangers snatching children from upper-class vacation resorts.

As with the case of Shasta Groene, the themes that dominated coverage of the young girls missing during the summer of child abductions were adapted and deployed in framing Madeleine McCann, her parents, and myriad suspects in the case.

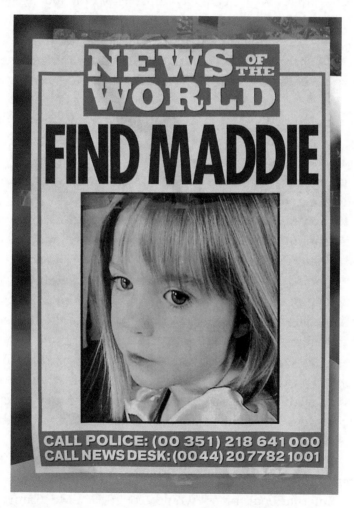

Figure 2.3. Picture taken 13 May 2007 (Maddie McCann case).
A poster shows the face of the now-iconic missing four-year-old British girl Madeleine McCann who disappeared from her family's vacation home in Praia da Luz, southern Portugal. Madeleine's disappearance captured headlines around the globe, and remains one of the most heavily reported international child abduction cases of the last decade. Maddie has not been found, and her case remains unsolved.
(Melanie Maps/AFP/Getty Images)

Initial speculations about the McCanns's potential negligence seemed to vilify them for leaving Madeleine alone and vulnerable to abduction, while Portuguese police even suspected the parents of causing and covering up her death. In much the same way that the van Dam and Groene parents were treated as culpable for potential drug use and less-than-vigilant parenting, Kate and Gerry McCann faced suspicion at various stages of the investigation. However, not only were they not officially charged with the crime, the overwhelming consensus in U.S. news coverage was that they were devoted parents and innocent victims.

The framing of the McCanns as an ideal family despite tabloids reveling in their culpability hinged on journalists deferring to their version of the night's events, which follows the pattern of privileging the perspectives of wealthy white parents. News coverage of the McCann case actually bears striking resemblance to coverage of a non-abduction case in which the parents became the central focus of the investigation—the 1996 murder of six-year-old JonBenet Ramsey (Conrad, 1999). The pattern of damaging and then rehabilitating the parents' standing is similar to the coverage of John and Patricia Ramsey, in which the parents were initially vilified as potential suspects and later glorified as dedicated parents. Also, like the Ramseys, the McCanns became tabloid fodder as the case was treated as international intrigue, with celebrities weighing in and paparazzi following the parents. The fact that both cases remain unresolved and that police have investigated both sets of parents may account for why coverage of Madeleine's case remains different, in some ways, from the other abduction cases in this study.

Yet, in both the Smart and McCann cases, the parents had the resources, status, and clout to call news conferences and hold events that the international press would cover. The McCann parents launched an international multimedia campaign in much the same way as the Smarts. Kate McCann wrote a book, Gerry McCann kept a blog, and both staged media events and garnered celebrity support. As Michelle Kosinski reported, "The McCanns have appealed to the world. Celebrities have joined their cause, and they met the pope" (*NBC News*, September 8, 2007). Furthermore, they wielded power

through high-priced ad campaigns and could afford to hire expensive private investigators.

> Dawna Friesen, reporter: Across Europe, her face is everywhere from posters to billboards, even a video appeal shown at soccer matches. But, after 26 days, still no sign of four-year-old British girl, Madeleine McCann, snatched from her bed in this Portuguese resort while her parents dined 50 yards away. Their agony and private guilt, unimaginable. (*NBC News*, May 29, 2007)

> Stephanie Gosk, reporter: In August, Portuguese police named the McCanns official suspects in the case. Investigators say they found DNA linked to Maddie in the trunk of the parents' rental car. But no charges have been filed, and for now, even though this latest sighting was a dead end, attention seems to be back on the search for Maddie. The McCann family has taken that search into their own hands. The Find Madeleine Fund says their latest effort is a more than $150,000 media blitz. Ads and billboards are going up in Spain and Portugal, and now likely Morocco as well. (*NBC News*, September 27, 2007)

Similar to the Smart case, the power to have a voice and visibility is class-based and stands in contrast to parents of victims such as Jaycee Dugard, Shawn Hornbeck, Michelle Knight, and others from lower-income brackets whose pleas for national attention on their children's cases went largely ignored.

As Madeline's image circulated across global media outlets, the case became international in scope and took on nationalistic overtones as the story became framed as a clash between Britain and Portugal. Maddie became a symbol of British nationhood, the story of a country banding together to support her search, as the McCanns garnered the support from powerful British citizens and Scotland Yard. For example, the McCanns were able to command the attention of British entrepreneur Sir Richard Branson who created a defense fund for the family, as well as author J. K. Rowling and international soccer star David Beckham, who appeared in a public service announcement asking for leads on Madeleine's whereabouts.

Additionally, because they were British citizens vacationing in Portugal, the McCann case was dominated by constructions of national identity and othering of those deemed "foreign" by the national press outlets. Interestingly, constructions of otherness took two forms. First,

the primary suspects in the abduction also centered on descriptions of dark skin, vaguely implying "foreignness" to European citizens based on race:

> George Lewis, reporter: There have been persistent rumors that Madeleine may have been taken off to somewhere in North Africa, one reason for the tanned version of her photograph.
> Kate McCann: Everybody'll remember Madeleine as a blond-haired child, and she could well be disguised. I mean, that doesn't necessarily have to be a suntan, that could be a fake tan, you know, just like your hair can be dyed. (*NBC News*, November 3, 2009)

Furthermore, news entities continually linked the McCann case to unrelated cases in the U.S., reinforcing the illusion of a crime wave or epidemic of child abductions. After the high-profile discovery of Jaycee Dugard in the U.S., the McCanns redoubled their search efforts. As *NBC News* reported, "They [the McCanns] say their hope for finding Madeleine was renewed when they heard about the Jaycee Dugard case in California; that if Jaycee can be found alive after 18 years, then Madeleine could also be found alive as well" (*NBC News*, November 3, 2009).

> Clint Van Zandt, former FBI profiler: ... You know, everybody clings to that one—that one magic situation out there that maybe their child ...
> Matt Lauer, host: Well, with good reason. You've got people like Elizabeth Smart and Shawn Hornbeck and some other cases ... where, all of the a sudden, these are miraculous cases where they find these people months, if not years, after they're abducted. (*NBC News Today Show*, August 7, 2007)

With the international aspect of the McCann case, linking an abduction in Portugal of a British girl by a supposed "dark-skinned" foreigner to unrelated cases in the U.S. further fuels the fear mongering of foreign strangers and bolsters global anxieties over stranger danger.

Second, it treated the Portuguese authorities as "foreign" to the British citizens and lambasting the police for their incompetence in handling the investigation. Throughout the media coverage, news outlets treated the McCanns and the British authorities as more legitimate than Portuguese investigators. By privileging their accounts of events on the night of Madeleine's abduction and referring to the

need for British authorities to step in and "correct" the mistakes of the Portuguese authorities who initially suspected the McCanns in Madeleine's disappearance, the U.S. press privileged the perspectives of white, English-speaking parents while placing blame on "foreign" Portuguese authorities and dark-skinned male suspects. The following exchange on *The Today Show* demonstrates how the parental suspicions are largely put to rest as "speculations" and "rumors:"

> Keith Miller, reporter: Good morning, Meredith. Well, the mystery is still capturing headlines. And after 99 days, the story of missing Madeleine McCann has more twists and turns than a bad road to nowhere. Now it's the parents who are under suspicion, at least that's the speculation in the Portuguese press.
>
> Gerry McCann, Madeleine's Father: It's extremely hurtful to suggest that we're involved. Everything we have done over the last 100 days has been to try and increase the chances of finding Madeleine.
>
> Miller: Since British police discovered what appeared to be a blood stain in the bedroom where four-year-old Madeleine went missing, suspicion has fallen on the parents.
>
> McCann: It's incredibly difficult when people are implying that your daughter's dead and that you may have been involved in it. I mean, that is just unbelievable to try to cope with both of these things.
>
> Miller: Kate McCann is hurt by the rumors but has felt greater pain.
>
> Kate McCann: The pain of being without Madeleine is, you know, the strongest pain I think I'm going to feel. And, you know, sticks and stones and things like that, you know, I can—I can handle that." (*NBC News Today Show*, August 10, 2007)

Even though the Portuguese police did briefly name Kate McCann as a suspect, U.S. journalists and the experts they interviewed went to great lengths to fault the Portuguese police for incompetence and to remove any suspicions from the McCann family. In one telling conversation between *NBC News* co-host Amy Robach and former FBI profiler Clint Van Zandt, who was not directly involved in the case, they work together to bolster the authority of the British police, undercut the Portuguese police, and privilege the McCanns's innocence.

> Van Zandt: So, you know, I—you know, the British—the British police are trying to help the Portuguese. The Portuguese, I think, dropped the ball.

Robach: Right. In terms of the Portuguese investigation, I mean, didn't they basically go about it backwards when you look at most standard operating procedures for police?

[...] You usually look at the family first, you rule them out and then you take on a stranger theory ...

Van Zandt: ... But I kind of see the police flailing their arms around trying to come up with some working theory that may cover up because they didn't investigate. Could it be the parents? Yes, it could, but, you know, let's prove it with evidence. Let's not bury this family in the tabloids. (*NBC News Today Saturday*, September 8, 2007)

As the case remained unsolved years later, condemning the Portuguese police for wrongdoing further bolstered the narrative of the McCanns as innocent victims of an incompetent foreign investigation. After Madeleine had been missing for seven years, NBC news reported:

Dawna Friesen, reporter: "It's really crucial in an investigation like this," says a retired Portuguese police chief, "that the crime scene is isolated. But it was contaminated," he says, "and the searching was done in a haphazard way." It raises questions, are the police baffled, forced back to square one, reconsidering all options? (*NBC News Today*, June 2, 2014)

Just as powerful patriotic symbols such as American flags were used to frame the Smart case, and coverage of the Groene case included references to the rituals of July 4th celebrations, reporting of the McCann case frequently linked the search for Madeleine to Christmas celebrations and Christianity. From candlelight vigils at churches to talk of praying for her return, emphasizing religious symbolism reinforced tropes of western family values, community solidarity, and national identity.

Reporters like Meredith Viera and Matt Lauer often closed interviews by saying their "thoughts and prayers" were with the family, validating the family's claims of innocence and portraying the journalists as sympathetic and kind. However, when, in the case of McCann, journalists essentially privileged the parents' version of the story, they problematically reinscribe notions of innocence based on power, wealth, race, and national identity. Furthermore, journalists potentially shield themselves from criticism when they *do* engage in investigative questioning of parents and victims, as we will examine in greater detail in Chapter 4.

Throughout news coverage of this high-profile international abduction case, which remains unsolved to this day, Madeleine McCann has been consistently described as innocent and as "little," reinforcing her vulnerability as a three-year-old victim. As her father told *NBC News*, "It's not right that an innocent, you know, vulnerable British citizen is essentially given up on" (*NBC News Sunday Today*, May 2, 2010). Claims to rights of innocence as both a vulnerable girl and as a British citizen situated Madeleine as a national cause, and indeed one that demanded international attention, one in which U.S. journalists and their guests were aligned.

The Legacy of Lost White Girls and the Implications for Missing Children

As this chapter clearly demonstrates, the abductions that made the news in the summer of 2002 were disproportionally those of young white girls from middle-upper class families and communities. Drawing from cultural studies research, and interrogating the dominant themes used by media storytellers to report on child abductions, we uncovered the narrative devices that communicate powerful social lessons about family, community, strangers, girlhood and nationality.

In the 2000s, U.S. mainstream news media fixated on rare but dramatic stories of helpless young girls disappearing from culturally recognized "safe havens" at the hands of predatory male strangers. Furthermore, the exaggeration of victims as female and suspects as male strangers suggests that the stories achieving national prominence are those that successfully perpetuate the myth of predatory males abducting young girls. Considering the cultural context of post-September 11 America, this study further suggests how media stories of fragile, vulnerable, violated girls become metaphors for a fragile, vulnerable, violated nation.

Moreover, the narrative themes that emerged in news coverage were applied exclusively to missing white girls during that summer and in later years. In the high-profile cases of Elizabeth Smart, Shasta Groene, and Madeleine McCann in particular, the significance of "missing white girls" remained at the center of news coverage. In contrast, even though

Dylan Groene was abducted along with his sister, Shasta, sexually assaulted and murdered, the focus on his case was noticeably obscured by the media focus on his sister. We explore Dylan's case, and how boy victims were largely absent in national media coverage, in the following chapter.

Faludi's (2007) work on post-9/11 media culture reminds us of the ways in which deeply embedded cultural myths like cowboy masculinity and puritan sexuality pervade contemporary media frames during times of national crises. In the 2000s, these narratives circulated around missing girls, their images and bodies mapped with culturally inscribed notions of innocence lost and nationalism under threat. However, girls have not always held that exclusive symbolic power. The missing children's movement was initially fueled by fears of lost boys, the images and narratives of vanishing white boy victims attracting national headlines and circulating throughout the media culture. However, in the timeframe of our study in the 2000s, male abduction victims were virtually invisible in mainstream news narratives. The following chapter explores this shift.

Chapter 3

When Boys Go Missing

Before Etan, kids played outside. They walked to school. The thought that a six and a half year old would walk two blocks to the school bus stop was unheard of after Etan.

—(Jay Schadler, *ABC News*, May 29, 2009)

On May 29, 1979, six-year-old Etan Patz begged his parents to let him walk to his bus stop for the first time on his own. The stop was only two blocks away from his Soho apartment in New York City, much of the route visible from the Patz fire escape. But Etan never returned home from school that day. As the May 29, 2009, episode of *20/20* memorialized on the 30th anniversary of his disappearance, Etan's kidnapping marked not only the beginning of the contemporary missing children's movement, but "the moment when innocence was abducted" from American life (*20/20*, May 29, 2009).

As Jay Schadler of *ABC News* narrates, unknown to the American public at the time, with the disappearance of Etan Patz "the rhythm of our lives was about to change, especially the way we think about our children" (*20/20*, May 29, 2009). In many ways, Schadler was right. Etan's case became known as the abduction that "awakened America"

and, as historian Paula Fass and others argue, launched a coordinated national movement to bring awareness to, and help fund and solve, cases of stolen and exploited children. Etan's image became the "symbol of lost children" everywhere (*60 Minutes II*, June 2, 2004), in particular those horrific cases of children who are "missing forever," whose cases are never solved (*20/20*, May 29, 2009).

Moreover, as evidenced by the ways in which these media narratives evolved over the 30 years since his disappearance, Etan's loss became symbolic of a national loss of innocence. Etan's disappearance "sparked a worldwide manhunt, and in the months and years that followed, he became the symbol for lost children all over America" (*60 Minutes II*, CBS, June 2, 2004). His disappearance, like those of the young telegenic girl victims of 2002, was a *national* loss, and the search for Etan Patz "consumed New Yorkers and the nation." His iconic image was one of the first to be reprinted on milk cartons, posters, buses and direct mail advertisements, a perpetual "reminder to parents that their own quiet streets might not be safe" (*60 Minutes II*, CBS, June 2, 2004).

By the 2000s, however, the faces of young boy victims no longer held that kind of symbolic power. In the timeframe of this study, as we explore in this chapter, male abduction victims were virtually invisible in national news stories. When boy victims did rise to the level of national prominence, it was usually in the context of sexual assault and presumed predatory homosexual pedophilia, reflecting not only a discriminatory selection of victims based on gender, but also a homophobic bias in news framing of boy abduction crimes.

This chapter first situates the cases of missing boys in a historical context and then relies primarily on the few cases of boy abduction victims whose stories made national headlines in the 2000s—cases like those of Dylan Groene, Nicolas Farber, Shawn Hornbeck and Ben Ownby. As such, this chapter offers a comparative case study of how boy victims, contrasted with young girls victims, are treated in contemporary news discourses.

As Howard and Prividera (2004) remind us, nationalism is gendered, with women and girls representing the motherland in need of protection and men and boys signifying her unwavering defenders. As we explored in Chapter 2, though girls became symbols of victimhood

in the aftermath of 9/11, media texts have traditionally heralded boys as bearers of patriotism, moral fortitude and hegemonic masculinity in the face of threats to family and nation. This chapter takes a different approach, analyzing how boys are constructed as *victims* through the crime of child abductions, examining news coverage memorializations of historic cases as well as contempory stories of missing boys in the 2000s.

In stark contrast to the images of young girls who captured headlines in the 2000s, the missing children's movement actually arose around the disappearance of young boys who dominated headlines in the early 1980s, namely the 1979 disappearance of six-year-old Etan Patz and the 1981 abduction and murder of six-year-old Adam Walsh. This chapter begins with these influential cases of the late 1970s and early 1980s that defined the movement and subsequently redefined meanings of childhood. These historic cases then lay the groundwork for our analysis of boy victims in the 2000s by first discussing their overall erasure from national media discourses, followed by the anti-gay bias that revolved around narratives of predatory pedophilia, and finally, by examining how codes of innocence and culpability were used to differentiate guiltless victims from culpable participants.

Patz and Walsh Define a Moment and Movement

The aforementioned Etan Patz case is an important one not only because of its historical significance, but also because his case continually reemerged in the contemporary coverage under study. The year 2004 marked the 25th anniversary of his disappearance, and 2009 the 30th anniversary, and so on. As the opening epigraph to this chapter demonstrates, his case became commemorated and memorialized through media narratives. May 25th was named Missing Children's Day in his honor, a news hook for journalists to "remember" those missing children lost, discuss the problem of child abductions, and provide a platform for victim advocacy [i.e., a news hook to ask victim-spokespersons, "What is your message to folks on this day, this Missing Children's Day?" (*Good Morning America*, May 25, 2007)].

Etan's case also demonstrates how normative conceptions of "innocence" are gendered, raced and classed during particular time periods, marking this period when "the transhistorical, naïve, and asexual yet teleologically heterosexual white boy" held significant symbolic power (Mokrzyckil, 2013/2014). Boys were the center of concern in the larger missing children's campaign that was formulated in the early 1980s. This period was marked by a mediated obsession with missing young white boys while few girl victims attracted prominent coverage. These were isolated cases, but took on national salience. As Mokrzyckil notes, the missing young boys of this time period became emblematic of larger societal fears:

> As feminists, African-Americans, and members of the LGBT community challenged white male patriarchy and heterosexism, the abductions and presumed abductions of numerous white boys took on symbolic salience as threats to the future of the white American male. (Mokrzyckil, 2013/2014)

The sexualized nature of these crimes during this time period also reflected cultural homophobia and further fed anti-gay fears in backlash to the sexual liberation movement. The Patz, Steven Stayner and Walsh cases were used to "substantiate fears about the 'predatory homosexual,'" as mediated narratives falsely conflated child sexual abuse with male homosexuality (Mokrzyckil, 2013/2014). In stark contrast to the sexual liberation movement in the 1960s and '70s, these cases became an important part of the "metanarrative about national decline catalyzed by the sexual and moral permissiveness of American liberalism" (Mokrzyckil, 2013/2014).

Moreover, it was Etan's unsolved case that forever altered public understandings of child abductions. Before Etan's disappearance, sexual exploitation of children was not a probable theory in the vast majority of abduction cases. For example, during at least the first year of his disappearance, his parents and the investigators in the case believed that Etan had been taken by a maternal figure who desperately wanted a child but couldn't have one of her own. A year and a half after he vanished, on his birthday, his mother Julie Patz was quoted in national media reports citing this notion that, "We still think

some misguided person who wanted to have a beautiful boy took Etan" (Fass, 1997, p. 215).

Paradoxically, the telegenic nature of Patz was emphasized in media reports and heightened the newsworthiness of the story, in particular for television and visual print media. Etan was described as "an extremely handsome child with blond hair, an upturned nose and glowing blue eyes" (Fass, 1997, p. 215). As Jay Schadler reported in 2009, Etan's iconic image, captured by his father who was a professional photographer, gripped the nation: "On store fronts, posters and flyers, Etan's face peered out, and the media weighed in" (20/20, May 29, 2009). John Miller, a local New York TV reporter at the time, described the televisual appeal of the tragic case: "It had all the elements of a television story. It was just one of those things you looked at, you didn't have to think a lot about, you said, 'This is gonna be big'" (20/20, May 29, 2009).

It wasn't until the Steven Stayner's case broke in the spring of 1980 that a "new" theory of abductions emerged, one centered on child sexual exploitation. Steven's case dominated national headlines in March 1980 when he escaped from captivity along with five-year-old Timothy White. Stayner was abducted at the age of seven in Merced, California in 1973, and had endured seven years of sexual and physical abuse at the hands of Kenneth Parnell. With Stayner's horrific story of abuse and sexual exploitation, and his escape to save young "Timmy" from the same fate, public understandings of child kidnappings were forever altered. As Fass explains, with Stayner's escape, police and media "began to jell a new theory that eclipsed most previous speculations. That theory centered on the sexual abuse of young children and their entrapment by adults driven by uncontrollable urges" (1997, p. 220)

As childhood historians argue (Bernstein, 2011; Calvert, 1992; Gooren, 2011; Higonnet; 1998), by the late 19th century the sexuality of children had been cast in opposition to childhood innocence. Moreover, as Bernstein (2011) argues, the "invention of childhood innocence" and its bestowal on certain children were highly raced, with white children being constructed in stark contrast to dark-skinned children. However, the scholarly and public understandings of child sexual abuse that predominated in the mid-to-late 20th century were not defined as predatory

or violent, nor was it considered particularly "harmful" to the child. As Fass writes, from the 1950s to the 1970s, molestation was understood to be committed mostly by neighbors, family friends and family members. The social science literature at the time focused more on the "pathology of victims' families" rather than molesters themselves: childhood victims were understood as mostly girls who were culpable in their exploitation, easily seduced because they came from "bad homes" and traded sex with an adult for the attention they weren't getting at home (Fass, 1997, p. 226). Indeed, a 1976 dissertation examined the major sociological studies at the time about child sex abuse and concluded that the "child is believed to participate in the offence in some way" (Fass, 1997, p. 226). Cultural understandings of child molestation, rooted in the social scientific tradition of the time, centered on blameworthy victims and wayward but largely innocuous perpetrators:

> While there had always been some small place in the literature for the entirely innocent victim of vicious sex crimes, the literature was sharply focused on the complicit child with the 'mild mannered, much maligned molester' hidden in the background. (Fass, 1997, p. 226)

But the cases of Etan Patz, Steven Stayner and Adam Walsh changed the narratives around child abduction, pedophilia and childhood sexuality. The 1981 kidnapping and tragic murder of Adam Walsh in Hollywood, Florida, further fueled public panic about missing and exploited children and solidified the national campaign. The six-year-old was kidnapped from a Sears department store at a suburban shopping mall and his remains were discovered a few days later by fishermen in a canal. Walsh, like Stayner, became the subject of national publicity as his story was featured as a made-for-TV movie. His case also helped to solidify the formation of the National Center for Missing and Exploited Children (NCMEC), established in 1984 by the U.S. Congress. Adam's father, John Walsh, became a nationally known media figure as an important voice for victim's advocacy, host of the long-running American television series *America's Most Wanted*.

Like Adam Walsh, it was difficult to see Etan Patz as anything but entirely innocent. Both boys came from a normatively "good," stable homes with loving parents. Fass points out that just like ransom

kidnapping was considered a "new" problem in the 1874 abduction of Charley Ross, "so the crime of sexual kidnapping was in some sense 'new' as an explanation" (1997, p. 227).

Therefore, by 1980, when Steven Stayner and Timmy White emerged in March of that year, and the remains of Adam Walsh's body were found in August 1981, the picture of child sexual victimization had changed dramatically. Child sexual abuse transformed into a widespread social problem that required increased public awareness and social policy action. The scientific literature, media constructions and public understandings "increasingly portrayed pedophilia as the special sexual pathology of those who prey on children" (Fass, 1997, p. 228). By emphasizing the many faces of the pedophile and the widespread nature of child sex abuse, now "the danger to children seems both ubiquitous and endemic." Moreover, pervasive media coverage of these cases "brought the sexual monster out from behind the bushes into practically every house and neighborhood in America" (Fass, 1997, p. 228).

These shifts, brought about by a neo-conservative backlash to the sexually liberated attitudes of the 1960s and 70s, help explain why Etan's disappearance was understood so differently in the culture between 1979 and 1983. By the 80s, the sexual exploitation of children was both "dangerous and apparently prevalent." The pedophile was understood to be both predatory and violent, "sexually indiscriminant," and alarmingly, "almost any child molester is capable of violence or even murder to avoid identification" (Fass, 1997, p. 231). By the 1980s, this "new kind of horror" had become every parent's worst nightmare and the narratives surrounding Etan's disappearance had evolved. The fears around predatory pedophilia are evident decades later in how Stan Patz, Etan's father, described Etan's prime suspect, Jose Ramos, in a 2004 interview commemorating the 25th anniversary of the boy's disappearance:

> He's (Ramos is) a predator, and he should never be allowed to be near children again. He should be kept behind bars until he's too old to walk. (60 Minutes II, June 2, 2004)

Like the missing boys that headlined in the 1980s, the few cases of boy victims in the 2000s focused predominately on the sexual nature

of the crimes, the abductions that made the news presumably moti-
vated by sexual exploitation. These cases in the 1980s paved the
way for understandings of child abductions in the 2000s. News nar-
ratives surrounding child abductions began to fixate on predatory
pedophilia, depicting innocent American children (initially boys, but
eventually girls) snatched by sexually uncontrolled and violent male
strangers lurking almost anywhere—shopping malls, playgrounds
and neighborhoods.

The Enemy among Us: Predatory Pedophilia Emerges

By the time Kevin Collins's face was on the cover of *Newsweek* maga-
zine in the spring of 1984, America's "stolen children" had become an
epidemic, "a symbol of a national tragedy" (Gelman et al., *Newsweek*,
March 19, 1984). The fourth grader had vanished from the Haight-
Ashbury neighborhood of San Francisco on his way home from bas-
ketball practice. The new "problem" of child abduction was embodied
in the image of the frightened ten-year-old-boy, staring out from the
magazine cover, eerily over his shoulder, at the viewer. The problem
of child abduction was thus "just a logical expression of a much wider
phenomenon" along with kiddie pornography and pedophilia, and
"the enemy seemed everywhere" (Fass, 1997, p. 237).

Moreover, the presumption was that the problem centered
around the sexual exploitation of young boys, as the *Newsweek* article
described: The "stranger abduction" was "a crime of predatory cru-
elty usually committed by pedophiles, pornographers, black-market
baby peddlers or childless psychotics bidding desperately for parent-
hood" (Gelman et al., *Newsweek*, March 19, 1984). These depictions
helped to substantiate fears about "predatory homosexuality," and
drew from false assumptions equating child sex abuse, in particular
those cases involving male victims, to male homosexuality. In fact,
to help combat the homophobic fears that surrounded the case, a
local gay organization in San Francisco sponsored a special search
for Kevin (the Community United Against Violence). As Mokrzyckil

(2013/2014) writes, "anxieties about homosexuality could almost always be found lurking in political and media rhetoric on missing children." In the 1980s, the script around child abductions was solidified and according to news media, when a young, "innocent-looking" white boy like Adam Walsh or Kevin Collins went missing, he was most likely "abducted by a sinister male stranger."

News coverage fixated on descriptions of lurking, predatory pedophiles poised to prey on America's innocent children. This pattern can be seen in the way the Etan Patz story evolved and was memorialized in the 2000s. Depictions of uncontrolled, voracious male sexuality dominated in coverage across victim gender, but in the case of boys, it was used to fuel homophobic fears. Journalists relied upon specific labels and language that conjured up predatory, presumed gay male sexuality in the public imagination.

The coverage of the Etan Patz case initially centered around a homeless vagrant, Jose Antonio Ramos, who for years was believed to be the prime suspect in the Patz's case.[1] Ramos was arrested in 1985, according to a *60 Minutes* report, "suspected of trying to lure young boys into this drainage tunnel where he was living" (*60 Minutes II*, June 2, 2004). Stuart GraBois, a lead investigator in the Patz case, told *CBS News* in 2004 that Ramos exhibited a patterned and voracious obsession with young boys, solidifying fears of predatory pedophilia and stranger danger narratives. He reported that Ramos would "travel around the United States in a converted school bus giving out matchbox cars and toys to young boys to entice them onto the bus." To kids, he came across as a "nice man, a friendly man," but GraBois saw him as "Manson-like, like Charles Manson" (*60 Minutes II*, June 2, 2004).

ABC News described the planned, deliberate abduction of Patz, using descriptive active verbs like "stalking" and "trailing." As ABC's Jay Schadler reported, "Ramos makes a hand-drawn map, marking Xs where he picked up Etan, where the Patzes lived, and where he took Etan." (*20/20*, May 29, 2009). Furthermore, reporters relied on language and descriptors to link cases in order to portray an epidemic of premeditated, patterned and discriminate selection and abduction

of young boys. These descriptions helped to perpetuate a historically significant and powerful social myth that predatory molesters prey on a particular "type" of victim, contributing to fears about the sexual pathology of child abductors. CNN emphasized that investigators of Jose Ramos found photos "in the tunnel of boys, mostly blonde, like Etan Patz" (60 Minutes II, June 2, 2004). One investigator confirmed for ABC News, "What I thought was striking, looking at the photographs, was these kids have the general, some of them, had the general look of Etan Patz" (20/20, May 29, 2009).

Furthermore, the following exchange in an ABC interview with Jose Ramos in 2009 demonstrates how assumptions around predatory pedophilia were continually reinforced in news discourses. ABC's Jay Schadler grills Ramos on his suspected kidnapping of Etan, emphasizing the sexual nature of the crime:

> Jay Schadler, reporter, ABC News: You never had a particular fascination for blond hair, blue eyes, young boys?
> Jose Antonio Ramos, suspect in the case of Etan Patz: No. I wasn't into the, to the, to the Viking thing, if that's what you're trying to say.
> Jay Schadler: Stuart GraBois (lead investigator in the case of Etan Patz) calls you a pedophile.
> Jose Antonio Ramos: I don't feel I was a, a total pedophile.
> Jay Schadler: Isn't that like saying, "I'm just a little bit pregnant?" I mean, how can you be … either, you're either a pedophile or you're not a pedophile.
> Jose Antonio Ramos: No, no, no, no, no, no. Don't, don't go into that condemnation of that. I was a little mentally unstable. (20/20, May 29, 2009)

These mediated discourses about the Etan Patz case demonstrate how the fears surrounding predatory pedophilia were entrenched in the culture, and reinforced throughout the 2000s, presumptions that were virtually nonexistent at the time of Etan's initial disappearance. These narratives surrounding the cases of missing boys in the early 1980s set the stage for mediated constructions of boy victims and male perpetrators in the 2000s. However, it is first important to demonstrate how cases of missing boys were relatively invisible in the 2000s, at least in terms of their initial disappearances, unless and until the cases "fit the frame" of predatory homosexuality.

Invisible Victims: The Erasure of Boy Victims in National News Coverage

As previously articulated, only a few cases of missing boys reached the level of national prominence during the timeframe of our study. Narratives of child abductions in the 2000s became almost exclusively centered on telegenic young girls, leading to the erase of boy victims in national media coverage.

For example, when two-year-old Jahi Turner disappeared in April 2002 while playing at a San Diego park, his case failed to reach the level of national prominence. Turner's disappearance fell during the exact time period of the media-dubbed "summer of child abductions," and took place in the same city/media market where Danielle van Dam was abducted and killed. However, Turner was African American, and many argued that since his case failed to conform to the "missing white woman" frame, he did not meet the standards of "newsworthiness" in the national media.

Also that same summer, nine-year-old Nicolas Farber was kidnapped from his Palm Desert home after gunmen attacked his father in the middle of the night and drove away with Nicolas in a white SUV (*CBS Morning News*, August 30, 2002). Farber had been at the center of a custody dispute and his mother, Debra Rose, became the focus of the investigation. After tips generated by an Amber Alert, Nicolas was found at a campground about 90 miles from his father's home in the custody of his mother and her male companion. Even though Farber was recovered within a few miles of where Danielle van Dam's body was found, Farber's case failed to garner the same level of prominent media attention. Farber's disappearance initially attracted coverage based on the violent nature of the abduction, but was not as high profile as Danielle's. The case ultimately did not fit the frame of the missing white girl victims, since he was recovered safely and relatively quickly, within 48 hours, and had been abducted by his mother, not a male stranger (*The Early Show*, September 5, 2002). The case did not meet the standards of "newsworthiness" in the 2000s because it wasn't an instance of "stranger danger," nor was the crime sexual in nature. Alternately, in the 1990s, kidnapping reporting centered on parental

abductions, representing distrust of the court system and family structures (Fass, 1997).

Similarly, in the case of the horrific North Idaho kidnapping and murders of the Groene family in 2005, the majority of the media attention focused primarily on eight-year-old Shasta. Even though there were two kidnapping victims, news coverage of the case tended to foreground Shasta and sidelined reporting on Dylan, the nine-year-old brother who was also abducted. After Shasta's recovery, it was revealed that Dylan had been brutally and tragically murdered while Shasta was spared (Associated Press, July 3, 2005; CNN.com, July 3, 2005). Coverage then tended to focus on Shasta's care, mental state, and speculations about their abductor, Joseph Duncan, while Dylan was typically mentioned only briefly in mourning.

However, it is important to note that when news broke of the children's initial kidnappings, Dylan was relegated to the margins, treated as more of a sidestory to Shasta's disappearance rather than as a central figure in the case. One telling example of the differntial treatment of Shasta and Dylan was the release during their captivity of the video of Shasta at a science fair. No such video of Dylan was released. While it is possible that a video of Dylan did not exist to aid the search efforts, nonetheless, the presence of video footage of Shasta spawned discussion of her mannerisms and personality that were meant to help identify the missing girl, yet little to no such discussion occurred about Dylan.

When the details of Dylan's ordeal emerged, his suffering was graphically described in ways that framed him through the eyes of his traumatized sister and heinous assailant. First, it is Shasta who tells investigators where to find her brother's body, details what happened to them both, and eventually testifies at Duncan's trial. As the survivor, it is her story that drives news narratives that only sometimes include Dylan as one piece of his sister's story. Next, a second video did become the center of news coverage about Dylan, but it was an entirely different video than his sister's science fair. During the prosecution of Duncan, a video he made of his sexual torture of Dylan alone in a cabin while Shasta was left outside was entered into evidence. Duncan made Shasta watch the video and killed Dylan in front of her, and jurors were also shown the video, in which Dylan begged to go home. As the victim

of such a reprehensible crime, Dylan's horrific suffering was discussed as evidence of his assailant's depravity and as the culmination of Duncan's decades-long history of sexual violence. As the Associated Press reported from Duncan's trial:

> The crime was meticulously planned, the killer choreographing every step from his surveillance of the doomed north Idaho family to the videotaped torture of one of his youngest victims [...] Moss told jurors they'd have to watch video footage of the sadistic sexual torture of 9-year-old Dylan Groene, filmed shortly before Duncan killed him. Duncan forced then-8-year-old Shasta Groene, the sole survivor, to watch that video and made her watch—standing so close her clothes were spattered by blood—as he killed her brother, jurors were told. (Associated Press, August 13, 2008)

Taken as a whole, Dylan was not treated as an individual child with his own characteristics and experiences. Rather, his abduction was marginalized by coverage of Shasta, and his torture and murder were subsumed under her survivor story and Duncan's vilification.

The cases of Shawn Hornbeck and Ben Ownby were by far the most prominent cases of missing boys during the timeframe of our study. However, it is critical to note that the *initial* disappearances of both boys, in particular that of Shawn Hornbeck, were virtually ignored by the national media. A Lexis-Nexis search yielded only local reporting from one regional newspaper, the *St. Louis Post-Dispatch*, covering the St. Louis, Missouri area (*St. Louis Post-Dispatch*, October 8, 2002). There was no national newspaper, online or broadcast coverage. Despite attempts by family members to raise the awareness and national attention in Shawn's case, it remained under the radar, unable to attract coverage or fit the frame of other "newsworthy" missing children cases which centered primarily around girls.

The role of media coverage in both the search for Hornbeck and his return demonstrates how deterministic factors of gender and class, as well as the race, of the victim are in reporting on the crime of child abductions and influencing the newsworthiness of the case. Even though Shawn's parents advocated for him, his case was treated by police and media as a "runaway." Shawn's parents were not treated as "respectable," "good" parents in the same way, comparatively, that the

Smart's were, and were therefore rendered largely powerless to influence media coverage of their son's abduction. It wasn't until Shawn was found after four years of captivity, along with Ben Ownby, that his story was catapulted into the center of national media. Even though Shawn first disappeared in 2002, his first national news story didn't appear until his "shocking discovery" in Michael Devlin's apartment in 2007.

Likewise, Ben Ownby's initial disappearance attracted a few stories in the regional paper, *The St. Louis Post-Dispatch*, but no national newspaper reporting. The Ownbys were slightly more successful in attracting a handful of national television news stations to cover Ben's abduction, but these stories were limited to short broadcast briefs and only one story each on CBS, Fox News, and NBC, that ran between January 9–11, 2007, before the "big story" broke on January 12. Ownby's parents were more successful at tapping into the news values of innocence, as opposed to Hornbeck who was labeled a runaway. This is to argue that the Hornbeck/Ownby story didn't become a story, their initial disappearances largely ignored, until the boys were found alive, together, taken by the same perpetrator years apart (this framing also bears similarity to the Cleveland case that we explore in Chapter 5). The framing of the boys' reappearance in 2007 is critiqued in the following section.

Anti-Gay Bias and Predatory Pedophilia in the Contemporary Era

The 2000s were primed for reconstructed fears concerning predatory homosexuality. As Marcel (2013) contends, a similarly "consistent homophobic and misogynistic bias" (p. 288) was employed in the reporting of the priest sex abuse scandal which served to both erase the victimization of women and girls as well as echo the Vatican's false framing of the perpetrators as exclusively gay men (Marcel, 2013). Despite reports that hundreds of women and girls were serially raped by priests, major newspapers such as the *Boston Globe* focused their reporting exclusively on young male victims and their presumably predatory homosexual perpetrators. By selectively focusing on victim gender (male) and perpetrator gender and sexuality ("gay" priests),

news organizations fed anti-gay fears, cast boys as the sole victims in a larger sex abuse crisis, demonized homosexuality, and rendered crimes against women and girls invisible. The universal and widespread sexual abuse crisis in the Catholic Church was constructed as "a problem of only of a few liberal, 'gay,' American priests" (Marcel, 2013, p. 288). Erroneously ignoring the sexual abuse of women and girls met both the public's homophobic presumptions and supported the Vatican's agenda, speciously equating child sexual abuse to "a gay male sexual orientation" (Marcel, 2013, p. 306).

Likewise, coverage of male abduction victims in the 2000s shows how framing devices and language choices drew similarities to mediated constructions of the Catholic Church pedophilia cases. In particular, the case of Shawn Hornbeck and Ben Ownby bears a close resemblance to coverage of the Vatican sex scandals in that the victims exist in the shadows of public discourse. We argue that this case raised the level of national prominence because it "fit the frame" of predatory homosexuality. Through the use of coded language, journalistic speculation, and the reporting of select explicit details, news organizations emphasized and sensationalized the sexual exploitation of boy victims.

As news of Shawn Hornbeck and Ben Ownby broke, speculation about the presumed sexual nature of the crime ran rampant in the absence of factual confirmation. Police reports of sexual abuse had not yet been released, but when journalistic commentators like Bill O'Reilly broke new evidence, he did so by implying that Hornbeck and Ownby were abducted for sexual exploitation:

> Now here's another eerie report ... That this guy Devlin took a leave of absence for three months right after Shawn was kidnapped. That means that this guy could have been in proximity to the boy for three months solid, no break, doing whatever this guy does, which would have been a harrowing, harrowing experience, for anybody, not even counting a child, but for anybody. (*The O'Reilly Factor*, Fox News, January 22, 2007)

Through the use of language and descriptors like "eerie," "doing whatever," and "harrowing," O'Reilly primed the audience to imagine the unspeakable. This coded language was also used in the questioning of those friends and family members who were close to Shawn, indicative

of the overall journalistic obsession and speculation over "what really happened" in those four years. In particular, when the story broke, there was a fascination with documenting what took place in those first 30 days of "intense" captivity between Hornbeck and Devlin. As *ABC News*'s Eric Horng reported, "Hornbeck's family say they haven't gotten around to asking Shawn the tough questions, what these past four years had been like. They say those answers will come in time" (*Good Morning America, ABC News*, January 17, 2007).

However, waiting for Hornbeck to tell his own story wouldn't come soon enough for the journalists reporting the story, and they began pressuring family members to reveal lurid details of Shawn's time in captivity. Within hours of the discovery of the missing boys, ABC's Katie Snow grilled Shawn's sister Jackie on *Good Morning America*:

> Snow (reporter): Did he say anything about what had happened to him? Has he, has he told you the story at all?
> Jackie Huncovosky (Shawn's sister): No. And we're not gonna ask right now.
> Snow: It's not the time to ask?
> Huncovosky: No. (*Saturday Good Morning America, ABC News*, January 13, 2007)

Later in the same episode Snow asked,

> Snow: Jackie, do you have a lot of questions that you'd like to ask your brother?
> Jackie: A couple. Not that many.
> Snow: You really don't want the details, you just wanna move on?
> Jackie: No, I'm just happy that he's home. (*Saturday Good Morning America, ABC News*, January 13, 2007)

News reports cited early speculation from standard journalistic sources about Shawn's time in captivity, readying the audience for its dominant framing. Donald Cooksey, the lead investigator in the case, told *ABC News*, "This kid's been traumatized. So whatever he did, I'm sure it was under duress" (*World News Sunday, ABC News*, January 14, 2007). The day following the discovery of the boys, news reports confirmed that, "Shawn's parents say they haven't yet asked him how he was

treated, but they do believe he was sexually abused" (Donald Cooksey, investigator in the Hornbeck case, as cited in *World News Sunday, ABC News*, January 14, 2007).

However, a week later, journalistic speculation gave way to an implied questioning of whether or not Shawn was "complicit" in his captivity, as we unpack more fully in Chapter 4's analysis of victim blaming. While Fox's Bill O'Reilly confirmed that Shawn was "indeed a victim" (apparently, it needed to be stated), within a week of the boy's recovery, O'Reilly began to question the "level of cooperation or coercion that indeed occurred between Shawn Hornbeck and Michael Devlin" (*The O'Reilly Factor*, Fox News, January 22, 2007). John Gibson of Fox News also cited an Associated Press reporter, Christopher Leonard, regarding Hornbeck's "cooperation with Michael Devlin," (*The Big Story with John Gibson*, Fox News February 1, 2007).

When the indictments against Devlin were released in May of that year, a whopping 71 charges, speculative media reports confirmed the worst, and the initial assumptions morphed into explicit details. The bulk of the charges reported involved Shawn, "who was in that apartment for four years" (Fox News Network, May 21, 2007). Chris Leonard, a reporter for the Associated Press, admitted, "beyond the charges that were laid out, there is not a lot of detail," but that "Devlin has admitted to committing the kidnappings and these forceable acts of sodomy." As Fox News reported:

> Gibson: If I have got the math right, Chris, out of the 71 charges, 18 involve Ben Ownby and 53 involve Shawn Hornbeck. On each of the young men, there is one kidnapping charge and the rest of them are essentially sexual assault charges, right? (Fox News Network, February 5, 2007)

Furthermore, coverage of Devlin's trial that began in October further opened up reports with its graphic testimony:

- a litany of horrific crimes
- all captured on videotape for the defendant's sexual gratification
- kidnapping 11-year-old Shawn Hornbeck at gunpoint then submitting him to years of sexual abuse
- tied him to a futon or a couch inside the apartment, and also with duct tape [sic] SH's mouth closed. (*Good Morning America*, October 10, 2007)

The predatory homophobic framing drove a presumptive narrative that Ben Ownby's abduction served as a sort of replacement for Shawn, again reinforcing the conception of sinister predatory abductors who prey on a particular "type" of victim. As Geraldo Rivera theorized on Fox News:

> I would also be of the opinion that the reason he went to snatch Ben Ownby and took Shawn along with him was because Shawn had aged out. He was now 15. He was becoming a young man. And maybe Devlin favors young boys. And he went after someone who was the same age as Shawn when he originally snatched him. (*The O'Reilly Factor*, January 26, 2007)

Shawn, clearly cast as an innocent victim in the initial coverage of his discovery, within a few weeks had morphed into a culpable and willing suspect, as this next section explores.

Codes of Innocence and Culpability

As we analyzed in Chapter 2, new reports unwittingly created a hierarchy of "worthy" or "innocent" vs. "culpable" or "compliant" victims. Much like the "bad girl" (sexual, lower class) vs. "good girl" (respectable, higher classed, innocent) dichotomy guides media coverage of girl victims, so "good boy"/"bad boy" distinctions differentiated innocent boy victims from culpable suspects. While the reporting originally framed both Hornbeck and Ownby as tragic victims, as the story evolved, stark distinctions in coverage emerged. As we explore in this section and unpack more fully in Chapter 4, Shawn quickly became framed as a suspect rather than a victim.

Ben Ownby was continually referred to as a "young" or "little" boy; Shawn Hornbeck was referred to or represented as a teenager or even young man. However, Ben, thirteen, was not much younger than Shawn when he was found at age fifteen, and Ben was older than Shawn when he was originally abducted at age eleven. Nonetheless, news narratives used language and descriptors to construct Ben as an innocent child and therefore sympathetic, while Shawn was constructed as more adult, more sexual and therefore more suspect.

Ben Ownby was labeled as "the 13-year-old A student" (*On the Record with Greta Van Susteren*, January 12, 2007), described by his bus driver as "a happy child, not a troublemaker. I'd say he'd help anybody, if he could." He was described by *CBS News* as "the straight-A student and Boy Scout" (*CBS Evening News*, January 12, 2007). Normative conceptions of American boyhood were used to explain why Ben's initial disappearance was considered an abduction, not a runaway:

> The possibility of Ben being a runaway didn't seem strong. He is, by the accounts of his family and friends, a model student who makes good grades, likes to play computer games and is a member of the Boy Scouts and his school's Science Olympiad team. (Deere, 2007, January 7, p. A1, *St. Louis Post-Dispatch*)

Again, these descriptors framed Ben's reentrance into public life after he was released from captivity: "He's back in Little League, he's back in Boy Scouts, he's back in school" (*On the Record with Greta Van Susteren*, May 21, 2007).

On the contrary, similar to the ways in which lower-class and non-normative families were pathologized historically in abduction cases, Shawn Hornbeck was described as "a runaway kid," "a wayward kid," and Devlin, his abductor, as his "savior" "who took him and helped him somehow" (*The Big Story with John Gibson*, February 2, 2007). Rather than a young boy, Hornbeck came to be described as "The kidnapped 15-year-old," aging him considerably older than he was at his time of abduction at age 11 (*The O'Reilly Factor*, January 18, 2007). Shawn, "now 15," had "become a young man," "the kid with a pierced lip" (*The O'Reilly Factor*, January 18, 2007).

News reports firmly placed Shawn in the realm of teenagehood with "another new strange piece of the puzzle just as shocking" (*On the Record with Greta Van Susteren*, January 22, 2007). National media reported that Shawn presumably had a "long-time girlfriend" who didn't know his true identity until the story broke. Shawn, already classed as a wayward runaway, had "found a girl at a top tier Catholic girls school" in St. Louis and they had reportedly been dating for six months. Friends said they "would see them holding hands in the malls" (*On the Record with Greta Van Susteren*, January 22, 2007). Note

how this speculative news report positioned his having a girlfriend as "strange," "shocking" and suspect. Within a week of Shawn's recovery, then, these reports marked him as older, heterosexual and with a great deal of normative teenage interests and freedoms. These reports quickly morphed into questions as to "why didn't he leave" when he clearly had the agency to do so (see Chapter 4).

A week after the "shocking" girlfriend story, news constructions of Shawn as a complicit and willing suspect were inscribed when an Associated Press story broke that alleged Shawn was an accomplice in the abduction of Ben Ownby. Police reports raised suspicions when they reportedly revealed that when police initially came to the Devlin residence, Shawn didn't say anything to the officials, and in fact, he helped to hide Ben. News organizations began to report that, "Shawn actually helped Devlin kidnap and hide Ben Ownby" (*The Big Story with John Gibson*, February 2, 2007).

Again, journalistic speculation drove the narrative. Bill O'Reilly cautioned viewers that "there are going to be other headlines coming out ... that authorities have got to get to the bottom of this and report the whole story to the folks" (*The O'Reilly Factor*, February 1, 2007). In the absence of fact, "Fox hasn't confirmed it, nobody else, that somehow your client helped kidnap Ben Ownby." Shawn was not simply complicit, he himself was guilty of committing a crime himself:

> Bill O'Reilly (host): The A.P. reporting that the police came to Devlin's door, Shawn was there, talked to the police. Eleven-year-old Ben was in the bathroom held and threatened and Shawn didn't say anything. Does that mean anything to you?
>
> Van Susteren (commentator): It certainly is alarming. Either Shawn certainly has suffered at the hands of Michael Devlin and has become you know his pawn and he is doing things that Michael Devlin has asked him to. Or Shawn himself is a bad player. (*The O'Reilly Factor*, February 1, 2007)

Journalists, reporters and pundits acted as judge and juror in the case of Shawn Hornbeck. While many discussed Shawn's physical and psychological torture while in captivity, defending his actions as he was "subject to the duress" of Devlin (*Good Morning America*, March 5, 2014),

media storytellers ultimately raised suspicions about Shawn's role and his apparent agency. As Fox News concluded, Shawn, no longer fully considered a completely innocent "victim," should stand trial himself: "If I were the prosecutor on the case, the investigator, I would want to sit Shawn down, I would want to spend a lot of time with him, debrief him" (*The O'Reilly Factor*, Fox News, February 1, 2007).

These narratives circulated despite the concerted efforts by Shawn's family members to reclaim his innocence. Craig Akers, Shawn's father, repeatedly referred to Shawn as a "boy," telling media how elated he was to "have our boy back" (*Good Morning America*, October 11, 2007.) He was quoted as saying, "He [Devlin] tore an 11-year-old child from his family, destroyed his innocence, and attempted to end his life. He stole away so many of the wonderful life experiences a boy shares with his father" (*48 Hours*, June 16, 2009.) He spoke emotionally about the many firsts he missed out on with his son, "the first time he shaves, the first time he drives a car, his, you know, first dates, school dances. We'll never, ever get to experience those" (*48 Hours*, June 16, 2009.)

These descriptions of a young boy torn from his family were ultimately drowned out by mediated constructions of a fifteen-year-old "man" who had considerable freedoms, a girlfriend he hung out with at the mall, facial piercings, and the motivation to help kipnap the real innocent victim in the case, Ben Ownby. These distinctions between "good boys" and "bad boys," between innocent victims and culpable ones, were further used to demarcate "good families" who shielded their children from the media circus and those willing "make a buck" off their kids' suffering.

Conclusion: The Politics of Shame and the Implications for Victim Advocacy

During the 1980s, as the first half of this chapter demonstrates, boys held the kind of symbolic power to represent not only the nation-state but also the rose-colored nostalgia of American life. As the May 29, 2009, edition of *20/20* framed the 30th anniversary of Etan Patz's

disappearance demonstrates, Etan's vanishing symbolized the loss of a "carefree" way of American life:

> Jay Schadler: Go back in time, 10 years, 20, 30 years, and we will mark the moment when innocence was abducted. It was 1979. You could fill up your Pontiac Trans Am for 79 cents a gallon. At the movies, *Kramer versus Kramer* laid out the changing roles of men and women. And if you were lucky enough to have the newly invented Sony Walkman, odds are you were listening to Sister Sledge and "We Are Family." But the rhythm of our lives was about to change, especially the way we think about our children. On May 25th, 1979, right here in the Soho District of New York City, a 6-year-old boy vanished and was never seen again. (*20/20*, May 29, 2009)

The cultural anxiety of the 2000s mirrored, in some ways, those of the 1980s in which the white male patriarchy was under attack. The conservative backlash against progressive gains of the civil rights era produced and/or recycled hyper-masculine political figures and popular culture icons (Jeffords, 1994) as well as valorized (white, male, middle class, heterosexual) children as ideal citizens. As Lauren Berlant theorizes about the "Reagan revolution":

> In the reactionary culture of imperiled privilege, the nation's value is figured not on behalf of an actually existing and laboring adult, but of a future American, both incipient and pre-historical: especially invested with this hope are the American fetus and the American child. (Berlant, 1997, p. 6)

Thus, with both traditional American masculinity under threat, anxiety over sexuality at a peak, and childhood exalted in the public discourse, the abductions of young boys by sexual predators in the 1980s became a narrative that contributed to what Berlant argues was a mediated "suppression of American gay identity on behalf of a national fantasy of a military life that, even after the Cold War, is more vital than ever for (re)producing national boyhood and heterosexual national manhood" (1997, p. 52). The construction of boy abduction victims as idealized, innocent citizens is specific to the time period in which they were snatched because, as Connell (2005) writes,

> Masculinities are neither programmed in our genes, nor fixed by social structure, prior to social interaction. They come into existence as people act. They

are actively produced, using the resources and strategies available in a given social setting. (Connell, 2005, p. 12)

This remains true, of course, in the 2000s, as the 1980s cases were memorialized and new abductions framed through the prevailing paradigm of homophobia and investment in young girls as the contemporary idealized citizen in a nation under threat from "foreign" attackers.

The legacy of Etan's loss, as well as those of Steven Stayner and Adam Walsh, forever altered public understandings of the crime of child abduction as one that involved a predatory, and almost always fatal, sexual exploitation of children. But the boy victims who survive this sexual assault are denied the same opportunities for victims' advocacy that girl victims receive. As we discuss in Chapter 4, victims like Elizabeth Smart and Michelle Knight contend that commanding a lack of shame in the public sphere empowers them to counter the victim blaming that pervades mediated and public discourses. This articulation is consistent with feminist campaigns that encourage rape and domestic violence survivors to tell their stories and de-stigmatize victims.

However, problematically, no such space exists for boy victims of rape, abduction and sexual assault. In these media reports, homosexual rape was so stigmatized that boy victims were excluded from the larger victims' advocacy movement, ostracized from the emerging high-profile activism efforts led by former victims like Elizabeth Smart and Michelle Knight. Survivors of homosexual assault are treated differently, in other words, as if there is no erasure from the culturally ascribed "shame" that renders boy victims voiceless.

Shawn Hornbeck's case demonstrates the relative inability of the media to treat homosexual rape as anything other than cause for humiliation for the victim. Media pundits who presumed that Shawn *would and should avoid testifying* at Devlin's trial reinforced this narrative. As 20/20's Robin Roberts suggested:

> Robin Roberts, reporter, *ABC News*: Are you hoping it doesn't have to come to that, that he will not have to testify? It'd be so traumatic.
> Scott Sherman, Shawn's family attorney: Well, well, as a lawyer, you always wanna protect your client and try to throw a blanket over him. But everybody

out there needs to know and your audience that Shawn Hornbeck is an incredible, young man. (*Good Morning America*, May 25, 2007)

And several months later:
Robin Roberts: I'm sure you're very grateful because you've been saying all along you did not want it to go to trial for Shawn's sake and for Ben's sake. (*Good Morning America*, October 11, 2007)

Unfortunately, the gendered, lopsided media coverage of boy victims silenced their perspectives and created a hierarchy of those victims who were granted a voice and those who were forced to retreat from the media spotlight. As we explore in the following chapter, the gender of the victim was also deployed in specific ways to assign blame and describe some victims as "innocent" while other were cast as "complicit."

Note

1. As of January 2015, the murder trial of Etan Patz case was underway to prosecute a new suspect, Pedro Hernandez, fifty-three. Hernandez has been in jail since he confessed to the murder of Patz in 2012, but his attorneys have worked to get the confession thrown out on the grounds that Hernandez is mentally incapable. The trial ended with a hung jury and a new trial is set to begin in February 2016.

Chapter 4

Why Didn't They Leave?

Despite the elation over Elizabeth Smart's return, there are still many questions about the case. The biggest, why the teenager apparently didn't try to get away from her captors.

—(Charles Gibson, *ABC News*, March 13, 2003)

Shawn Hornbeck spent four years with his alleged abductor and appeared to have had many chances to escape. So many people are asking why didn't he make a run for it.

—(Robin Roberts, *ABC News*, January 15, 2007)

When police served a search warrant at an apartment complex in Kirkwood, Missouri, in early January, 2007, they were following leads in the disappearance of Ben Ownby. As we discussed in Chapter 3, thirteen-year-old Ownby had vanished after getting off a school bus near his home. Witnesses reported seeing a white truck in the area. After local media were flooded with reports of Ownby's abduction and calls for information about the truck, a neighbor called police, suspicious of Michael Devlin, a forty-two-year-old manager of a local pizza restaurant. Police recognized his white pick-up truck, which matched the description, in the complex's parking lot.

After learning that Devlin was a convicted sex offender from Oregon who had not registered in Missouri, police obtained a search warrant and returned to find Ownby held captive in the apartment. While news outlets lauded the swift return of "little Ben Ownby," a "straight A student" pictured wearing glasses in photographs, the "astonishing" "surprise twist" that catapulted the case to the top of major news headlines was the "unbelievable" discovery of Shawn Hornbeck residing in the same apartment where Ownby was recovered.

Shawn Hornbeck was 11-years-old when he went missing in 2002 from the same area as Ownby. Although his parents tried to bring national attention to his case, police treated his disappearance as a possible runaway. As described in Chapter 3, Hornbeck was not able to garner media attention at any time during his disappearance until his "shocking" discovery in Devlin's apartment in 2007. Though Shawn Hornbeck and Elizabeth Smart disappeared within 4 months of each other, both close in age to one another, the media's treatment of their disappearances could not have been more different. Hornbeck failed to ignite the sympathetic treatment that Smart received when she was snatched from her bedroom. Smart was the focus of intense media attention during her captivity. National news media only turned its gaze to Hornbeck when details of his four-year ordeal began to emerge.

Yet, once Smart and Hornbeck were rescued, their stories began to share some very important similarities in the way that media discourses characterized their recoveries. Within hours of being found by police, both Hornbeck and Smart were treated with suspicion by journalists, reporters, and pundits who simply could not come to terms with the lengthy abductions and the victims' inability to escape their captivities. Likewise, when news media began reporting the recovery of Jaycee Dugard in 2009 after 18 years in captivity, similar narratives circulated around her confinement. Dugard was also abducted at age eleven, and her case received no discernable national news media attention until her dramatic discovery and rescue.

This chapter examines the specific framing devices used to represent children of long-term child abductions, in particular, the ways in which news organizations deploy historically rooted frames of "victim blaming" by scrutinizing an abductee's motives, behaviors, and

desires. Initial reports of elation over the recovery of victims quickly turn to raising "puzzling questions" and floating vague accusations that victims were somehow complicit in their own capture and confinement. In examining these problematic framing devices implicit in the journalistic "why," we ask: What social myths underlie the framing of child victims of long-term abductions? In what ways do news reports represent victims as having "failed" to escape their captors?

Coverage of cases in which the victims are recovered alive by law enforcement after months or years feature compelling media speculations about the sexuality and agency of victims. Casting suspicion on victims of child abduction also adopts the frames long used in victim blaming, often employed exclusively to women, in cases of domestic violence, rape, and child abuse. Questions about individual agency and the possibility of escape converge with graphic details and implied speculation about sexual assault, creating problematic discourses in which anxieties over teenage sexuality percolate beneath the surface. Child victims who have been threatened, tortured, beaten and sexually assaulted are assigned a perplexing degree of agency over their situations, one that holds them personally responsible for colluding with their captors.

Initial Doubts, Growing Skepticism, and the Journalistic "Why"

The prurient cable news coverage of the Smart and Hornbeck recoveries demonstrated a contradictory ability to discuss sexual assault as a loathsome crime while simultaneously speculating that the sexual contact between the victims and perpetrators could have been consensual. While describing graphic details of the victims' bodies and the crimes performed against them, reporters decried the acts as vile yet raised concerns about accepting victims' accounts as valid and "true."

In part, this questioning can be seen as an important tenent of investigative reporting, a reticence to condemn the accused perpetrators until they confess or are convicted. To some extent, this tendency

has the potential to demonstrate a kind of admirable restraint that is considered one of the best journalistic practices. Yet, in practice, the 24/7 news cycle and rampant speculation resulted in commenters not just *withholding* judgment while the crime was still under investigation, but rather assigning blame to victims. The "he said/she said" dichotomy commonly used to frame cases of sexual assault, rape, and domestic violence does not allow for journalists to give accused perpetrators the benefit of the doubt without casting that doubt onto victims. Commenters often convey a sense of stunned disbelief about the return of child victims, which in turn contributed to the speculative tone that spiraled into the journalistic questioning of the victims behaviors, motives and mental states.

Blaming victims for their "failure" to escape is predicated on the myth of rugged individualism and a deeply rooted cultural ideal that individuals (even children) can determine their own fate. The repeated attempts to explain victims' inability to escape their captors reflect a larger insecurity about the strength of individual agency during a time of national vulnerability. Note how, following Elizabeth Smart's euphoric rescue in 2003 after 9 months of captivity, framing surrounding her case existed within the broader mediasphere of war and instability. Commenters lauded Smart's return as a ray of hope during a dark time but subsequently fixated on the failings of her individual agency. News storytellers situated Smart's return as an allegorical narrative:

> Aaron Brown, host: There is an "Alice in Wonderland" quality about the last couple of days. The return of Elizabeth Smart on the one hand, the pending war with Iraq on the other. Perhaps on any day ..., any time, the Smart case would have been a winner. But coming as it did, after weeks of such difficult news, and the prospects of even more difficult days ahead, seems to make the Smart case even more wonderful than it otherwise would have been. (*Newsnight*, CNN, March 13, 2003)

The seeming failure of individual agency in cases where children did not thwart or escape from their abductors needs to be explained and rectified in news framing that relies on societal myths to organize disparate events. Based on the assumption that Smart, Hornbeck, and

Dugard *could* or *should* have escaped, news seeks to explain *why* they didn't.

Of course, victim blaming in news discourses is not a new practice, and it's most often used to assign blame to women and girls who are victimized by crime (Durham, 2011; O'Hara, 2012; Rice, et al., 2012; Taylor, 2009). As feminist media scholars like Marian Meyers remind us, "myths and presumptions embedded in the journalistic 'why'" force victims on the defense" (Meyers, 1997). Furthermore, "whether the doubt is cast at the end of the story or earlier, it is tied to an ideology that reflects cultural myths and patriarchal assumptions about the proper role and behavior of women" (Meyers, 1997, p. 63). Despite the frequent inclusion of caveats, pop-psychology theories, and testimony from "expert" sources, the predominant narratives surrounding the return of long-term abduction victims centered on one question, "Why didn't they leave?" The framing strategies were patterned and repetitive across news outlets in a manner that suggests the questions arose naturally and legitimately from the "facts" of the cases. Yet, the accusations began long before the facts emerged, and instead served as titillating and speculative filler in the initial reporting of the recoveries.

The clearest example of these speculative questions is in the case of Elizabeth Smart's recovery, when, after the police received several tips, they discovered her in a Salt Lake City suburb in the company of Brian Mitchell and Wanda Barzee. Her initial recovery gripped the nation arguably more than her initial disappearance and was treated ecstatically by media reports that credited an intense police manhunt and endless news coverage for having rescued the young teen. Yet, within a few hours of Smart's recovery, mainstream news coverage took on a different tone. The first question became, Why didn't she run?

The March 13, 2003 edition of *World News Tonight* opened with Charles Gibson asking "puzzling questions" about Elizabeth Smart's return: "Despite the elation over Elizabeth Smart's return, there are still many questions about the case. The biggest, why the teenager apparently didn't try get away from her captors" (*World News Tonight*, March 13, 2003). The same day, CNN struck a regretful tone as host

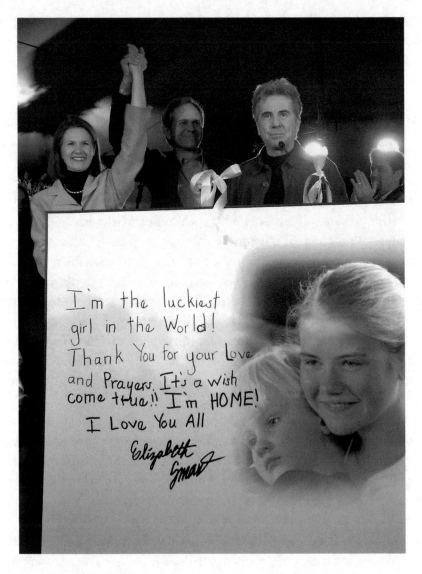

Figure 4.1. Celebration Held For Elizabeth Smart.
Elizabeth Smart's parents Lois and Ed Smart acknowledge the cheering crowd as they listen to *America's Most Wanted* host John Walsh speak during a celebration at Liberty Park on March 14, 2003 in Salt Lake City, Utah. Elizabeth Smart was found alive on March 12, nine months after being abducted from her home at knifepoint by Brian David Mitchell. While her discovery was universally celebrated by national media within the first few days of her return, the narratives of elation were soon replaced by troubling journalistic speculations concerning why she did not escape from her captivity sooner. (Danny La/Getty Images News/Getty Images)

Aaron Brown implied the probing line of questioning originated from external forces:

> Aaron Brown, host: We begin with Elizabeth Smart and something unfortunate that crept into the coverage today, the question: Why didn't she try to escape? There's something faintly accusing about that, putting the burden not on the culprits, but on a child who was stolen from her home, from her bedroom. (*Newsnight*, CNN, March 13, 2003)

Employing language like "unfortunate" and "crept," within a tone of puzzlement and disappointment, journalists and pundits treated the questions about why Smart didn't escape as emerging organically and inevitably. Reporter Pat Reavy of the *Deseret News* said that "questions have been asked" which indicates that an unknown, amorphous entity lies behind the inquiries (*CNN Newsnight*, March 13, 2003).

In the earliest days of Smart's return, speculations about why she did not escape also privileged the perspective of anonymous "eyewitness" observers, casting her behaviors and actions in a suspicious light. Furthermore, assumptions that Smart could have and should have "just walked away" or "just left" simply and easily presumes a level of agency and responsibility on the child victim, one that dovetails the framing of Smart as culpable in her own captivity.

> Cynthia McFadden, reporter: We now know that Elizabeth Smart frequently went out in public with her alleged captors. No one ever saw her being coerced with a weapon or held against her will. And even more surprising, we've now learned that for six days last month, Brian David Mitchell, the self-proclaimed prophet of God, was in jail, arrested for vandalizing a church in San Diego. All of this raises the question, why couldn't Elizabeth have just walked away during all those days Mitchell was in custody? (*ABC News Primetime Live*, March 13, 2003)

> Paula Zahn, anchor: She is safe at home, but there are still a lot of questions about her disappearance. Why didn't she try to escape? For example, when she was being held so close to home at one point, we are told for many, many months, she was literally four—a little less than four miles away from her family's home. (*American Morning*, CNN, March 14, 2003)

This line of journalistic narration and questioning is predicated on presumptions that a traumatized girl could have the physical

or psychological ability to escape from her abductors and navigate unknown terrain to find her way home.

In a similar move, when reporting on the return of Shawn Hornbeck, *Good Morning America* sidestepped accusations by claiming "a lot of people," not the reporters themselves, were questioning Hornbeck's "credibility" (*Nancy Grace*, CNN, January 31, 2007). The use of inquisition as a rhetorical strategy also shields journalists from being accused of engaging in victim blaming themselves because, after all, they aren't *claiming* victims are culpable but merely *asking* whether they are. In fact, by the time these questions mysteriously arose in Hornbeck's case, some reporters were re-writing history by claiming that Elizabeth Smart's case had not aroused such queries.

> Megyn Kelly, correspondent: I don't know. And I'll tell you, I'm nervous to say anything, because, you know, look at what happened with Elizabeth Smart. I mean, she was at the same age. She was gone for several months. No one raised such questions with her, even though she, too, had the opportunity—she encountered police. She had opportunities to escape, but no one raised these questions.
>
> It's almost like they see that it's a boy, and he looks like a typical teenage boy, you know, sort of rabble-rouser, maybe. People are thinking that maybe somehow he wanted to be away from his parents. I think that there's some sort of discrimination going on against this kid, because it hasn't been done to others. (*Hannity & Colmes*, January 19, 2007)

After presenting the questions as legitimate and natural, the door was opened for journalists and others to speculate about the sexual and emotional desires, or conversely the horrific abuses, that could lead victims to stay. As the questions were raised, journalists and pundits sought to answer them by pouring over minute details of police reports and statements from family members. In all three cases of Elizabeth Smart, Shawn Hornbeck and Jaycee Dugard, the explanations may be categorized as psychological or physical. As we explore in the following section, by blaming the victims for *wanting* to stay or alternately describing the tortures that *forced* them to stay, victims were stripped of privacy by news narratives that fixated on exposing their bodies and psyches.

Mental Chains and Pop Psychology

In attempting to justify victim's motives for "staying" with their captor, news organizations and the sources they cited settled, for the most part, on one explanation: Stockholm Syndrome. The discussions of Stockholm Syndrome were laden with caveats and speculation, such as forensic psychiatrist Clay Watson defining the supposed condition for viewers as, "a psychological reaction that people who may be held in captivity either through kidnapping or as hostages, they begin to have positive feelings or attachments towards their captors. And they may pass up opportunities to escape" (*CNN Newsroom*, August 30, 2009). Frequent use of words such as "may" or "might" suggests that psychologists are uncertain that victims suffer from the condition labeled Stockholm Syndrome, yet journalists also frequently present the diagnosis as something that "must" be accepted as the only viable explanation for victims not escaping.

> Pat Reavy, staff reporter for *Deseret News*: Was she (Elizabeth Smart) drugged? Was it the Stockholm Syndrome? Was it psychological impairment, I guess is what we have to believe. But why she went along with it for so long. And it seems obvious she had chances to escape. When Mitchell was in jail for six days in San Diego, obviously it would be one time. It seemed like he wasn't watching her. She had plenty of time to escape. It seems like she, I guess, became one of them. And for a lack of a better word, I guess, what is being used by both her father, Ed Smart, and police is brainwashing. How that occurred, I think that's not known yet. (*Newsnight*, March 13, 2003)

The vaguely accusatory tone suggests that there is no reasonable explanation for the why Smart did not escape when she had "plenty of time" and "obvious chances" to do so. The only conclusion available to reporters is that she suffered from Stockholm Syndrome and "became one of them." Presenting Stockholm Syndrome as a viable explanation for "failure" to escape is in itself a form of victim blaming because "succumbing" to the condition is used to indict rather than excuse the victims. The conveniently fluid diagnosis of Stockholm Syndrome became the prevailing theory with which to answer the

confusion over why victims remained in captivity for months or even years. An unscientific diagnosis made by journalists and pop child psychiatrists not officially involved in the cases (but usually promoting their latest books) was presented as "expert" testimony, and the definition of Stockholm Syndrome shifted to accommodate the frames deployed by prominent news organizations.

Linking unrelated cases within a single news cycle also provided the illusion that the disparate victims' experiences were similar enough to prove that there is a well-established theory of Stockholm Syndrome. For example, after Jaycee Dugard's discovery, she went immediately into hiding with her family. Her lack of public presence in the mainstream media left reporters covering the story to rely on pseudo-psychologists who compared Dugard, Smart, and other victims and created a narrative of presumed complicity between Dugard and her captors. By weaving a thread from Patty Hearst (perhaps the most well-known example of Stockholm Syndrome being presented as a legitimate diagnosis) to Elizabeth Smart to Jaycee Dugard, commentators created the artifice of proof that Smart and Dugard suffered from the condition.

> Brianna Keilar: Dr. Watson, one of the really interesting things that we've learned here over the last day is that Jaycee Dugard actually had access to e-mail. She may have had access to a phone. And yet she didn't try to escape. We've seen this before. You know, be it Elizabeth Smart or Patty Hearst. But just make some sense of this for us.
> Clay Watson, forensic psychiatrist: It certainly is counterintuitive. (*CNN Newsroom*, August 30, 2009)

Treating Dugard's behavior under duress as "counterintuitive" and thus defying rationality, the experts place themselves in the position of judging her mental state and diagnosing her as just another victim in a decades-long string of Stockholm Syndrome sufferers.

> Larry King, CNN host: Did you learn if there was any Stockholm Syndrome involved?
> J.D. Heyman, Assistant Managing Editor, *People*: Well, I really …
> King: Getting attached to the captor?

Heyman: Well, I really can't speculate about—about whether there was any sort of, you know, quote, unquote, Stockholm Syndrome. Obviously, when a young child is kidnapped and—and held for that long of a time, there is going to be a complex relationship between anybody and the people that are holding them so ... (*Larry King Live*, CNN, October 14, 2009)

When returned child victims are accused of being complicit in their captivity, they may also be treated as possible consensual partners in the sexual contact. Alluding to sexual assault vaguely as a "relationship" implies that the victims were willing participants at some point, whether from the beginning or after "brainwashing." The suggestion not only assigns abducted children agency in granting sexual consent, but also negates the violence acted upon them. In one particularly disturbing exchange, Hornbeck is cast in the role of Devlin's "wife," a characterization that is at once laden with homophobic connotations and assigns a puzzling level of maturity and complicity to an eleven-year-old abduction victim.

Nancy Grace, host: Now, there he is with a family friend. They studied together. They slept over at each other's homes. They played together. You see him there outside the apartment, free to come and go as he wanted with his little friend. (*Nancy Grace*, CNN, January 26, 2007)

Bethany Marshall, Psychoanalyst: Well, the word Stockholm Syndrome has been bandied around, but I think abused wife syndrome afflicted upon an 11-year-old child is a much better construct or a way to look at it. (*Larry King Live*, CNN, January 26, 2007)

Likening Hornbeck's captivity to cases of domestic abuse or marriage in particular frames abduction victims as consensual partners in a "relationship."

Sean Hannity, host: You know, it seems, Pat—you mentioned the Stockholm Syndrome earlier. It seems that a lot of people don't fully understand this. It's a very common reaction to being under this type of enormous pressure. And that is that you take on the identity of the person that is your captor. Patty Hearst is a classic case, when she went out with the Symbionese Liberation Army, and she started robbing banks. She was not the same person she was when she was taken.

Pat Brown, criminal profiler: Exactly. And you're not exactly taking on their identity, but you're believing what they tell you. Take a look at domestic abuse; it's very similar. A woman is in a relationship where the husband is telling her, "You're worthless. Nobody wants you. If you leave me, I'll kill you. If you leave me, you'll never earn a penny. If you leave me, I'll make your life hell." And he tells her all these things. And eventually she is so stuck in that little world, her reality is down to what that person says ... (*Hannity & Colmes*, January 19, 2007)

This sort of flawed mediated discourse first characterizes Stockholm Syndrome as "taking on the identity" of the abductor and losing one's own identity, but then redefines this syndrome as the dynamic whereby victims of long-term domestic abuse are made to believe themselves unworthy of love. Neither of these notions fit the field-accepted definition of Stockholm Syndrome to begin with, but the totality of the exchange again places child abduction victims in the role of victims of *domestic abuse*, a patently false construction. Not only does the torture, sexual assault, and physical confinement of child abduction victims become obscured in the homey language of "domestic" violence, but the tropes of victim blaming historically used against domestic abuse victims further comes into play. Domestic violence coverage often "represents the victim as guilty, as somehow at fault" for contributing to the abuse, even causing it, not protecting oneself from the abuser (Meyers, 1997, p. 63). The frame deployed is that one must either fight back or be labeled as a "passive victim." All women are "represented within the news as potentially to blame for causing their own victimization" (p. 64). Yet, fighting back is not always rewarded, either. Meyers refers to this as "questions of complicity" if victims passively "endure." Victims are guilty or at fault if they somehow contribute to, cause, or fail to protect themselves from violence.

McGregor Scott, Attorney for Jaycee Dugard: I think she very clearly understands that some very bad and terrible things were done to her and that the people that committed those crimes need to be held accountable.

Velez-Mitchell: This is amazing. I mean, she was obviously traumatized originally. She was sort of almost defending Garrido saying that she hadn't been

touched in years by him et cetera, et cetera. Now it seems like the brainwashing is wearing off and she's coming to terms with this horror that was inflicted on her and maybe getting a little bit angry, we hope. Dr. Reef?.

Reef Karim, addiction specialist: Yes. The—some people are talking about Stockholm Syndrome here. Stockholm syndrome essentially is where you start bonding with your captures. You idealize your captors because they are kind of taking care of you. It ends up with having a perceived threat that they might hurt you; a perceived sense of lack of escape in a situation and random acts of kindness that they give you. So you're in this bubble where your sense of survival—as sick as this is—is idealized by your captors.
Velez-Mitchell: But it's rubbing off now it seems.
Karim: Exactly. (*Issues with Jane Velez-Mitchell*, CNN, September 24, 2009)

When victims of child abduction are basically accused of being brainwashed and beginning to "bond" with their abductors, the victims are treated as not only being highly traumatized but also surrendering to "sick" behavior themselves. Stockholm Syndrome suggests positive identification and a willingness or desire to remain with the captor. There is a discomfort with the possibility that teen victims shifted from unwilling to complicit participants in the sexual contact that unpins the more troubling fixation on graphic details.

As discussed in Chapter 2, the race, class, and gender of victims contribute to whether they are "worthy" of news coverage and whether they are treated sympathetically in media discourses. Yet, in the case of recovered victims such as Smart and Hornbeck, age is also inextricably linked to judgments of victim agency. Meyers (1997) makes the point that child abuse victims are often presumed "innocent" because of age, so victim blaming is very rare in child abuse cases. However, the perception of age or maturity during the ambiguous teen years when adolescents may be treated more or less as an adult contributed to Smart and Hornbeck being scrutinized in a way that younger victims rarely are. Furthermore, by the time Dugard emerged in the mainstream media as a twenty-nine-year-old mother of two, the extent to which she may have evolved into a willing sexual partner with her abductor is cause for anxiety in news coverage over the sexual agency of children and teens.

Figure 4.2. *People* Magazine's October 26 issue of Jayce Lee Dugard.
People Magazine's October 26, 2009 issue with recently freed kidnapping victim Jaycee Dugard on the cover appears on a newstand in Washington, D.C. The cover marked the first time a current image of Dugard had been published since she was kidnapped by a sex offender in Lake Tahoe in 1991 as an eleven-year-old. Cases of long-term abduction victims like Dugard's circulated media narratives of the "Stockholm Syndrome" and implicitly blamed child victims for being complicit in their captivity.
(Sam Loeb/AFP/Getty Images)

Meyers (1997) reiterates that "advocates for rape survivors and battered women make clear, many of the details of sexual assault or other acts of violence serve to revictimize the victim," (p. 67) just as would public identification. It is standard practice for news outlets to withhold the names of juvenile victims of sexual assault. In contrast, when victims of child abductions are found, their identities are already known in their communities or internationally because of the searches that were performed and the publicity generated by campaigns to find them. So, upon their return, they become publicly and irrevocably linked with the sexual crimes committed against them. These details are not used to help "protect" children who have been or may be abducted, but are the

sensationalistic, commercial imperatives of a for-profit, ratings-driven media system.

The discussion of Stockholm Syndrome and the speculation about potential emotional bonds that victims may develop for their captors are reinforced through the subtle and explicit references to the sexual assaults that victims suffered. Journalists at times skirt around the issue of reporting on child rape by focusing on the details presented in police reports and official statements. Rape and sexual assault have often been the subject of broadcast news. By focusing on the details of the sexual assault and the physical/psychological abuse outlined in police and court records, as well as relying on pseudo-experts and testimonial speculation, news broadcasts sensationalized the cases and turned these recoveries into media spectacles. Cloaked in a fixation on "understanding the facts" surrounding Smart's captivity, coverage relayed graphic details of how and when her body was clothed, restrained, and assaulted as well as how she was tortured emotionally.

> Jeanne Meserve, CNN correspondent: The chief also said that he knows, he believes whether or not Elizabeth was sexually abused during her time in captivity, but he won't share what he knows with us. He did say that Mitchell did view himself as a polygamist. Again, he carefully said he didn't want to draw any connection between that and Elizabeth. (*Connie Chung Tonight*, CNN, March 13, 2003)

Hornbeck's case also raised questions about Stockholm Syndrome, but did so in a way that skeptically suggested that he was using the condition as an excuse to hide his willing participation in his captivity. In one telling conversation between cable news host Nancy Grace and a "legal expert," the technique of raising questions for debate demonstrates how the victim's motives are scrutinized.

> Richard Herman, defense attorney: Nancy, I'm telling you, the Shawn Hornbeck case is a very interesting case. It's not a slam dunk. His credibility, Mr. Hornbeck's credibility, is going to be at issue here.
> Nancy Grace, CNN host: Wait, wait, wait, Mr. Hornbeck?
> Herman: Big issue.
> Grace: I'm sorry, I thought he was 11 at the time of his kidnap? And you're telling me his credibility ...

Herman: Nancy, you're going to be upset to hear this, but some jurors are not going to buy the Stockholm Syndrome, and they're going to be upset over all the chances he had to get away and he didn't get away. There's more to this story, Nancy. It's not over. (*Nancy Grace*, CNN, January 31, 2007)

Here, the accusation is that Hornbeck so clearly demonstrated a willingness to be with Devlin that he couldn't even use the pathology of Stockholm Syndrome as a defense. However, by couching the accusation in questions that *some jurors* may ask and featuring the host defending Hornbeck, the tone again creates an illusion that the questions are legitimate and arise naturally in the course of reporting. The initial coverage of Hornbeck's recovery was riddled with journalists' baffled speculations about his seeming physical freedoms. By describing Hornbeck's behaviors as factual evidence of his duplicity, journalists and their guests cloak their criticisms in objectivity.

Hannah Storm, CBS anchor: As far as we know, he (Hornbeck) had at least three Web pages of his own, and Shawn even posted his picture several times on the Web. Could police have found him sooner had they investigated the Internet aspect of this more thoroughly? [...] Because the question so many people are asking, Pat, is why he didn't try to escape. He was left home alone for hours on end. He was allowed to ride his bike through the apartment complex. He was allowed to go to the mall. He had friends. Why not reach out for help? (*The Early Show*, CBS, January 16, 2007)

But first in this half-hour, those two kidnapped Missouri boys, survivors of the physical ordeal and a psychological one. Shawn Hornbeck spent four years with his alleged abductor and appeared to have had many chances to escape. So many people are asking why didn't he make a run for it. (*Good Morning America*, January 15, 2007)

As these examples highlight, questions about whether police could have done more to rescue Hornbeck are answered by laying the blame on Hornbeck for failing to engineer his own escape. Still more disturbing, several prominent commentators chose to ignore the horrific tortures that Hornbeck was subjected to, characterizing his four years in captivity as "better" than their own children's privileged lives.

Bill O'Reilly, host: The kidnapping of those two boys should be front page news in your house if you have kids. I actually hope I'm wrong about Shawn

Hornbeck. I hope he did not make a conscious decision to accept his captivity because Devlin made things easy for him. No school, play all day long. (*The O'Reilly Factor*, January 16, 2007)

Reports that Hornbeck was seen outside riding a bike and playing are leveraged against him to make the four years of abuse seem like he had led an idealized childhood of "play all day long," enjoying the "easy" life with Devlin. The unspoken accusation is that the sexual contact with Devlin would have also been "easy," something that Hornbeck enjoyed or tolerated for the sake of living this idyllic existence.

Geraldo Rivera, "Geraldo At Large" Host: You can do that with the conditions of captivity. But the things you were right about, let me hasten to add that this kid had more freedom than my 14-year-old does. This kid went on the Internet. This kid was in the presence of police officers without the kidnapper, the fiend present. There are questions that must be answered because why, not because of voyeuristic interests in where Shawn Hornbeck's head is at but because we instruct our children. (*The O'Reilly Factor*, January 19, 2007)

The two connections drawn between Hornbeck and Rivera's child show a stark lack of compassion for Hornbeck. First, being held captive, assaulted and threatened with death as well as the death of his family is likely not "more freedom" than Rivera's child had, placing suspicion on Hornbeck for choosing to remain. Second, Hornbeck's case becomes "valued" as a case study, making him the star of a cautionary tale that will help Rivera protect his child. Thus, Hornbeck is denigrated in comparison to other children and stripped of any value other than the use his story can be as a warning to others.

In the face of accusations of complicity, Hornbeck's family is put on the defensive. Family members were forced to defend Shawn by focusing on his young age at the time of abduction and the psychological torture he suffered.

Pam Akers, Shawn Hornbeck's mother: I don't want everybody to think that he had this perfect life with this guy. There's no way he had a perfect life with this guy. Shawn was happy at home. He had a good home. I know he wanted to be at home. So for people to speculate that he had every opportunity to get away, I'd just like to remind them, he's the victim. He's the child. He was 11 at the time. He wasn't 15. He wasn't an adult. Devlin was the adult, and

he should have done the right thing and not taken the boy in the first place. (*Nancy Grace*, CNN, January 25, 2007)

John Rupp, Washington County Prosecutor: I did receive a call from a reporter today who in essence asked me is it true that Shawn ran away from home and was voluntarily with Devlin? And I'm going to tell you what I told her. We categorically deny that. If these charges do not clear that up, I don't know what else we can do to clear that up. Shawn was abducted against his will, period, end of the story. (*CNN Newsroom*, January 18, 2007)

As in the preceding exchanges, family members are forced to defend victims and remind reporters of how young they were when abducted and how heinous the captors' crimes were. Yet, when victims or family members made statements that ran counter to the narratives being constructed about them, their voices were obscured or simply ignored. In the following example, Hornbeck's statement that he spent every day of four years in fear for his life is dismissed as a viable explanation for not running away from his captor and instead establishes that Hornbeck bonded with Devlin.

Shawn Hornbeck stated: "There wasn't [a] day when I didn't think he was just going to kill me."
Maggie Rodriguez, reporter: Eleven-year-old Shawn Hornbeck was held four and half years, and even though Shawn was allowed to leave his captor's home and even make friends, he never ran.
Rodriguez: So why didn't they run?
Lawrence Kobilinsky, forensic psychiatrist: It's a way of dealing with the stress of having your life at risk. This person becomes emotionally bonded to their abductor and develops a long relationship, and once they are freed, it becomes a long process of healing. (*The Early Show*, CBS, August 28, 2009)

Likewise, the earliest CNN reports of Dugard's return are a jumble of conflicting accounts that give voice to the abductor and construct a biased view of Dugard's captivity that could be interpreted as a willing living arrangement. Going almost immediately into hiding, Dugard did not provide public statements, but her abductor did. In a "rambling telephone interview from jail" with a CNN affiliate station, Dugard's captor Phillip Garrido described his perspective on having first snatched the 11-year-old and then providing a good life for Dugard. Besides quoting Garrido at length, police were cited as stating,

"There are no known attempts by her to outreach to anybody" (CNN. com, August 28, 2009). When Jaycee Dugard told police that her captor had not physically abused her in some years, journalists' disbelief led them to dismiss accounts and again rely on Stockholm Syndrome as a reason to distrust victims' voices:

> Jane Velez-Mitchell, CNN host: A really shocking glimpse inside Jaycee Dugard's 18 years of hell. Jaycee answered the horrifying question—did Phillip Garrido allegedly rape his own children? Did he abuse the two daughters he apparently fathered with her? *The San Francisco Chronicle* reports Jaycee told investigators no, that never happened. *The Chronicle* also reports Jaycee insists Garrido has not raped or molested her, Jaycee, in years. Is this true? Or could Jaycee be suffering from Stockholm syndrome? Is she trying to protect her alleged captor? (*Issues with Jane Velez-Mitchell*, CNN, September 21, 2009)

Reports of horrific abuse were juxtaposed with Dugard's claim that the abuse had ended, serving to simultaneously sensationalize the conditions of her captivity and dismiss her voice.

The potential damage of forcing victims and families on the defensive is that it perpetuates the cycle of re-hashing sordid details while the same time placing the victim under scrutiny. Similar to the way in which "news coverage of violence against women serves as a warning to women by defining the boundaries of appropriate behavior and the punishment for transgression," some child abduction victims are held up for judgment in the mediasphere (Meyers, 1997, p. 53). The news reporting divides victims into those who are deemed faultless and those who are guilty for causing or "provoking their own suffering" (Meyers, 1997, p. 53). These tropes reassert themselves in coverage of child abduction when victims are divided into categories of innocent targets and culpable suspects.

For example, the fixation on solving the mystery of why Smart didn't escape lingered throughout the subsequent seven years of coverage and into the trial in which she testified against her abductors. Never fully granted standing as a wholly innocent victim, Smart's testimony again raised the spectre of doubt about her motives.

> Joy Behar, CNN host: Elizabeth Smart took the stand for the third and final time today. And while her testimony has included graphic details of her

nine-month ordeal, one glaring question remains. One that even Elizabeth has asked herself. Why was she unable to escape when the opportunity presented itself? (*The Joy Behar Show*, CNN, November 10, 2010)

By focusing on Smart's questioning of herself and her own actions, commentors could again shift themselves from the role of accuser to that of objective observer of *others'* doubts in much the same way initial reports created an illusion of questions arising from thin air.

Conclusion: The Complicit and the Blameless

Although Smart, Hornbeck, and Dugard suffered immeasurably, they were still treated with journalistic suspicion once they were recovered. However, in several high-profile cases of long-term abduction, the details of the crimes were deemed to meet an undefined standard of horror that placed victims beyond fault, what we term "the blameless." In these so-called "dungeon cases" that involved "houses of horror," reporter incredulity at the torture and confinement of victims is predicated on the impossibility of victims willing consenting to the conditions in which they were forced to live for months and sometimes years. The barbarity of their confinement and torture overwhelms news content, leaving little room for speculation about whether they willingly engaged in sexual contact or developed attachments to their captors.

The case of Elisabeth Fritzl in Austria bears some resemblance to the Jaycee Dugard and Amanda Berry abduction cases, in that her captivity lasted 24 years and she bore seven children as a result of being raped by her captor. However, press coverage emphasized the pathology of the perpetrator, Elisabeth's father, and the heinous nature of her confinement in a basement, where she did not see sunlight for 24 years. The troubling questions that arose about this case did not resemble those expressed about Smart, Hornbeck, and Dugard.

The main question reverberating from the small Austrian town: How could a man keep his daughter locked in his basement for 24 years, where she gave birth to seven of his children while her mother and three of those children lived upstairs without an inkling of the horrors in the cellar?

Fritzl explained Elisabeth's disappearance by saying she had run away from home, a story backed up by letters he forced Elisabeth to write, including one that begged her parents not to look for her.

Other letters made it seem the missing daughter had left the three children on the parents' doorstep—when in fact they had been born in captivity in the family's basement.

Elisabeth told police that she and her three children Kerstin, 19; Stefan, 18; and Felix, 5, did not see the light of day during their entire time in captivity underneath the building in Amstetten, a rural town about 150 km (93 miles) west of Vienna.

Elisabeth is described as 'very disturbed' and having trouble talking to police about her ordeal, reports CNN correspondent Fred Pleitgen. She went missing in 1984, when she was 18 years old, police have said. (CNN. com, April 28, 2008)

Whereas Smart's, Hornbeck's, and Dugard's motivations, mental states, and desires were questioned in news media after their releases, the questions raised about Fritzl focused on the heinous motives of the perpetrator and the seeming impossibility of his crimes. The victim was never blamed and attention to the case swiftly faded.

Similarly, Beatrice Weston was rescued from a "house of horrors" in Philadelphia at the age of nineteen after being held in captivity for a decade. Again, the narrative fixated on the criminality of the perpetrator, the victim's aunt, who was a convicted killer when she was awarded custody of Beatrice after she was orphaned. Just as Dugard received compensation from the state of California because authorities failed to adequately monitor her captor during his parole and find her during the dozens of "inspections" that police made of his home, Weston also won compensation from the city of Philadelphia for placing her in the custody of her aunt. Yet, while Dugard was treated with suspicion, Weston was unequivocally exonerated for any wrongdoing or culpability in her captivity.

As the following chapter will examine in detail, not all long-term victims were treated equally; some "dungeon" victims were questioned for their motivations and failed escapes. Perhaps as problematically, women like Fritzl and Weston became spectacles of sensational media coverage that graphically described their bodies and experiences for the titillation of audiences.

The lieutenant said the girl's (Weston's) torture in the 'house of horrors' included signs of a spoon being heated and then burned into her skin. She had fractured bones that healed over incorrectly, and bones in her ankles showed the effects of being shot repeatedly with something like a pellet gun, he said. There are open wounds on her head, which she had covered with a hood when police found her. She had scars over her face, arms, and legs, he said. (*ABC News*, October 19, 2011)

Weston was allegedly beaten with a baseball bat, forced to consume her own urine, held in a tiny closet and prostituted in the 10 years she was in the custody of her aunt, Linda Ann Weston. The cruel conditions were discovered last October when four mentally-disabled adults were found in the dank, cramped basement of an apartment building where her aunt lived. (*Daily Mail*, August 21, 2012)

These details of torture and confinement may serve to exonerate the victims, yet they also objectify and exploit their suffering. In each of these cases, the perpetrators were family members who took elaborate measures to hide the victims. The relationships between victims and perpetrators contributed to the disbelief in reporting that family members could behave so cruelly, yet paradoxically, did not result in speculation that victims could have formed the same kind of emotional bonds with their captors as was presumed to be the case with Smart, Hornbeck, and Dugard. In much the same way that Ariel Castro locked Amanda Berry, Michelle Knight, and Gina DeJesus away, and Duncan hid Jaycee Dugard, Fritzl had also been hidden and bore her captor's children. Yet, Elisabeth's suffering and the conditions in which she was found released her from the accusations of culpability that were placed on Dugard. (See Chapter 5 for the complex discourses that developed after the Cleveland victims' escapes).

The coverage of returned children after long-term abduction has been dominated by the need to establish the innocence or culpability of individual victims. As we argue in the previous chapters, coverage of missing white girls and discourses about missing young boys have framed their ordeals as a national loss of innocence. However, framing children as potentially *complicit* in their captivity, or at the very least unwilling to run when they had the chance, calls into question cultural myths of sexual innocence, brings to bear fears of teenage sexuality,

and shifts the blame for this "national loss" of innocence squarely onto the young shoulders of child victims. As we explore in the following chapter, stories of child victims who "got away," who thwarted their abduction attempts or were able to escape captivity, offer a counternarrative to victim blaming. The trope of the courageous heroine or brave survivor, however, was not available to all children, but only to a select few who successfully exhibited characteristics of the "tough girl."

Chapter 5

The Ones Who Got Away

"Unlikely" Heroes and Brave Survivors

Forces of good, neighbors, police, even the victims themselves. Tonight, on the frontlines of evil, a look at the heroic men and women ... who defeated captors and turned tragedy into triumph. Tonight, on this special edition of *Nightline*, 'Breaking Free: The Escape in Cleveland.'
—(Terry Moran, *ABC News*, May 6, 2013)

On May 6, 2013, two neighbors living in the poor, working class community of West Cleveland, Ohio, heard screaming and pounding coming from a "boarded-up shoe box of a house" in the Tremont district (Gabriel, Kovaleski & Goode, *The New York Times*, May 8, 2013). Unknown to the two men at the time, the cries were coming from twenty-six-year-old Amanda Berry who, after a decade of captivity in that house at 2207 Seymour Avenue, had seen her opening. An interior door was left unlocked, and while her captor was out, Berry got to the screen door on the front porch, made a loud commotion, and screamed out for help. The two neighbors helped her kick in the door and lifted Berry and her six-year-old daughter through the small opening. Berry "appeared ragged—her clothes dirty, her teeth yellowed and her hair 'messy,'" but her identity didn't register with the men who helped free

her until they overheard her frantic 911 call: "Help me, I'm Amanda Berry ... I've been kidnapped, and I've been missing for 10 years. And I'm here. I'm free now" (Roig-Franzia, Markon & Lazo, *The Washington Post*, May 8, 2013, p. A15).

When police rushed to the scene, a startling discovery transformed the bizarre case into one of the most notorious crimes of the last decade: two more women, also missing for years, were found alive in the home. Michelle Knight, missing since August of 2002 at the age of eighteen, and Georgina DeJesus, missing since April of 2004 at the age of fourteen, were also freed that day. Berry had last been seen in 2003 after leaving her job at a Cleveland Burger King. Sixteen years old at the time, her disappearance was categorized as a runaway.

All three women were abducted separately as teenagers between 2002 and 2004 and held for approximately 10 years. The perpetrator was fifty-two-year-old Ariel Castro, a former school bus driver who had a record of multiple charges and arrests for assaulting his former wife, having broken her nose, ribs and arms and cracked her skull.

As news of the Cleveland kidnappings broke, and the horrific details of the case emerged, the story catapulted to the center of national and international news. The Cleveland kidnapping case dominated headlines over the Benghazi attack and the U.S. military sex abuse scandal. Press reports recounted an almost unbelievable "stranger-than-fiction ordeal" (Alcindor & Strauss, *USA Today*, May 8, 2013, p. 1A). Trapped for years in what came to be known as "a house of horrors," the girls-turned-women had been chained and locked in separate rooms, brutally raped, and beaten so severely that they sustained brain injuries.

The women endured multiple pregnancies and forced miscarriages while imprisoned: according to police and media reports, Michelle Knight "became pregnant at least five times during her captivity, and at each time Castro starved her for at least two weeks and punched her repeatedly in the stomach, forcing miscarriages" (*CNN Live Special Event*, May 12, 2013). Castro only allowed one pregnancy to reach full term. On December 25, 2006, Amanda Berry gave birth to her daughter in a small inflatable swimming pool. Castro ordered Michelle Knight to deliver the child, threatening to kill her if the baby did not survive.

As *Dateline's* opening narrative that leads this chapter demonstrates, the story of the Cleveland kidnappings and the women's eventual escape came to symbolize an allegorical tale of good vs. evil. In large part, that was because of its "made-for-Hollywood ending": the women made it out alive (Alcindor & Strauss, *USA Today*, May 8, 2013, p. 1A). While the neighbors and police were critical in the rescue effort, what made this story different from the recovery of victims like Elizabeth Smart and Jaycee Dugard was that it was ultimately Berry's heroic actions that led the dramatic escape. The freed women came to epitomize the "ultimate definition of survival and perseverance," and Amanda Berry was "hailed as the hero of the saga" (Roig-Franzia, Markon, & Lazo, *The Washington Post*, May 8, 2013).

This chapter explores the news narratives centered on the cases of "tough girls" and heroic survivors who were able to thwart kidnapping attempts or escape their abductors, in some cases after a few hours and in other cases after years of captivity. As the example of Amanda Berry's "daring" escape from a decade of captivity in Cleveland highlights, news stories focus on particular characteristics to label some girls as tough, brave and heroic, while other victims were considered "passive" and unable or unwilling to escape. The characteristic of toughness was often used to describe the women and girls who fought back against their abductor(s), attacked their abductor in any way, tried to escape or were able to successfully free themselves.

All abduction victims ought to be considered tough and heroic for enduring and surviving these horrific crimes, but the title of "hero" has been reserved for a select few. The uniquely American myth of the rugged individual has been deployed to exalt some young girls who demonstrated "masculine" toughness to free themselves, as opposed to those victims who were implicitly and sometimes explicitly blamed for "failing" to escape. In contrast to those abducted girls and women who were *rescued by* police and state authorities, news narratives become particularly riveted by these cases in which the young girl or in some cases young woman escaped *by her own volition and actions*, in particular if she used physical force to save herself. Narratives of strong, tough girls who outran, overpowered or outsmarted their male captors offer a counter-narrative to the "Damsel-in-Distress" cases in which girls were

rescued by police, neighbors, media publicity and/or Amber Alerts. The girls and women who engineered their own escapes were cast differently from the girls who are saved by others. These were victims who, as in the case of nine-year-old Calysta Cordova, "saved herself from every parent's worst nightmare" (*Good Morning America*, January 22, 2012). The novelty and newsworthiness of these rare escapes are reflected in CNN's reporting which described the improbable outcome: "The unlikely hero? The victim herself" (*World New Sunday*, January 21, 2012).

The image of the brave, tough "little" girl who cried out for help, attacked her abductor, or "ran when she had the chance," makes a compelling case which calls out for critical feminist analysis. This chapter analyzes the deferential treatment of the tough girl-victims whose heroic tales of bravery are situated as an instructive "lesson for all of us" (*Good Morning America*, October 29, 2013). Not only were these stories at the center of a media spectacle, but they offer a unique opportunity to unpack how the tough girl is constituted in our modern culture through the lens of crime coverage and journalistic storytelling.

Specifically, this chapter focuses on the cases of victims who successfully ran, fought and got away, in particular Erica Pratt, Tamara Brooks, Jacqueline Marris, Elizabeth Shoaf, Marissa Graham, Natascha Kampusch, Amanda Berry, Calysta Cordova, and a fourteen-year-old immigrant teen who remained anonymous in media coverage. These were not cases we actively selected or sought for analysis; our research search terms (in this case "escape" and "kidnapping" and/or "child abduction") indicated that these were the cases that attracted national, and at times international, media attention during the period of our analysis, 2002–2014.

Rather than discuss each escape individually, we position these narratives in conversation with one another to unpack three central arguments about toughness in girls and women. To begin, we first situate the stories of abduction escapes within the larger mediated "Girl Power" movement, in particular the emergence of tough girl figures and narratives in media and popular culture. Next, we discuss the ways in which toughness is largely constituted as a set of physical actions and behaviors, and alternately, how toughness is softened by discourses that both feminize and infantilize girl victims. Finally, we

conclude by exploring how girls' brave and heroic actions are framed as not only physical but as mental toughness, in some cases opening up spaces in media and popular culture for alternative victims' voices.

Tough Girls in the Media and Popular Culture

The trope of the strong, brave, heroic girl has to first be situated within the increased popularity of "tough girl" heroines and narratives that have permeated media and popular culture in the 1990s and 2000s through programs like *Xena: Warrior Princess, La Femme Nikita, The Powerpuff Girls, Buffy the Vampire Slayer*, and a host of other media products (Duvall, 2010; Hains, 2012; Inness, 2004; Mazzarella and Pecora, 2007; Wilkinson, 1984). A growing body of scholarship has analyzed the "tough girl" figures largely within the context of entertainment television series, popular film, and narratives surrounding female athletes. For example, Sherry Inness's work examines the once-absent but now increasingly prevalent tough girl images from the 1970s through the 1990s, including such texts as *Charlie's Angels*, Sigourney Weaver's leading role in *Aliens*, and the animated kick-boxing agents in the *Avengers*. This work has highlighted not only how toughness, as a gendered construct, is created in the culture, but also "what the challenging representation of tough women in recent years suggests" (Inness, 2004, p. 14).

Tough girl figures are an increasing "lucrative commodity" in the contemporary media marketplace, as pushing the boundaries of gender display can prove profitable (Inness, 2004, p. 7). The tough girl image draws from third wave feminism and is part of a larger "girl power" movement that characterized media and marketing in the 1990s and 2000s. These representations have proved popular in violent fantasy and science fiction media targeting adults and animated series targeting kids, from sexy women warriors to adorably rough-and-tumble female cartoon superheroes (Inness, 2004; Duvall, 2010).

While toughness as a concept is difficult to describe and universally define, it is best understood as a *performance* (Innes, 2004; Moscowitz, 2014). This performance is characteristically constructed as a

"masculine" one. Men are tough; women are not. That is to say, many of the characteristics of toughness—agency, bravery, courage, strength (both physical and mental fortitude), decisiveness, endurance, and power—are associated primarily with the masculine, not the feminine. As Rupert Wilkinson points out, toughness has historically been set in binary opposition to femininity: "By using femininity as a defining opposite, the tough-guy tradition puts pressure on women to be wholesome, sweet and ultimately submissive" (Wilkinson, 1984).

The ways in which toughness is constituted in our culture is tied to hegemonic power relations and white male patriarchy. Because toughness is inherently masculine, not feminine, these representations work to "ensure male privilege and authority" (Inness, 2004, p. 17). "The connection to men and toughness assures that men, not women, will be the only 'real' heroes in a culture where toughness is frequently associated with power and typically only men are allowed to display it" (Inness, 2004, p. 15). The lack of female toughness keeps girls and women "from the mechanisms of power" (Inness, 2004, p. 18).

This is not to argue that women and girls can't be tough, of course. Toughness in girls and women can openly challenge and subvert codes of gender and cultural constructions of what it means to be a girl (Inness, 2004). After all, toughness incorporates not only physical endurance and force but also intellectual and moral strength. However, toughness in girls is often positioned paradoxically: Tough women must adhere to traditional modes of femininity and sexual stereotypes, attributes that work to mitigate the threat of and "diminish the impact of women's toughness" (Inness, 2004, p. 49). In other words, girls and women who are tough have to look like a girl but adopt behaviors that are coded as masculine.

Tough girl representations in the media, then, whether vampire slayer Buffy or secret agent Nikita, combine "traditional and even exaggerated representations of femininity with the physical and verbal assertion usually reserved for male heroes" (Brookfield, 2013, p. 317). Not surprisingly, these tough girls are more often than not anchored to dominant classist and racist notions of femininity: the heroines are almost always white, slender, fit, young, and conventionally beautiful,

"an image that serves to only empower women who fit this narrow vision of femininity" (Ono, 2000, pp. 163–64).

Inness argues that toughness is communicated through four main modes: body, attitude, action and authority (2004, p. 24). Women who are tough are typically muscled and have a "hard" physique, dress the part, show little fear themselves, inspire fear in others, are strong, command respect, are competent and controlled, show little emotion, are intelligent, and demonstrate authoritative leadership, especially under pressure. But their toughness is often contained and constrained by discourses that sexualize and feminize the characters: they are either hypersexed warriors or hard-bodied heroines who remain "soft on the inside." In other cases, women who perform tough acts to protect their children and families (the "mama bear" trope) are considered normal and natural, as this display of toughness doesn't trouble traditional gender roles (Inness, 2004, p. 20).

In the context of crime news, the trope of toughness is particularly ripe for analysis because toughness represents the antithesis of passivity and weakness. Toughness can also be considered a response to victimization (Moscowitz, 2014). Crime victims who survive horrific crimes constitute toughness as they "endure tremendous physical and emotional suffering and emerge the victor" (Inness, 2004, p. 13). However, girls grow up in a culture having "learned that toughness has little to do with them; they should be the ones being rescued, not the ones doing the rescuing" (2004, p. 7). Girls who therefore thwart or escape abduction hold the promise of rewriting the "Damsels-in-Distress" narratives that prevailed in the 2000s, and offer feminist media scholars an opportunity to understand how toughness is framed in the context of crime and gender.

Toughness, of course, also has a "dark side" and can be understood as violent, aggressive and even barbaric (Moscowitz, 2014; Inness, 2004). Toughness is defined not only as brave and strong but also as stubborn and unyielding, incorrigible, hostile, antagonistic, "unruly, rambunctious, disorderly," and proactively violent (Moscowitz, 2014, p. 7). This incarnation of toughness in women and girls reverberates in larger popular concerns about and renewed scholarly attention on

so-called "aggression" in girls: "violent" gangster girls or suburban "mean" girls. The "girl in crisis" (Mazzarella & Pecora, 2007) and "wild girl" (Currie, Kelly & Pomerantz, 2009) representations are a part of alarmist, media-fueled panics about bad girls who need saving from their own poor judgments and violent tendencies. Bad girls are often defined along lines of race and class, "coded as working class and racialized" as black or Latino (p. 15). These media discourses breed anxieties over "what to do" about girls' violence while "also fueling public unease about modern girlhood" (Chesney-Lind, 2010, p. 1).

As previously cited, much of the work on tough girls has highlighted how toughness is undercut or softened by an emphasis on the feminine. The tough acts of the women and girls who escaped were tempered by stereotypical femme descriptions emphasizing "cuteness" or "adorableness." In the following section, we demonstrate how toughness in girls is almost exclusively and narrowly constituted as physical force.

Fight or Flight

When seven-year-old Erica Pratt "miraculously escaped" her captors in July 2002 by gnawing though duct tape, punching out a window, and kicking out the panel of a basement door, she was lauded as a "role model for kids everywhere" (Hoffmann, *The New York Post*, July 26, 2002). In Pratt's coverage, and in other media stories of escape cases across this decade of analysis, patterns emerged in how news narratives made clear differentiations between the girls and women who used physical force to break free from their captors as opposed to those who took an opportunity to run or sought out help to escape. Repeatedly emphasized in news coverage, "the how" victims escaped mattered, with a distinct focus on describing victims' bodily restraints (chains, ropes, duct tape) and whether or not they had to rely on their own aggressive physicality to free themselves by kicking, punching, biting, tearing, cutting, attacking, or running.

These cases of physical toughness not only garnered more dramatic news coverage, but the heroics were heralded as superior to those who, for example, whispered to a clerk behind the counter, snuck away when

the abductor wasn't watching, or used social media to reach out to a family member who helped them escape. In some cases, these narratives created a problematic hierarchy of victim newsworthiness, so that the cases in which victims used physical force, adhering to a more culturally constructed "masculine" understanding of "toughness," were given the most dramatic play. Victims who were not physically restrained were inadvertently "less tough," and at times marked as complicit in their captivity. The implication in these media narratives was clear: these were girls who "could have escaped" since their bondage was psychological, not physical.

Media storytellers relied on language and labeling to brand the physically forced escapes as "daring," "harrowing," or "dramatic." While all escaped victims were considered brave and courageous, journalists emphasized individual agency by distinguishing those victims who "saved themselves" from those who "allowed themselves to be saved." An important point here across these cases is that few victims were actually "children" at the time of their escape. This makes sense as it is rare and nearly impossible for a child to be able to break free from bodily restraints—duct tape, chains and ropes, for example—and physically overcome an adult male perpetrator. Many of the escape cases that garnered widespread media attention were adult women by the time of their escape, as in the case of the Cleveland kidnappings, having been abducted as children or in their early teens and held for years or even a decade.

There were, in fact, only a few cases in our period of analysis in which a child victim used physical force to break free from her abductor. Because these cases were novel, they tended to attract widespread attention and become fodder for morning news programs as instructive "lessons for us all" (*Good Morning America*, October 29, 2013).

One of the most dramatic getaway stories of this decade was the previously mentioned "remarkable escape" of seven-year-old Erica Pratt, an African American girl from a working class suburb of Philadelphia, in July 2002. As her heroic escape was recounted across media, albeit for a brief news cycle, she was named *Time's* "Person of the Week," "as a reminder that not all abductions end in tears" (Coatney, *Time*, July 26, 2002). As Philadelphia's police inspector

William Colarulo said of Pratt, "I have twenty-one years in the Police Department, and I have never seen this kind of heroic act of bravery committed by a seven-year-old" (Fazlollah, Achrati & Soteropoulos, *Contra Costa Times*, July 25, 2002).

Significant to a primary argument in this book, it is important to note that Erica Pratt's initial disappearance received no national media coverage prior to her "harrowing" escape. Because Pratt was a young African American girl from a "rough part" of Southwest Philadelphia, her case failed to garner the national media attention of victims from largely white, middle- to upper-class neighborhoods like those of Elizabeth Smart, Danielle van Dam and Samantha Runnion (Liebler, 2002). Pratt's initial disappearance only made headlines in local and regional media such as the *Philadelphia Examiner*; however, following her escape, she quickly became the subject of national newspaper reporting and morning news programs as a "remarkable little lady" (Jones, *New York Times*, July 25, 2002) and a "very tough little girl" (*American Morning with Paula Zahn*, CNN, July 24, 2002).

CNN's coverage recounted Pratt's heroic escape, describing the conditions of her abduction as well as the physical barricades she had to break through:

> She was dragged off the street by two males. We found out last night that as soon as they abducted her, they wrapped duct tape around her eyes and her head so she couldn't identify her kidnappers ... They then duct taped her ankles together, they duct taped her hands together. She was left in a cellar. She was there practically 24 hours without anyone at—in this house. She was able to chew through the duct tape to free her hands, then she managed to climb out of the cellar in total darkness. She was able to kick a panel out of a door, get through that door and then break a window with her bare hands. (*The Early Show*, July 24, 2002)

Similarly, coverage the following day in the *New York Times* emphasized not only Pratt's dire conditions, but also her fortitude:

> There was a dirty mattress. A small container of juice. A bag of potato chips. And a bucket that the men who kidnapped 7-year-old Erica Pratt told her she should consider a toilet. But Erica's abductors left her with something besides

meager provisions: her irrepressible will and determination. (Jones, *New York Times*, July 25, 2002)

Likewise, note how CNN's coverage emphasizes active, physical verbs to describe Pratt's escape:

Lieutenant Michael Chitwood (Inspector, Philadelphia Police Department): She gnawed her way out of the duct tape to free herself, and then to work her way up the stairs and have the fortitude to—to kick the panel of the door out and then work her way over to the window. I mean, she's an amazing little girl; strong will to live.
Bill Hemmer (Anchor, in response): Wow! That is amazing. (*American Morning with Paula Zahn*, CNN, July 24, 2002)

Following her break, two boys who had been playing outside the house heard her cries and led a pair of police officers to her. Important in the reporting is how Pratt's story was recounted not as a "rescue" or an "assisted escape" but by emphasizing her "rugged individualism," that she had saved *herself*. An officer in the case was quoted in the *New York Times* saying, "Erica did all the work. She deserves all the praise. She freed herself," (Jones, *New York Times*, July 25, 2002).

In Pratt's escape, socio-economic class was used to explain her toughness as a stereotypically "working-class" trait inherent to living and surviving crime and poverty in "the ghetto." The same class status that arguably *prevented* Erica's disappearance from reaching national news audiences was now used to emphasize her roughness and hardiness. Pratt's neighborhood was described as "a poor working-class, predominantly African American community plagued by drug violence and crime" (Moore, *The Philadelphia Inquirer*, July 25, 2002).

One local report went as far as to suggest that such crimes should be expected in a neighborhood like Pratt's. As *The Philadelphia Inquirer* reported, "No one could say that Erica's abduction was something out of keeping in a neighborhood like Erica's ... Unlike recent kidnapping cases in Utah and California, this crime suits its surroundings" (Moore, *The Philadelphia Inquirer*, July 25, 2002). However, neighbors who were interviewed for the story reported that no kidnapping crimes such as this one had ever occurred in their neighborhood.

Furthermore, news narratives emphasized that Pratt's abduction was a ransom kidnapping, arguing "the motive was definitely money," (*The New York Post*, July 26, 2002). Reportedly, Pratt was abducted after news spread that the family had received $150,000 from a life insurance policy after another family member had been gunned down earlier that year. Within the first few hours of the abduction, Pratt's grandmother received several phone calls asking for that sum of money in exchange for Erica's return. Highlighting the crime and poverty in Pratt's neighborhood, the nature of the kidnapping for ransom, and the "gunned down" murder of her cousin, all worked to mark Pratt's class status. In these cases, toughness becomes classed in stereotypically problematic ways, reinforce white, middle- and upper-class fears about inner-city black crime and poor white neighborhoods. "Tough girls," while lauded for their heroic actions, become constituted as the binary opposite of stereotypically "delicate," "little," white, upper-class girlhood.

Another successful escape attracted media attention a few days later, this case in California. On July 31, 2002, a violent escape attempt by two teenage girls was followed by a life-saving rescue by police. Two teenage girls, Tamara Brooks, sixteen, and Jacqueline Marris, seventeen, were abducted from a lover's lane overlooking the Mojave Desert in Quartz Hill, California. The girls were abducted by a thirty-seven-year-old ex-con and eventually rescued after a barrage of broadcast media stories and Amber Alert messages publicized the faces of the victims, the abductor, and the license plate across local and national media. While the teens were "rescued" by police, who shot their captor dead, their harrowing battle story was central to media coverage (*The Washington Post*, August 6, 2002).

The teens' dramatic and violent attempt to escape captured the national media spotlight. After having been held prisoner for 12 hours, one girl grabbed a hunting knife from inside the vehicle and stabbed her abductor in the throat while the other smashed a bottle on his head. They managed to lock him out of the car, and although he was hurt and bleeding badly, he pulled a gun on them and started a countdown to their death. But drivers and viewers who had seen the Amber Alerts had tipped off police, who surrounded the suspect and shot him dead (Stepp, *The Washington Post*, August 6, 2002; Carter, *The New York Times*,

August 6, 2002). While the girls were acknowledged for their heroics, the media enjoyed taking partial credit for this rescue; media coverage stressed that were it not for the "new symbiosis" between police and the news media, the girls would have been killed within ten minutes of the shootout (Murr, *Newsweek*, July 29, 2002).

The differential treatment between Pratt's heroic coverage and that of Brooks and Marris caused controversy since both escape-rescues occurred the same week and shared the same news cycle. The conundrum for journalists came shortly after the Brooks and Marris escape-rescue when police reports confirmed tragically that the girls had been raped while in captivity (*The New York Times*, August 11, 2002). Brooks and Marris had initially been identified after their disappearance, but once it was revealed they were rape victims, the major news organizations withheld their names in the coverage. "Protecting" the girls' confidentiality is in keeping with the standard journalistic practice of not identifying rape victims. However, as an editorial in *Salon* magazine pointed out, the erasure of the girls' identity inadvertently worked to reinforce the shame and stigma of rape. "In effect, the girls disappeared twice—once when abducted, and again when the media erased them" (Magowan, *Salon*, August 9, 2002). While Pratt was rightly celebrated as a brave hero, Brooks and Marris vanished from sight:

> The lopsided coverage was especially disorienting because early in the story, the girls' [Brooks and Marris's] identities were broadcast everywhere— constantly—as a means of saving their lives. And it worked. But once the teens went from being kidnapped youths to rescued rape survivors, their status changed. They were branded with the Scarlet R. They had been raped. It was suddenly better for them, and us, to contemplate this shame without fanfare. (Magowan, *Salon*, August 9, 2002)

The controversy came to an end after the girls agreed to a public television appearance with Katie Couric to share their story. Nevertheless, as we revisit in the book's concluding chapter, reporting on child and teen victims of sexual assault has significant repercussions for journalism ethics.

Physical force was also credited in the dramatic escape of ten-year-old Marissa Graham in 2007, who kicked her way out of the trunk of a

car at a gas station 200 miles from her home. She was riding her bike to a friend's house when she was grabbed, tied up, her face covered, and thrown in the trunk of a car. She was then driven all the way to Clovis, New Mexico, from Texhoma, Oklahoma, approximately a 200-mile trek. Note the ways in which news narratives fixated on the physicality of her escape, which she reportedly accomplished with her hands tied:

> When the kidnapper stopped for gas, Marissa, who takes martial arts classes, kicked her way out of the trunk. She then walked into the store and calmly told the clerk that she had just escaped. (*Good Morning America*, January 22, 2007)

> She "kicked her way out of an abductor's vehicle" and "used her foot to trigger a latch on the purple vehicle door, ran into the store and told a clerk to call Texhoma police." (Previch, *The Oklahoman*, January 21, 2007)

> She "kicks out vehicle's window at a store" then "bolted from the vehicle." (Previch & Jackson, *The Oklahoman*, January 20, 2007)

Again employing the frame of rugged individualism, media narratives emphasized that Marissa was credited with saving her own life when she kicked her way out of the car and ran into the store, where she "calmly told the clerk she had just escaped" (*Good Morning America*, January 22, 2007). Marissa's father was later quoted in news narratives emphasizing active, physical verbs to describe his daughter:

> Mr. Chris Graham (Father): She'd kick and scream and bite and fist and everything she's got before she'd give up. (*Good Morning America*, January 22, 2007)

These qualities differentiated Marissa and other "fighters" from those who failed to escape, qualities that made the difference between life and death:

> Marissa's instincts were right on, some observers say. Putting up a fight can call attention to an abduction, and that can make the difference between getting away and getting killed. (*Good Morning America*, January 22, 2007)

In the aftermath of the escape, details emerged in a press conference—one that was not reported by the media—that altered the initial account of the ten-year-old's escape. Police later revealed that the kidnapper may have opened the trunk latch and released Marissa.

When the suspect drove to an Allsup's convenience store in Clovis, Ward said the man activated the automatic latch for the vehicle's rear door and let the girl out of the vehicle. The girl then walked into the store and notified store employees, who called police. (Clovis County press release, January 23, 2007)

Graham's brave actions to escape her abductor are laudable and should not be discounted. However, this unreported alternate ending to the story demonstrates how these narratives of toughness are shaped and constructed by reporters. News coverage slotted Graham into the "fighter" character even as new details of the case emerged.

As this chapter demonstrates, the girls and women who form the center of these heroic escape tales are described by news reporters as courageous, determined, strong, brave, resilient, and "fighters." Importantly, however, news media relied upon specific labels and descriptions to define these tough survivors as—still—"little girls." Consistent with the literature on gender and toughness, in these escape tales, the girls who got away were portrayed as exhibiting masculine bravery within a "softer" feminine realm.

"Spunky" Little Girls: Toughness Has a Softer Side

In each of these escape cases reported by national news organizations, the girls performed brave, even violent acts culturally constructed as "masculine," such as kicking, punching and even stabbing. However, they were nonetheless cast as feminine through the use of gendered language and by relying on physical descriptions of their clothing, appearance, personality and demeanor. In other cases, the revelation of sexual assault reinforced their helplessness until an eventual "rescue" saved them.

The masculine nature of how toughness is traditionally constituted in the culture was reinforced in news stories like in the case of Calysta Cordova, a nine-year-old "young lady who saved herself from every parent's worst nightmare" (*Good Morning America*, January 22, 2012) when she broke free from her abductor in a convenience store and told the clerk she had been kidnapped. Cordova was taken by Jose Garcia while she walking home from school in Colorado Springs in January

2012. She traveled captive in Garcia's truck for 18 hours until he got a flat tire and crashed the vehicle. The two hitchhiked to a Circle K convenience store. Cordova marched ahead of him into the store and asked the clerk for the phone, saying she had to call her uncle. Instead, she dialed 911. Garcia then attempted to get her out of the store, but according to the clerk, who was interviewed for *ABC News*,

> Efrin Villapando, witness: She looked at me point in my eyes and just said, 'I ain't going nowhere, I'm waiting right here for my momma.' I looked at the guy. He looked at me, into my eyes, spun around and just high-tailed it out of there. (*Nightline*, January 26, 2012)

Police found and arrested Garcia a few hours later at a bus stop a few miles from the Circle K.

The story of Cordova's escape was mostly confined to regional news, but it did run on a few "soft news" morning shows like *Good Morning America*. Cordova was dubbed "the hero in this investigation" by FBI special agent Michael Rankin, saying, "She did a nice job to preserve her own life" (Bonham, *The Pueblo Chieftain*, January 20, 2012). When Cordova was interviewed on *Good Morning America* she told ABC's Clayton Sandell the origins of her toughness:

> Calysta Cordova, escaped from her kidnapper: I got my fight from my daddy.
> Clayton Sandell, reporter, *ABC News*: Fight from daddy, huh? What did he teach you?
> Calysta Cordova: How to stand up for myself. (*Good Morning America*, January 22, 2012)

While Cordova was credited for "taking charge of her own fate," after a "harrowing 18-hour ordeal," for her "quick thinking" and "courage to speak up" (Coffman, *Alamogordo Daily News*, January 21, 2012), the juxtaposition of her physical descriptions and the insistence that she was just like any other little girl her age worked to soften the strength and power shown through her tough actions. She was described as "4-foot 10-inch girl" who after the ordeal was waiting to "play with all the stuffed animals and open the gifts that keep getting dropped off, including a blanket with a picture of her favorite singer"—Justin Bieber (Coffman, *Alamogordo Daily News*, January 21, 2012). As ABC's Dan

Harris concludes the excusive interview, Cordova met the characteristics of both toughness and femininity: "She is resilient *and* adorable. Great story" (*Good Morning America*, January 22, 2012).

Similarly, the narratives surrounding Erica Pratt's dramatic escape situated her firmly in the realm of girlhood with gendered language and physical descriptions. Despite Pratt's heroics, media descriptions of her emphasized the socially accepted gendered behaviors, mannerisms and dress of girlhood. She was described as "petite," clad in pink; when approached by reporters, readers were told Erica "buried her face in a stuffed animal" (Ewers, *U.S. News & World Report*, 2002). The Associated Press story ran a story about the case in print publications across the country headlined as, "Spunky girl saved herself" (Gillin, Porter & Gibbons, *San Jose Mercury News*, July 25, 2002). She was almost exclusively described as "brave *little* Erica Pratt" (emphasis added) (Previch & Jackson, *The Oklahoman*, January 20, 2007), an "an amazing little girl," (Hutchinson, *New York Daily News*, July 24, 2002), a "pixyish youngster" (Hoffman, *The New York Post*, July 26, 2002), a "plucky 7-year-old" (Hoffman, *The New York Post*, July 26, 2002), and at one point, a "prankster" (Panaritis, Soteropoulos & Porter, *The Philadelphia Inquirer*, January 24, 2002). Her powerful aggressive escape feels watered down when Pratt is described as "the girl with short ponytails and a radiant smile" who was "savvy and spunky" enough to defeat her abductors (Panaritis, Soteropoulos & Porter, *The Philadelphia Inquirer*, January 24, 2002). This use of these labels and descriptions is clearly gendered; journalists did not refer to male crime victims who survived abduction and assault as "savvy," "spunky," or "pixyish."

News texts also relied on physical descriptions to paint a picture of the "3-foot-5 and 30 pound" girl with "pretty, brown, big old eyes" (Gillin, Porter & Gibbons, *San Jose Mercury News*, July 25, 2002). As a regional newspaper described the crime, "her big brown eyes were covered with duct tape wound round and round her head" (Gillin, Porter & Gibbons, *San Jose Mercury News*, July 25, 2002). Her hairstyle and clothing, seemingly irrelevant to the story of her abduction and escape, were emphasized in descriptions of "the pigtailed girl," "the second grader with ponytails and an easy smile" (Jones, *The New York Times*, July 25, 2002), and the "pig-tailed imp" who "managed to foil

[her captors'] plan" (*The Baltimore Sun*, July 29, 2002). The *Washington Post* described her feminine dress upon her return to her family: She was "dressed in a pink shirt and flowered shorts, held a black-and-white stuffed animal and kept her head buried in the shoulder of an uncle, Derrick Pratt" (Goldberg, *Washington Post*, July 25, 2002). Quoting a family friend, Erica was described in the *Post* just like "any other girl," adhering to the standards of conventional femininity: she spent the day after her recovery "getting her hair done and playing on the computer—just being Erica" (Goldberg, *Washington Post*, July 25, 2002).

Similarly, the survivors of the Cleveland kidnappings were lauded for their "amazing resilience and gratitude in the face of unimaginable horror" (*New Day*, CNN, July 9, 2013). Amanda Berry, considered the only true "hero" of the escape, was sixteen at the time of her abduction, and press accounts emphasized her "normal" teen girlhood: "By all accounts, she (Berry) was a typical teenage girl—who wore her hair in a ponytail, had mild acne, liked to shop and loved rapper Eminem" (Roig-Franzia, Markon, & Lazo, *The Washington Post*, May 8, 2013). However, Berry's *initial* disappearance did not make national headlines; it was only when she became a heroine during her daring escape that the media gaze turned toward her. Journalistic norms dictate that media ignore cases are treated as runaways and instead focus intense attention on the stereotypical "stranger danger" cases.

Physical Chains and Psychological Bondage: Breaking Free from the Shackles

When Amanda Berry escaped from her "House of Horrors" by screaming through a crack in the door, pounding on the door she'd been locked behind, and kicking it down with the help of neighbors, she was credited not only with saving herself, but the three others held captive in the house with her: Berry's daughter, six; Michelle Knight, twenty-six; and Gina DeJesus, twenty-four. As Amanda Berry's grandmother told CNN, "I'm just glad Amanda was strong enough to come to that door and come on out" (*CNN Live Event*, May 12, 2013). The three young women, and Amanda Berry in particular, became heroines

overnight. As Diane Sawyer told evening news audiences on May 8, 2013, "Tonight we begin with three women who are changing our idea of human strength and endurance. We are learning the searing details of what they endured in that Cleveland house for ten years" (*World News Tonight*, May 8, 2013).

Central to the hero story in the media reporting of the Cleveland case was the repeated emphasis on the physical restraints and abuses the women endured. These details served two key purposes: ensuring that the victims were "blameless" against accusations that they "could have" escaped and further fueling the media spectacle around this dramatic mega-media event. Their actual physical bondage was emphasized in a number of ways—by describing the chains and locks that held them captive in the house, by emphasizing their isolation inside the home, and by repeating journalists' and police emphatic claims that the women had not been able to leave the home in ten years.

Those "searing details" that led the evening broadcasts fueled continuous media coverage fixating on "a disturbing tale of sexual assault, physical abuse, bondage and other horrors" (Alcindor & Strauss, *USA Today*, May 8, 2013), with a particular emphasis on their physical confinement. Viewers were told the women were "locked up in separate holding spaces. First the basement, then upstairs, not together in the same room, but each knew of the other women in the house. Chains and locks have been recovered from the home" (CNN, May 12, 2013). CNN coverage confirmed that, "Police say they were tied up. They were beaten severely. Police found chains and restraints throughout the house. Based on the original police complaint, 10 years of brutality, 10 years of confinement" (*CNN Live Event*, May 12, 2013).

Likewise, *USA Today* relied on police reports to paint a "chilling portrait" of the conditions of the house: "All three were chained up in the basement, but Castro eventually freed them to live on the second floor ... Victims were held in chains at least part of the time" (Alcindor & Strauss, *USA Today*, May 8, 2013). Media reports focused on the gruesome physical evidence of abuse that marked the women, from bruises on their bodies to the brain damage suffered as a result of continuous severe beatings. The women were "beaten while pregnant, with unborn

children not surviving," living in "a dungeon of sorts with chains in the home" (Alcindor & Strauss, *USA Today*, May 8, 2013).

Anderson Cooper's exclusive interview with Amanda Berry a year after the women were freed emphasizes the gruesome physical constraints and torture the women faced, reinforcing for viewers that the women *could not have fled* prior to that morning in May. Preemptively answering the charge that the women could have escaped at some point in that decade captivity, Cooper described the futility of their cries for help. Berry, twenty-seven at the time of the interview, said she would scream but "no one would hear you." As Cooper recounts in horrific detail:

> She was chained to a pole gagged with a sock and a motorcycle helmet placed over her head. Eventually he moved her upstairs where she was kept naked and often chained to a wall in a boarded up bedroom. She only had about a foot and a half of chain, just enough for her to stand up and use a bucket for a toilet. (*CNN Newsroom*, May 6, 2014)

The women's almost unfathomable isolation for a decade in the boarded-up home was important to the media narrative, reinforcing for news audiences that the women were not allowed outside, going out only twice in 10 years, according to police and experts. Reports emphasized that the women were "tied up in the house when they were found," (Roig-Franzia, Markon & Lazo, *The Washington Post*, May 8, 2013), and that "the women never left the house except for two brief visits to the adjacent garage" (Gabriel et al., *The New York Times*, May 9, 2013).

This seclusion inside the home was stressed repeatedly in media reports, time and again, becoming one of the most reported facts that reverberated across news texts:

> In the 10 years, they walked out of that home only twice, only to be taken into the garage, their captor would disguise them, never did they leave the property. (*World News Tonight with Diane Sawyer*, May 9, 2013)

> The women were "kept in the basement like dogs." (Gabriel et al., *The New York Times*, May 9, 2013)

> They had no ability to leave the home or interact with anyone other than each other, the child, and the suspect. (Gabriel et al., *The New York Times*, May 9, 2013)

This was "their first opportunity to escape." (*World News Tonight with Diane Sawyer*, May 9, 2013)

The message was clear, perhaps best summarized by CNN's Anderson Cooper: "The only opportunity to escape was the other day when Amanda escaped" (*CNN Newsroom*, May 6, 2014).

The repeated focus on the women's *physical* confinement also demonstrates its importance to the narrative. The women were only heroes—particularly in the case of Amanda Berry—because there was no possible way they could have escaped before. Their previous failed attempts also became critical to the story because they emphasized the futility of the women's escape.

Officials say Castro would trick the women, pretending to leave only to beat them if there was any sign they tried to escape. (*CNN Live Event*, May 12, 2013)

Unfortunately, despite the overwhelming emphasis on their confinement, several media reports still used descriptions of their physical restraint to then transition to "troubling questions" about why they hadn't fled earlier. This pattern, inherent in the journalistic "why," is consistent with the journalistic practice of victim blaming analyzed in Chapter 4:

Prosecutors say Castro beat and sexually assaulted the three women and restrained them with ropes and chains. But they say the women weren't always tied up. So many people are wondering why they didn't try to escape earlier. (*CNN Newsroom*, May 9, 2013)

As previously argued, Amanda Berry was marked as the true "hero" for having engineered her escape, broken through the interior door and yelled for neighbors to assist her in breaking the exterior door and pulling her and her daughter free. Similar to other long-term abduction victims, journalists and "experts" began to speculate about the role of the other women in the house. In the exchange below, CNN's Wolf Blitzer insinuates that since the other two women remained in the house when Berry fled, Knight and DeJesus were not "hero" enough.

Wolf Blitzer, CNN Anchor: On Monday, as you know, Amanda Berry took the lead on the escape. Why does that tell you—what does that tell you

> about the mindset of her and the fact that the other two women were apparently too afraid to follow her and to try to escape that day? (*CNN Newsroom*, May 9, 2013)

Swanson, in his response, not only validates his questioning but uses a quality of toughness that is gendered as uniquely feminine and considered "natural" for women (Inness, 2004): Berry ran to save her daughter. It was "only the love of a mother" that defined her source of strength, motivating Berry to make the move while the others refused to leave.

> David Swanson, Licensed clinical psychologist: You know, Wolf, that's a great question. And she is truly a hero. You and I both have kids. And I think, in my heart, I truly believe that what happened is this child gave her a new resolve. It renewed her hope. And one thing for sure, she was not going to let her child die in a house like this. And I think that's why you saw her make that attempt, to save her child. (*CNN Newsroom*, May 9, 2013)

Despite these speculations, fewer questions remain implicit in the journalistic "why" if the media reports emphasized the physical confinement of the victims, chained, locked up and physically unable to leave. However, if their captivity is described as psychological, with the supposed "physical freedom" to leave, victims are put on the defensive. It was only when the actual voices of victims emerged in media reports—often years later—that a recognition of the psychological chains provided a counter-frame to the journalistic speculation and victim blaming that predominates in media discourses.

Not (Quite) Tough Enough: Reaching Out to Get Out

In comparison to the cases in which the victim used physical force to escape her abductor, far more buried underneath the media radar, there were a few cases during this time period of girls who escaped after days or even years of captivity by reaching out to family members, typically utilizing digital technologies, cell phones and/or social media. These technologically assisted escapes received far less media coverage, often being discussed as a part of a news story involving

other more "dramatic" escapes. While these girls and women were heralded for their bravery, survivor skills and smart decision making, they were not labeled as "heroes" in the same way the physically restrained victims who escaped were, and these victims were more likely to be marked as complicit in their captivity.

The first technology-assisted escape of this period was engineered by Elizabeth Shoaf, age fourteen, who was abducted from her school bus stop in Lugoff, South Carolina, on September 6, 2006. Her abductor, Vinson Filyaw, had posed as a law enforcement officer and led her into nearby woods to a hand-dug, 15-foot bunker located near his trailer home. There he restrained her and raped her several times daily. Shoaf was afraid to leave because Filyaw repeatedly told her that the bunker was booby-trapped with explosives and that they would detonate and kill her if she tried to leave. Despite multiple pleas from family and community members, the sheriff refused to issue an Amber Alert in this case, and there was little news coverage until nine days into Shoaf's disappearance. That was when Shoaf waited until Filyaw fell asleep and managed to get his phone and sent a text message to her mother that simply read, "Hey mom, it's Lizzie" (*NBC News*, March 7, 2008). Shoaf described where she was, what road she had traveled down, that she was "in a hole," and to "get the police."

The case had initially received little press attention, but after her escape NBC's *Dateline* produced and aired a special report entitled "Into the Woods" detailing the saga (*Dateline*, March 7, 2008). But the program problematically framed her abduction, torture, rape and escape as an allegorical "mythical fairy tale," with Shoaf the "little red riding hood" and Filyaw "the big bad wolf." As the story recounts, Elizabeth began playing mind games with Filyaw to "trick" him into trusting her, to see her as a person, not a captive. The troublesome *Dateline* narrative paints an almost Lolita-like cat-and-mouse game:

> And then, in her desperation, she began to play with an insane idea. A sort of reverse psychology. What if she pretended she was falling for him? And before long, he began to act like he was sweet on her. A little. He unchained her … And she became to behave like a child in some dark fairy tale. (*Dateline*, March 7, 2008)

The mediated narrative then continues the story in this way: Filyaw awoke to find her playing with his phone, but because he allegedly trusted her, she convinced him she had only been using it to play games. However, when Filyaw heard helicopters circling above the bunker, he turned on the TV and discovered two things: that police knew he had Elizabeth, and as the text message was pictured in the coverage, that Elizabeth had "betrayed him." Frightened, he turned to her for advice, and she told him to run:

> Fourteen years old, traumatized beyond comprehension, she offered instruction to the tormentor suddenly now in power. (*Dateline*, March 7, 2008)

Filyaw ran and Shoaf was able to call out for help until authorities found her at the mouth of the bunker. In Elizabeth's barely told story, she is lauded as the girl who saved her own life:

> When Elizabeth lived through that tale as grim as any ancient myth, no woodsman snatched her from the jaws of the big bad wolf. Elizabeth Shoaf looked terror in the face and saved herself. (*Dateline*, March 7, 2008)

While Shoaf emerges as the brave heroine, the same news special goes on to include salacious details of her time in captivity. The sensationalistic, made-for-TV-movie-style treatment becomes almost entirely about the perpetrator and the publicity surrounding him. Elizabeth is problematically sexualized in the narrative, which refers to the fourteen-year-old as a "sought-after virgin" with descriptions of her "inseparable" relationship with "a boy she'd just started to date before it all happened" (*Dateline*, March 7, 2008). As Sherry Inness's (2004) work shows, tough girl figures have historically been marginalized to fantasy, science fiction, and/or alternate realities, perpetuating the myth that "real girls" cannot be tough in "real life." Girl toughness is treated as improbable and only occurring in fantasy worlds. This mythical, allegorical treatment of Elizabeth's story by mainstream news media demonstrates the ways in which journalists relied on fantasy language to explain girl toughness that seemed unfathomable in real life.

Figure 5.1. Getty Images: Several Austrian newspapers (Natascha K. case).
Several Austrian newspapers including, the 'Salzburger Nachrichten', carry frontpages of Natascha Kampusch one day after her first interview in Salzburg September 7, 2006. Natascha, an Austrian teenager held captive in a basement dungeon for eight years by Wolfgang Priklopil, gained worldwide media attention when she escaped from her captor on August 23, 2006. Coverage of "dungeon cases" like Kampusch highlight the limitations of the tough girl narratives by implicitly and explicitly casting blame on the victim for failing to "save herself" sooner.
(Josch/AFP/Getty Images)

A similarly problematic treatment was in the case of Natascha Kampusch, a young girl from Vienna who was held captive in a cellar for 8 years. This story received less coverage in the U.S. but attracted a great deal of attention in the European press. Kampusch escaped her captor after she saw an opportunity to run while he was vacuuming his car:

> She was just 10 years old in 1998 when her kidnapping sparked the biggest manhunt in Austria's history. Wolfgang Priklopil, then a 36-year-old technician, was questioned and released. In fact, he had taken Natascha just a few miles to this unremarkable looking house, but underneath the garage at number 60 Heinestrasse, [was] a 10-by-six feet windowless room that was to

become Natascha 's nightmare, its door padded to conceal her cries from the street. (Hall, *Daily Express*, February 28, 2013)

What she denies until this day are the complex feelings she still holds for the man whose name she cannot bear to say and who raped her but for whom she still appears to retain a troubled affection. (Hall, *Daily Express*, February 28, 2013)

The treatment of these "dungeon cases" of Shoaf and Kampusch demonstrates the limitations of girl toughness in news narratives and also highlights the implicit and explicit victim blaming woven into these tales: these are girls and women who escaped their captors, surely, but they are not cast as the tough, brave heroes who saved themselves like in the previous cases discussed. These girl victims were cast as mischievous vixens who toyed with their captors' emotions, girls that came to accept, and perhaps even enjoy, the bondage to their abductors.

Victims Speak Out: Redefining Toughness

As discussed in Chapter 2, a common journalistic practice was for news narratives to link disparate child abduction cases that had no connection with each other and discuss them in conjunction with one another as part of the same news cycle. This standard practice constructed child abductions as something of a "crime wave," but as time evolved, it also gave victims a unique opportunity to share their stories in their own voices. As later cases emerged in the news cycle, producers turned to previous abduction victims, now not girls, but grown women, to speak out and share their perspectives. This was especially apparent after the Cleveland case when abduction victims like Elizabeth Smart, Jaycee Dugard and Michelle Knight took an activist stance against journalistic questioning of "why didn't the women just leave." Smart, now routinely interviewed as an activist-survivor, reinforced for news audiences the power of her emotional and psychological manipulation:

As a survivor who has been chained up in physical chains and also had the chains of threats held over me, I can tell you firsthand that threat is so much stronger than physical chains. Now, I don't have intimate details on what

threats he was holding over her head, but I understand that he was holding her family, that he was threatening her family. And for me, that was the strongest threat anyone could have ever made to me. (*@thishour with Berman and Michaela*, May 22, 2014)

As Michelle Knight explained to CNN, "Chains don't have to be made of iron":

And just because you're not chained up and you're not locked in a basement, doesn't mean you ain't trapped. I know exactly what it feels like to be trapped in your own mind, in your own emotional mind, and told that you can't do anything about it. Nobody will care about what you say. (*@thishour with Berman and Michaela*, May 23, 2014)

In this particular case, Knight was called upon in 2014 by CNN to comment on the case of a young immigrant woman in California who had been held captive for ten years. This type of journalistic questioning provided a unique opportunity for survivors to rewrite the script around victim blaming and redefine toughness:

Amanda Berry, escaped kidnapping victim: I may have been through hell and back, but I am strong enough to walk through hell with a smile on my face and with my head held high. (*New Day*, CNN, July 9, 2013)

In other cases, journalists forced victims like Michelle Knight on the defensive, asking them to justify their actions, to differentiate the mental and emotional suffering they endured from the physical restraints and abuse. Here media storytellers produced narratives and highlighted perspectives that differentiated psychological/emotional bondage from physical captivity. This forced victims to justify their emotional torture and bondage as just as, if not more so, incapacitating as physical bondage.

While news narratives cast some survivors as tough, brave and heroic, one consequence of this kind of reporting on escape cases was to create a problematic hierarchy of child victim worthiness. For example, coverage of Erica Pratt's escape, which fell during the same news cycle as Samantha Runnion and several other girl-victims who were found murdered, exalted Pratt but at the same time also seemingly

erased the experiences of girls who didn't make it out. As *The Baltimore Sun* opined, "Erica Pratt will be remembered because she's the one who got away" (*The Baltimore Sun*, July 29, 2002).

Tough girl narratives in the news force audiences to reconsider the gendered nature of how toughness is constituted in the culture, compelling us to "look past the binary of toughness and weakness" (Moscowitz, 2014, p. 9). Stories of toughness challenge systems of femininity/masculinity and allow us to examine how race, class and gender are problematically prescribed in constructions of strength and resilience. However, as this chapter has shown, "toughness may bind women more tightly to traditional gender roles" (Inness, 2004, p. 5) that reinscribe, rather than rewrite, the Damsels-in-Distress narratives that predominate in news discourses.

Conclusion: Innocence Lost

What if a man would have came and just snatched her because you have all
kinds of trucks that come up in here so you really don't know?
—(Tonya Cullum, *WJBF*, July 1, 2014)

In the summer of 2014, a mother in South Carolina dropped her nine-
year-old daughter off at a park, leaving her to play for hours at a time
over several days while she worked at a nearby McDonald's. When
police arrested the mother, Debra Harrell, for child endangerment and
placed the girl in child protective custody, a media frenzy erupted
over the mother's decision to leave her child unsupervised because
she could not afford childcare. Most opined that the police had over-
reached out of an unrealistic fear, expressed by community members
in the initial local reporting of the arrest, that the girl was in danger of
being snatched by a male stranger.

The current cultural discourses about childhood, innocence, fear
and danger are undergoing a compelling shift as anxieties over child
abductions and sexual predators are being simultaneously reinforced
and dismantled by parents, pundits, and journalists. In this conclud-
ing chapter, we seek to situate contemporary news narratives of child

abductions within the current milieu of tabloid journalism, fear mongering over childhood safety, and the ongoing disparities in news coverage of crime, race, class, and gender. We first examine the ethics of journalism that sensationalizes child victims and crimes against children more broadly, both for its potential impact on audiences as well as its professional implications. Additionally, we discuss the growing backlash against the "stranger danger" myth and the increasing visibility of the "free range kid" movement. We demonstrate the ways in which these mediated discourses intertwine with understandings of crimes against children and, indeed, cultural meanings of childhood itself.

Implications of Victim (In)Visibility

As we have examined in this book, the child abductions that garner the most pervasive news coverage demonstrate how race, class, and gender cohere to heighten the newsworthiness of some types of kidnappings and child victims over others. This is particularly evident when victims of long-term abduction are found and the question becomes: why did some cases receive attention only *after* the children are inadvertently discovered, as with Shawn Hornbeck, or are eventually recovered like Jaycee Dugard. The cases where victims did not receive coverage until they were returned or found under heinous conditions illuminate the patterns of deciding which victims are deemed worthy of coverage while they are missing as opposed to when they are returned.

Children such as Shawn Hornbeck, Jaycee Dugard, and Michelle Knight, who were from working or lower class backgrounds or broken homes, and who disappeared with no evidence of violence, are generally categorized as "runaways" by police. The propensity for journalists to defer to official sources means that these cases receive little to no media attention by editors and reporters who do not treat runaways as newsworthy. Parental efforts to bring their missing children into the national media were futile because the cases did not fit the newsworthy frame of stranger danger. However, the disappearance of victims such as Elizabeth Smart became national news stories overnight because these

victims and their families not only fit the journalistic frame, but their parents also wielded the economic power to command media attention. Furthermore, international cases of missing children and teens also adhered to the gendered, raced, and classed patterns inherent in the U.S. news media coverage. Cases such as Madeleine McCann's that featured white, middle- to upper-class girl victims were granted salience in international media, ignoring the countless other children missing and exploited around the world whose cases go largely unreported.

The journalistic reliance on official sources to determine whether a child is "worthy" of news attention may also lead to the initial and subsequent police actions shaping news coverage. Police inattention to some abduction victims, such as Shawn Hornbeck, who are treated as runaways, is then used to justify distrust of victims themselves. Police treatment of some victims as possible runaways when they disappear leads to continued speculation that they really may have fled from their "broken" homes. News media acquiesce to official police perspectives at the expense of crime victims, which also shields police from their own failings. When victims such as Hornbeck, Dugard, Knight, Berry, and DeJesus are found, inevitable questions arise about why their disappearances failed to garner national attention. Rather than engage in discussion and debate about the lack of coverage some victims receive, journalists and pundits instead can lay the blame on the police for treating these cases as runaways.

Police may be excused by journalists for not taking some cases seriously as stranger abductions, but in other reports, failure to investigate cases and missed opportunities by police lead to blaming the larger systematic ineptitude. As details emerged that showed police visited the home of Jaycee Dugard's abductor dozens of times as a condition of his previous parole, yet failed to discover her concealment, the police were lambasted in news media. Such dereliction of duty was made official when Dugard was awarded damages by the state of California for malfeasance. The shortcomings of police and the judiciary, in the case of outrage against the judge who failed to incarcerate the Groenes' abductor when he had the opportunity to do so, further fuels the drumbeat for increased policing, more laws, stricter enforcement, and even vigilante justice.

Constructing the Ideal Family

The practice of reifying some parents as ideal expert victim advocates who are called upon by news media to analyze each new abduction case continues to perpetuate these problematic narrative patterns. Parents such as Ed Smart, John Walsh, and Marc Klaas take part in a steady and repetitive series of media interviews over and over again, as they tell and retell the stories of their children's cases. What develops is a kind of script that is reiterated and strictly adhered to, even on the rare occasions when journalists break the narrative.

> Matt Lauer, host, NBC's *Today Show*: John, you've dealt with so many families over the last 25 years or so who are in this situation. What advice do you give them, especially in the early stages of a—of child being missing?
>
> John Walsh, victim advocate: Well, the—I think the McCanns are doing everything they can to stay focused. As Ed said, it's a double nightmare. First, your child is missing, and then the police do a horrible job. They turn the focus, the investigation onto you, and you're absolutely devastated. But I say it to parents all the time, and the Smarts are a perfect example: Remember who the real victim is. It's your child. Remember that most—the cases get the most attention are the cases that the parents are the strongest in, the parents that are available to give interviews and keep the focus on their child. And don't ever give up hope that your child will be found alive. Elizabeth got brought back after eight months against all those odds.
>
> Lauer: And I think it's important—I should just say, guys, and I know this is not—there is a darker twist to this, and that is that if, by some way, you know, the McCanns had something to do with the disappearance of their daughter, then all these photos and twists and turns don't mean anything to them because they already know the outcome.
>
> Ed Smart: Why in the world would anyone do all that they have done if they were guilty? I mean, to me, that's the unbelievable issue, is that, you know, both Kate and Gerry have—I mean, they could have let the whole thing die. And why would they keep on at the pace that they've gone? I just, you know, for the life of me I can't understand. (*NBC News Today Show*, September 27, 2007)

Similar to the news treatment of the Smart family and the McCann family, Shawn Hornbeck's family was *initially* praised for never giving up on finding Shawn, despite the adversity of being largely ignored by news media during his four years of captivity. However, soon after

Shawn's return, the family's actions were cast in a less than favorable light.

Kate Snow, *ABC News* reporter: Kim, so many couples when this happens end up breaking apart, they end up divorcing. These two people stayed together through, through all of this. What does that say about the family?

Kim Evans, friend of Hornbeck family: I think they held each other together. They're a good, close family. (*Good Morning America*, January 13, 2007)

Eric Horng, *ABC News* reporter: Shawn's mother and stepfather waited more than four years, nearly one-third of their son's life. The searching and the hoping consumed them. Craig Akers quit his job to continue the search after police gave up. Pam Akers became a two-pack-a-day smoker. (*World News Saturday*, January 13, 2007)

However, the parents' decision to appear with Shawn on *Oprah* within days of his return further fueled the critical narrative that was already brewing, and worked to produce an overall journalistic finger-wagging judgment of the Hornbeck family.

Bill O'Reilly, host: You know, just looking at this kid on *Oprah*, you can see he is traumatized. You can see the kid is just—you know, I said on this broadcast I wouldn't have put him on if it were my child, you know.

Bernard Goldberg: Exactly.

O'Reilly: I wouldn't have. I don't blame Ms. Winfrey, because if I were offered an interview with Shawn Hornbeck and his family, I would have taken it. But if I were a parent, I would never put the kid on. What do you think, Bernie, in general, of the media coverage?

Goldberg: Well, let me just comment on what you said. If, God forbid, anything like that ever happened in my family, God forbid, I guarantee you I wouldn't be on "Oprah" talking about it. That's something that has happened in this culture that I don't understand and I don't like and I don't feel at all comfortable with. (*The O'Reilly Factor*, January 18, 2007)

John Gibson, reporter: We all wanted to hear what Shawn Hornbeck would say on Oprah yesterday, but should he have been interviewed in the first place? Some people who sympathized with his parents for years are now mad at them for putting him out in front of the world to tell his story so soon, not to mention the parents told the world they think he was sexually abused. Thankfully, Oprah was smart enough not to ask the 15-year-old that question.

Linda Stasi, *NY Post* TV critic: I thought it was a horrible outrage to this child. The child was home four days. Four days, after four years of being held captive by a monster. And then instead of taking the child's welfare into consideration, he becomes a media star? It was awful. The child looked miserable. He looked so unhappy, he looked like he was going to die of embarrassment and fear. There was no reason to drag that abused child onto that show. (*The Big Story with John Gibson*, January 19, 2007)

Stasi, whose credentials include "TV critic," drew stark comparisons between the Hornbeck family who was cast as greedily trying to "make a buck on their kids' misery," and the Ownby family, who made the "right choice" when they decided they would not bring Ben onto the show (*The Big Story with John Gibson*, January 19, 2007). Problematically, in these stories of child abductions, class, gender and normative conceptions of family cohered to create dichotomies between ideal families and the ones who faced continued scrutiny in the loss of their child.

Judging Heroic Neighbors and Classed Communities

Likewise, the prominent discourses of community that structure narratives about child abductions established hierarchies of value in which socio-economic class is the basis for differentiating "good" communities from the "bad" ones. Coverage of missing children from suburban areas focused on the wholesomeness of close-knit communities of people who go out in search teams, hold vigils, and support grieving families. However, in the Cleveland case, as well as in the case of Dugard and Hornbeck, coverage focused on "bad" communities of lower-class people who "didn't notice" anything was wrong when they heard children screaming or witnessed suspicious behavior. Yet, the neighbors in this case were not held culpable; rather, the assumption on the part of reporters seemed to be that members of those communities *were not expected* to have close bonds, watch out for each other, or report criminal behavior to police.

Communities become constructed in ways that frame people living in lower-income apartment complexes or urban neighborhoods as failing to look out for each other, whereas those living in small rural towns and upper-income communities in the suburbs are idealized. While

some accounts focused on heroic neighbors, such as in Cleveland, who helped with daring escapes, problematic assumptions underlie claims of journalists and commenters that *of course* neighbors would not question the shady, boarded-up "house of horrors" in a low-income area because we should not expect the same kind of cohesive community bond assumed in suburbs and small towns.

Just as police forces were exempt for failing to prioritize certain victims, some neighbors were also excused for their negligence in failing to report missing children. In California, neighbors were reportedly "not expected" to know that the overgrown yard held a hidden shed in which Dugard and her children were confined. Some reports highlighted the obliviousness of neighbors, yet far from indicting them, these accounts of disbelief were used to further blame victims. In the case of Shawn Hornbeck, the neighbors in his apartment complex were not censured for inaction on his behalf; rather he was indicted for not calling attention to his condition and spurring neighbors to action.

> Bill Romer, Mike Devlin's landlord: It's strange because, frankly, he's one of my best tenants.
> Don Dahler, *ABC News* reporter: Neighbors say they frequently heard odd noises coming from Devlin's apartment.
> Rick Charles Richards, suspect's neighbor: Between Devlin and the boy, at times, he would scold Shawn. And at one point, he hit him, like hit him (makes noise).
> Dahler: Shawn didn't go to school the entire time he was being held, but he was often seen in the neighborhood riding his bike here. His best friend's mother regrets not seeing something wrong.
> Rita Lederle, Shawn's best friend's mother: I feel sorry for the parents not knowing he was away from them for four, four years. You know, I'm a mother of five. If I had known I would have contacted the parents in some way. (*ABC News*, January 15, 2007)

> Bill Weir, reporter: That's interesting considering the amount of time he'd been with this man. And we talked about a little bit how the St. Louis paper quotes neighbors who claim they called police after hearing a child screams, but the source of those cries could never be determined. Were there any signs of abuse on Shawn? (*Saturday Good Morning America, ABC News*, January 13, 2007)

> Brad Garrett, former FBI agent: The reality of this case is that you have neighbors that actually spotted him and, and there was even some comment that

he looked like of one of the missing kids, you know. I mean, what planet are people on? They, they should be calling the police. (*Good Morning America*, January 16, 2007)

Rick Charles Richards, suspect's neighbor: A lot of vulgarity. A lot of cursing. I even heard him hit the child. Shawn. I even remember him hitting Shawn. (*Inside the Newsroom*, January 15, 2007)

Despite the numerous warning signs that *something* horrific was occurring nearby, there is no expectation of community action and heroic intervention in the context of low-income apartment living.

Journalism Ethics in a Mediated Digital Age

As we have analyzed throughout this book, news coverage of child abductions communicate far more than mere crime reporting, but is embedded with narratives about innocence, nation, and childhood. Similar to other abhorrent crimes, tales of child abduction:

> … always tells an intimate story of loss, grief, betrayal, and violation. Although it deeply affects the persons directly involved, it is, nevertheless, a crime against the state and, therefore, a public concern. Journalism often bridges the gap between private and public life in North America, and storytelling is usually the vehicle used to cross that bridge. (Fullerton and Patterson, 2006, 305)

However, when the storytelling becomes prurient, we must reconsider "the balance between the public right to know and the need to protect vulnerable people from intensive scrutiny by the media" (Morton, 2012, p. 48). The key question, especially when vulnerable victims are identified in the press, becomes: "does the public right to know, whether justified or not, extend to the most intimate details, in short the invasion of the privacy of the victim, or even the victim's or perpetrator's families?" (Cameron-Dow, 2009, p. 73). In this digital era, the news coverage of child victims is not confined to a news cycle, but becomes permanently embedded in social media and recorded and disseminated online, making it impossible for survivors to ever escape.

More to the point, for how long should a victim continue to be identified? Crime stories remain on the internet indefinitely on sites such as Crime Library and are there for all to see, long after the cases have been officially closed, denying those involved the privacy they often desire. (Cameron-Dow, 2009, p. 73)

As we have found in the course of our over decade-long investigation of child abductions in the news, Internet searches for victims' names return not only the news reports of their disappearances, recoveries, and traumatic experiences, but also the rearticulation of the most graphic, gory, and private details of their sexual assaults, murders, and rumored culpability throughout the digital news realm and blogosphere. Victims' bodies and experiences become fodder for speculation, public commentary, and for-profit media products (books, made-for-TV movies, news specials) for years after the actual event of their abduction.

Turner (1999) argues that "the predatory strategies of contemporary television journalism" can lead to "the failure to fully recognize, or alternatively of the capacity to obscure, the implications of journalism's institutional reconciliation with its commercial function as a form of entertainment" (p. 74). Given that the sensationalized coverage of child abductions is driven by the profitability of "signal crimes," what possibilities exist for potentially altering future framing of victims, families, communities, and perpetrators? Below, we posit key suggestions from journalism ethicists who emphasize the key principles of accountability and minimizing harm.

Glasser and Ettema (2008) seek to "rehabilitate" common sense as a guiding principle of journalism ethics (p. 512).

The challenge of ethics in journalism is not, then, to facilitate the discovery of moral laws that yield ethical truths, for being ethical requires neither a knowledge of abstract principles nor a familiarity with arcane theories of morality. Rather, being ethical requires the facility to argue articulately and deliberate thoughtfully about moral dilemmas, which in the end means being able to justify, publicly and compellingly, their resolution. The aim of ethics is, in a word, accountability. (Glasser and Ettema, 2008, p. 513)

The discourse that journalists engage in their own experiences reporting on child abductions or their critique of other journalists' intrusive

behaviors do little to ameliorate the problem. As Frank (2003) argues about the pitfalls of pack journalism, journalists and pundits frequently discuss "the news media" and critique media coverage of child abductions. "Reflexive media criticism implicitly acknowledges that journalists' comportment and, indeed, their very presence affects both the people they write about and the way their audiences experience and assess the magnitude of an event. It suggests that they have become at least as worried about their perceived lack of sensitivity as they have been about their perceived lack of objectivity" (Frank, 2003, p. 443).

The core of "existential journalism" is found in the imperative for "journalists to live authentic lives—as private individuals as well as in their profession" (Holt, 2012, p. 3). The potential drawback of this approach, of course, is that each journalist and commentator may be compelled by narcissistic motivations or constrained by institutional pressures. To apply Holt's conceptualization of "existential journalism" to child abductions, sensationalized reporting "might very well be felt as truly authentic and self-fulfilling to another journalistic individual who perhaps sees it as a way of making a dream about a certain job in the future come true" (Holt, 2012, 12–13).

Whether news outlets are capable of refraining from sensationalizing the graphic details of sexual assaults against minors may depend upon the credentials of the journalist, pundit, or talk show host creating the content. Who counts as a "journalist" in the digital age and how one defines journalistic standards of reporting is highly contentious in the 24/7 cable news and digital journalism era. While it is debatable whether hosts such as Nancy Grace and Bill O'Reilly can be considered "journalists" in the same vein as Ann Curry or Robin Roberts, their function as providers of information employed by news organizations places them squarely in the journalism realm. However, their motivations, audiences, commercial imperatives, and expectations for their programs may be quite different from those of traditional news reporters.

Still, we argue that it should be possible to choose the path of conveying truth while seeking to minimize harm (Tolan, 2006). In the case of reporting on child abductions, that harm may be to survivors, their families, and even news audiences themselves. One option for

minimizing harm is to avoid the kind of rampant speculation that leads to victim blaming and reveling in graphic detail the sexual assaults against minors. Cenite (2005) argues that:

> Journalists should identify speculation clearly, attribute it to its source, report any basis for it, and offer appropriate qualification. This obligation is particularly strong when speculation involves members of stigmatized groups. (2005, p. 43)

There is no denying the newsworthiness of child abduction as a crime, yet the selectiveness of news outlets in covering only select victims and particular kinds of missing children crimes means that problematic scripts work to reinforce social norms, "employ predetermined formulas," and propagate fear, much as do reports of murder:

> Although news media devote copious time and space to murder coverage, it remains qualitatively insufficient. The coverage must be done with public, not prurient, interest at its core, if citizens are to take these seemingly random, isolated acts of extreme violence and use them to generate community discussion and introspection. (Fullerton and Patterson, 2006, p. 305)

The ironic twist to the highly sexualized representation of child abductions in news is that almost all of the media outlets included in this study have longstanding policies and codes of ethics that bar the release of identities of minor victims of sexual crimes. The basis of these policies is that media publicity of intimate details about traumatic experiences will prove psychologically or emotionally damaging for the child victim. Yet, child abductions are treated differently in news media that not only reveal, as we have shown, details of the sexual crimes committed against victims, but also do so in a sensationalized, titillating manner.

The unique nature of stranger child abductions means that the child's image and name are widely publicized in efforts to *find* her or him. Thus, the child's identity is well known (in cases that receive media attention) *before* the sexual nature of the crimes is known. Unfortunately, because the child is inextricably linked to the sexual details of the charges laid against the perpetrator only *after* an arrest, journalists and pundits grant themselves carte blanche to discuss and exploit the sexual nature of the crimes to further their narratives of everything from the myth of violent

homosexuality to the specter of drug-dealing immigrants. With rarely even a caveat or nod towards their codes of ethics, news outlets exploit the opportunity to sensationalize child victims of sexual assault. The alternative to the kind of problematic coverage examined throughout this study would be for journalists to consider the spirit of their own ethical codes and attempt to mitigate the exposure of graphic details and speculation about child victims of sexual crimes.

Advocacy and Exploitation

The tabloid coverage of child abduction is only one of the ways in which this loathsome crime has been commercialized. The search for missing children is an industry unto itself, with children's faces plastered on spaces used to sell commodities and specialized products being developed for fearful parents. As Paula Fass has eloquently written, this move began in the 1980s, with the painful contradiction of childhood exploitation represented on a single newspaper page:

> The extraordinary danger to children in modern American could not have been better illustrated than in the juxtapositioning on the same page of a newspaper of an advertisement for a "Children's Photograph Contest" and $3,000 in prizes with the picture of the search for Kevin's body. (Fass, 1997, p. 237)

Journalistic constructions of fear include the use of "official" numbers like crime statistics in contradictory ways and the promotion of "keeping our kids safe" industries that also serve the purpose of keeping the new cycle running.

> Government numbers show almost 800,000 children a year are reported missing, almost 2200 a day. Most are run-aways, victims of family abductions or lost for a short time. Then there are the others. (*World News Tonight*, January 15, 2007)

> American children must be prepared to fight against frightening things. Prepared to fight against them. And they must be warned those things are real. (*The O'Reilly Factor*, January 18, 2007)

Although statistics may be used to frighten or inform, the continued emphasis on children needing to protect themselves from elusive harm drives moral panics about innocence lost, and fears that any child any-where is in danger of being abducted at any time.

Advocacy around missing children has spawned the creation of numerous foundations, including those named for victims Kevin Col-lins, Polly Klaas and Adam Walsh. At the same time, recent years have seen several powerful survivor voices enter the discourses about child abduction, namely Elizabeth Smart and Michelle Knight. Their ability to speak at trials, author books, conduct interviews, and engage in vic-tim/survivor advocacy may contribute to conversations about survi-vors' mental and emotional toughness in overcoming trauma.

As survivors articulate their own needs and experiences, there is a bizarre confrontation with the journalistic "why," which at the same time elevates survivors' voices but also scrutinizes their motivations. Survivors are granted the media spotlight, but must then endure intense questioning.

> Jessyca Mullenberg, kidnapping victim: For Shawn, it's just gonna be really hard and you're gonna get ridiculed. I got ridiculed from junior high to high school to college and still today. Often they'll [ask], 'Why didn't you run? Why didn't you get away?"
> Elizabeth Vargas, reporter: Do you feel, in many ways, like that's a victimiza-tion again?
> Mullenberg: It is. I felt guilt. It's awful. I mean, they don't know what it's like to be in our shoes and to be kidnapped and traumatized. It doesn't pay not to go along with what he wants to do or what to say because, you know, instead of getting hit once, it's getting hit, like, 20 times instead of, like, the back of your hand, it would be a pot or a chair or a broom. So it's not worth it.
> Vargas: Literally, it's a matter of survival.
> Mullenberg: It is a matter of survival. (*20/20, ABC News*, March 16, 2007)

Shifting Conceptions of Childhood, Parenting, Safety and Fear

Our book has also been concerned with changing definitions of child-hood, as stories about child abductions demonstrate the ways in which

"young Americans also shoulder broader national anxieties about race, class, sex, and crime" (Mokrzyckil, 2013/2014). Likewise, the framing of "innocent" victims and "complicit" ones, of good families and bad families of child abduction victims, is paramount to understanding the emerging discourses and developing policies that govern childhood. As the current controversy over leaving children unsupervised indicates, law and policy decisions are made on assumptions that an unsupervised child is at risk of being abducted. These fears are predicated on myths about missing children constructed and disseminated over the course of several decades. As Conor Friedersdorf wrote in his critique of the case in South Carolina, in which a mother was arrested for leaving her child alone at a park:

> The actual safety of a given kid is not being rigorously determined. State employees are drawing on their prejudices to make somewhat arbitrary judgment calls. They wouldn't think of preventing many statistically riskier parenting decisions so long as those decisions jive comfortably with social norms. They're sometimes taking away children based on what amounts to their gut feeling—even though kids are far more likely to be abused in state-administered foster care. (Friedersdorf, 2014, n.p.)

Within the current paradigm of childhood, in which neglectful parenting is defined in part by largely irrational fears of child abductions, the book *Free Range Kids* and its adherents offer a counter-movement. Written by Lenore Skenazy after her blog post about letting her nine-year-old son take the New York subway by himself caused her to be labeled the worst mother on the planet. The Free Range movement challenges the taken-for-granted threat of strangers lurking near every park, school and shopping mall or planning to kidnap children from their homes. When followers of Skenazy's work chose to allow their children to take increasingly long walks from home unsupervised, authorities responded by investigating the family, questioning the children at school, and instigating child protective measures against the family.

> The latest case? A Silver Spring, Maryland, couple is facing a neglect investigation for letting their 10-year-old son and 6-1/2-year-old daughter walk home from a playground, about a mile from their house, by themselves on a

Saturday afternoon in late December. The story immediately brought to mind the South Carolina mom arrested for letting her 9-year-old daughter play at the park alone while she worked at a McDonald's and a Florida mom arrested after letting her 7-year-old walk to the park alone. (CNN.com, January 21, 2015)

The discourse about children being allowed to roam their neighborhoods invariably includes references to the perceived threat of crime against children and whether parents are neglectful for not monitoring their children at all times in all places.

In terms of crime, I lived in a more dangerous time period and my parents lived in a more dangerous time period ... so it just never occurred to me that this has to be a philosophy. Growing up in Flushing, Queens, in New York, [Danielle] Meitiv would go to the bowling alley or library at a young age by herself.

The idea that a parent would escort you somewhere, I mean my mother would have cracked up, 'What are you nuts?' As Meitiv's kids got older, she and her husband grew more aware of the whole concept of helicopter parenting—and the idea that kids had to be supervised all the time. (CNN.com, January 21, 2015)

The climate that Meitiv describes from her own childhood, a time when it was accepted that children like herself and like Etan Patz could be safe walking to school or playing at home alone, is in stark contrast to the contemporary milieu in which children cannot play in a neighborhood park unsupervised without raising the suspicion of neighbors and police. This contemporary construction of childhood is one in which children are imagined to be under constant threat from male sexual predators lurking behind bushes and around corners, underscoring the importance of understanding the evolving cultural understandings of child abductions in mainstream news.

Media Examples Cited

20/20, March 16, 2007. "Taken"; Children lost and found. John Stossel and Elizabeth Vargas (anchors). New York, NY: ABC News Productions.

20/20, May 29, 2009. Missing forever; What really happened to Etan Patz? Jay Shadler (reporter). New York, NY: ABC News Productions.

48 Hours, June 16, 2009. For June 16, 2009, CBS. Troy Roberts (reporter). New York, NY: CBS Worldwide Inc.

60 Minutes II, June 2, 2004. Vanished; Stan Patz wins legal case against the alleged murderer of his son, Etan Patz. Vicki Mabrey (reporter). New York, NY: CBS Worldwide Inc.

@thishour with Berman and Michaela, May 22, 2014. Woman escapes 10-Year kidnapping. Michaela Pereira & John Berman (reporters). New York, NY: Turner Broadcasting System, Inc.

@thishour with Berman and Michaela, May 23, 2014. Michelle Knight voices support for California alleged kidnapping victim. Michaela Pereira & John Berman (reporters). New York, NY: Turner Broadcasting System, Inc.

ABCNews.com, October 19, 2011. Girl in dungeon basement case held 10 years, tortured by captors. Colleen Curry (reporter). Retrieved from http://abcnews.go.com/US/girl-basement-dungeon-case-held-10-years-burned/story?id=14768875 on October 20, 2014.

ABC World News Tonight, July 3, 2005. Girl found: Missing child rescued. New York, NY: American Broadcasting Companies, Inc.

Alamogordo Daily News, January 21, 2012. Colorado girl escapes her kidnapper Keith Coffman (reporter). Alamogordo, NM: Alamogordo Daily News.

American Morning, May 18, 2005. Idaho Amber Alert; High-stakes battle over president's judicial nominees. New York, NY: Turner Broadcasting System, Inc.

American Morning with Paula Zahn, July 24, 2002. Interview with William Colarulo. Bill Hemmer (reporter). New York, NY: Turner Broadcasting System, Inc.

American Morning with Paula Zahn, March 14, 2003. Interview with forensic psychiatrist Helen Morrison. Paula Zahn (anchor). New York, NY: Turner Broadcasting System, Inc.

Associated Press, July 19, 2002. Despite grim headlines, experts say abductions of children by strangers are rare and getting rarer. David Crary (reporter). New York, NY: Associated Press.

Associated Press, July 3, 2005. Idaho Girl found alive; Brother feared dead. Retrieved from http://www.foxnews.com/story/2005/07/03/idaho-girl-found-alive-brother-feared-dead/ on December 12, 2014. New York, NY: Associated Press.

Associated Press, July 7, 2005. Long road ahead for 8-year-old Idaho survivor. Retrieved from http://www.nbcnews.com/id/8498686/ns/us_news-crime_and_courts/t/long-road-ahead--year-old-idaho-survivor/#.VTap18Y_1sM on December 11, 2014. New York, NY: Associated Press.

Associated Press, August 13, 2008. Rebecca Boone. Idaho jury hears horrid detail of family murders. New York, NY: Associated Press.

CBS Evening News, January 12, 2007. 2 missing boys found alive in Missouri. Bianca Solorzano (reporter). New York, NY: CBS Worldwide Inc.

CBS Morning News, August 30, 2002. Search continues for nine-year-old Nicholas Farber. S. Case (reporter). New York, NY: CBS Worldwide Inc.

Clovis County press release, January 23, 2007. Retrieved from http://missingexploited.com/2007/02/08/fbi-releases-new-details-in-kidnapping-of-marissa-graham-sketch-of-suspect/ on October 12, 2014.

CNN.com, June 6, 2002. Slain girls' dad admits drugs-sex lifestyle. Retrieved from http://edition.cnn.com/2002/LAW/06/05/westerfield.trial/index.html on November 17, 2014.

CNN.com, July 3, 2005. Missing Idaho girl reunited with her father. Retrieved from http://www.cnn.com/2005/US/07/02/idaho.children/ on December 11, 2014. New York, NY: Turner Broadcasting System, Inc.

CNN.com, April 28, 2008. 'House of horrors' children never saw daylight. Retrieved from http://www.cnn.com/2008/WORLD/europe/04/28/austria.cellar/index.html?iref=topnews on October 20, 2014.

CNN.com, August 28, 2009. Sheriff: Kidnap victim, children kept in backyard compound. Retrieved from http://www.cnn.com/2009/CRIME/08/27/california.missing.girl/ on July 20, 2014.

CNN.com, January 21, 2015. Maryland family under investigation for letting their kids walk home alone. Retrieved from http://www.cnn.com/2015/01/20/living/feat-md-free-range-parents-under-attack/ on January 25, 2015.

CNN Newsroom, January 18, 2007. Michael Devlin to be arraigned on kidnapping charges. Tony Harris (anchor). New York, NY: Turner Broadcasting System, Inc.

CNN Newsroom, August 30, 2009. California Police Search Home Next to Garrido's House. Brianna Keilar (anchor). New York, NY: Turner Broadcasting System, Inc.

CNN Newsroom, May 9, 2013. Ariel Castro charged, arraigned; Psychology of surviving an abduction. Anderson Cooper (reporter). New York, NY: Turner Broadcasting System, Inc.

CNN Newsroom, May 6, 2014. Michelle Knight remembers kidnapping. Anderson Cooper (reporter). New York, NY: Turner Broadcasting System, Inc.

CNN Live Event, July 2, 2005. Shasta Groene found alive. Fredricka Whitfield (reporter). New York, NY: Turner Broadcasting System, Inc.

CNN Live Event, May 12, 2013. Escape from Captivity: The Cleveland kidnappings. John Berman & Zoraida Sambolin (anchors). New York, NY: Turner Broadcasting System, Inc.

CNN Live Sunday, May 22, 2005. Laura Bush Meets with Protests at Holy Sites in Jerusalem; Florida Girl Found Alive Buried in Landfill. Alina Cho (reporter). New York, NY: Turner Broadcasting System, Inc.

CNN Saturday Night, July 2, 2005. 8-year-old Idaho rescued, brother missing. Carol Lin (anchor). New York, NY: Turner Broadcasting System, Inc.

Contra Costa Times, July 25, 2002. Officers try to resolve kidnapping case; reports are discounted that girl's family was to get a life insurance settlement of $150,000, which is the amount of ransom asked. Mark Fazlollah, Nora Achrati and Jacqueline Soteropoulos. Philadelphia, PA: *Contra Costa Times*, p. A18.

Contra Costa Times, July 25, 2002. Suspected kidnappers, family have web of ties. The men accused of abducting Erica Pratt have criminal pasts. One was charged after an attack at the girl's uncle's home. Mark Fazlollah, Nora Achrati, and Jacqueline Soteropoulos. Available from http://articles. Philly.com/2002-07-25/news/25357100_1_abduction-kidnapping-cases-erica-pratt

Connie Chung Tonight, March 13, 2003. Elizabeth Smart's return leaves many questions unanswered; Family of drifter couple say they knew they were involved. Jeanne Meserve (correspondent). New York, NY: Turner Broadcasting System, Inc.

Crossfire, March 12, 2003. Elizabeth Smart has been found alive. Rucker Carlson, and Paul Begala (co-hosts), Mike Brooks (correspondent). New York, NY: Turner Broadcasting System, Inc.

Daily Express, February 28, 2013. Will we ever know the truth about kidnapped Natashca Kampusch? Allan Hall (reporter). London, UK: Daily Express.

DailyMail.com, August 21, 2012. Woman, 20, 'who was locked in a cupboard for a decade by her ex-con aunt, beaten and forced to have sex' sues city of Philadelphia for 'failing to prevent abuse.' Lydia Warren (reporter). Retrieved from http://www.dailymail.co.uk/news/article-2191473/Beatrice-Weston-Woman-20-locked-cupboard-decade-aunt-sues-Philadelphia.html on October 15, 2014.

Dateline, July 8, 2005. Accused kidnapper and murderer Joseph Duncan. Ann Curry (host), John Larson and Rob Stafford (reporters). New York, NY: National Broadcasting Company.

Dateline, March 7, 2008. Into the woods: Teen escapes predator after bunker ordeal. Keith Morrison (correspondent). New York, NY: National Broadcasting Company.

Express, February 28, 2013. Will we ever know the truth about kidnapped Natashca Kampusch? Kidnapped at the age of 10, Natashca Kampusch was held in a secret cellar for more than eight years. As a film of her ordeal is released there are still so many questions that remain unanswered. Allan Hall (reporter). Available from http://www.express.co.uk/news/world/380667/will-we-ever-know-the-truth-about-kidnapped-Natashca-Kampusch

Good Morning America, June 25, 2002. Friends, Kate Vasconcellos and Amanda Coe, along with their mothers, discuss fears over kidnapping of Elizabeth Smart; Dr. Richard Gallagher of NYU discusses how to help children through difficult situations. Charlie Gibson (host). New York, NY: American Broadcasting Companies, Inc.

Good Morning America, July 4, 2005. Amazing rescue: Missing girl found. Robin Roberts (host). New York, NY: American Broadcasting Companies, Inc.

Good Morning America, July 5, 2005. Duncan charged: Groene's alleged kidnapper in court. Diane Sawyer (host). New York, NY: American Broadcasting Companies, Inc.

Good Morning America, July 21, 2005. Sex offender registry interview with John Walsh. Robin Roberts (host). New York, NY: American Broadcasting Companies, Inc.

Good Morning America, January 13, 2007. Kidnapped boys found; how police cracked the case. Kate Snow (anchor). New York, NY: American Broadcasting Companies, Inc.

Good Morning America, January 15, 2007. Why didn't boys leave captor?' Was it Stockholm Syndrome? Robin Roberts (anchor). New York, NY: American Broadcasting Companies, Inc.

Good Morning America, January 15, 2007. Missing boys hidden in plain sight; did their captor scare them? Robin Roberts (anchor) and Don Dahler (reporter). New York, NY: American Broadcasting Companies, Inc.

Good Morning America, January 16, 2007. News headlines. Diane Sawyer and Robin Roberts (anchors). New York, NY: American Broadcasting Companies, Inc.

Good Morning America, January 17, 2007. News headlines. Eric Horng (reporter). New York, NY: American Broadcasting Companies, Inc.

Good Morning America, January 22, 2007. Girl, 10, escapes abductor by kicking her way out of car trunk. Retrieved from http://abcnews.go.com/GMA/story?id=2812352 on November 20, 2014. New York, NY: American Broadcasting Companies, Inc.

Good Morning America, May 25, 2007. Keeping kids safe this summer; One family's personal journey. Robin Roberts (reporter). New York, NY: American Broadcasting Companies, Inc.

Good Morning America, October 10, 2007. Child kidnapper gets life; Young boy saved other's life. Robin Roberts (reporter). New York, NY: American Broadcasting Companies, Inc.

Good Morning America, October 11, 2007. Kidnap case: Shawn's parents on sentencing. Robin Roberts (reporter). New York, NY: American Broadcasting Companies, Inc.

Good Morning America, January 22, 2012. 9-year-old escapes abduction; 'I got my fight from my daddy.' Clayton Sandell (reporter). New York, NY: American Broadcasting Companies, Inc.

Good Morning America, May 9, 2013. Kidnapping suspect facing charges; Ariel Castro bail set for $8 million. David Muir (reporter). New York, NY: American Broadcasting Companies, Inc.

Good Morning America, October 29, 2013. Child's daring escape from kidnapper; Hunt for a dangerous predator. Robin Roberts (reporter). New York, NY: American Broadcasting Companies, Inc.

Good Morning America, March 5, 2014. Caught on tape: Parents caught in lie on camera? Gio Benitez (reporter). New York, NY: American Broadcasting Companies, Inc.

Hannity & Colmes, January 19, 2007. Analysis with Pat Brown, Megyn Kelly, Rod Wheeler. Alan Colmes and Sean Hannity (hosts). New York, NY: Fox News Network.

Inside the Newsroom, January 15, 2007. Weekend euphoria; astounding return of two teenage kidnap victims. Barbara Pinto (reporter). New York, NY: American Broadcasting Companies, Inc.

Issues with Jane Velez-Mitchell, September 21, 2009. Jane Velez-Mitchell (host). New York, NY: Turner Broadcasting System, Inc.

Issues with Jane Velez-Mitchell, September 24, 2009. Jane Velez-Mitchell (host). New York, NY: Turner Broadcasting System, Inc.

Larry King Live, June 26, 2002. Interview with John Walsh. Larry King (host). New York, NY: Turner Broadcasting System, Inc.

Larry King Live, January 26, 2007. Larry King (host). New York, NY: Turner Broadcasting System, Inc.

Larry King Live, October 14, 2009. Jaycee Dugard goes public. Larry King (host). New York, NY: Turner Broadcasting System, Inc.

NBC News, May 29, 2007. McCanns still searching for four-year-old daughter. Dawna Friesen (reporter). New York, NY: NBCUniversal.

NBC News, September 8, 2007. Some say police suggesting Madeleine McCann's mother may have accidentally killed her. Michelle Kosinski (reporter). New York, NY: NBCUniversal.

NBC News, November 3, 2009. New computer-generated images released to help find Madeleine McCann, missing now for two and a half years. George Lewis (reporter). New York, NY: NBCUniversal.

NBC Nightly News, May 21, 2005. Search continues for Shasta and Dylan Groene, children missing from triple murder site in Idaho. Michael Okwu (reporter). New York, NY: NBCUniversal.

Nancy Grace, July 5, 2005. Lisa Pinto (host). New York, NY: Turner Broadcasting System, Inc.

Nancy Grace, May 24, 2004. Hope Fades in Case of Missing Children in Idaho. Nancy Grace (host). New York, NY: Turner Broadcasting System, Inc.

Nancy Grace, June 28, 2005. Nancy Grace (host). New York, NY: Turner Broadcasting System, Inc.

Nancy Grace, January 25, 2007. New details about kidnappings in Missouri. Nancy Grace (host). New York, NY: Turner Broadcasting System, Inc.

Nancy Grace, January 31, 2007. Tampa rape victim jailed for prior offense as juvenile. Nancy Grace (host). New York, NY: Turner Broadcasting System, Inc.

New Day, July 9, 2013. Cleveland kidnapping victims Release YouTube video. Pamela Brown (reporter). New York, NY: Turner Broadcasting System, Inc.

Newsnight, March 13, 2003. Smart pressures Congress for Amber Alert legislation. Aaron Brown (host). New York, NY: Turner Broadcasting System, Inc.

New York Daily News, July 24, 2002. Nabbed Philly girl escapes. Bill Hutchinson and Maki Becker (reporters). New York, NY: Daily News, L.P.

Newsweek, March 19, 1984. Stolen children: What can be done about child abduction. D. Gelman, S. Agrest, J. McCormick, P. Abramson, N. Finke Greenberg, M. Zabarsky, H. Morris, & T. Namuth, (reporters). New York, NY: The Washington Post Company.

Newsweek, July 8. 2002. The plot thickens. K. Peranio (reporter). New York, NY: The Washington Post Company, p. 41.

Newsweek, July 29. 2002. When kids go missing. Aaron Murr (reporter). New York, NY: The Washington Post Company, p. 38.

Nightline, January 26, 2012. Kidnapped; Narrow escapes. Martha Raddatz (reporter). New York, NY: American Broadcasting Companies, Inc.

O'Reilly Factor, May 18, 2005. Interview with Robert Strang. (Bill O'Reilly (host). New York, NY: Fox News Network.

O'Reilly Factor, January 16, 2007. Talking point memo and top story. Bill O'Reilly (host). New York, NY: Fox News Network.

O'Reilly Factor, January 18, 2007. Media handling of Hornbeck kidnapping. Bill O'Reilly (host). New York, NY: Fox News Network.

O'Reilly Factor, January 18, 2007. Talking points memo; media handling of Hornbeck kidnapping. Bill O'Reilly (host). New York, NY: Fox News Network.

O'Reilly Factor, January 19, 2007. Bill and Geraldo discuss the Hornbeck case. Bill O'Reilly (host). New York, NY: Fox News Network.

O'Reilly Factor, *Fox News*, January 22, 2007. Factor follow up. Bill O'Reiley (host). New York, NY: Fox News Network.

O'Reilly Factor, January 26, 2007. What drives evil people? Bill O'Reilly (host). New York, NY: Fox News Network.

O'Reilly Factor, February 1, 2007. Impact. Bill O'Reilly (host). New York, NY: Fox News Network.

On the Record with Greta Van Susteren, January 12, 2007. Two Missouri boys found in home of sex offender. Greta van Susteren (host). New York, NY: Fox News Network.

On the Record with Greta Van Susteren, January 22, 2007. Report says kidnapped Missouri boy had girlfriend. Greta van Susteren (host). New York, NY: Fox News Network.

On the Record with Greta Van Susteren, February 5, 2007. Michael Devlin charged with sexual assault and kidnapping. Greta van Susteren (host). New York, NY: Fox News Network.

On the Record with Greta Van Susteren, May 21, 2007. Michael Devlin pleads not guilty. New York, NY: Fox News Network. Greta van Susteren (host). New York, NY: Fox News Network.

Primetime Live, March 13, 2003. Elizabeth Smart's captivity: why she didn't escape. Cynthia McFadden (reporter). New York, NY: American Broadcasting Companies, Inc.

Sunday Today, May 2, 2010. Kate and Gerry McCann still searching for their missing daughter, Madeleine. Dawna Friesen (reporter). New York, NY: NBCUniversal.

Saturday Today, September 8, 2007. Parents now suspects in disappearance of Madeleine McCann; NBC News analyst Clint van Zandt speaks about the case. Amy Robach (anchor). New York, NY: NBCUniversal.

Salon, August 9, 2002. The "shame" of rape: Why does the media hide rape victims who fight back instead of honoring them as heroes? Morgan Magowan (editorial writer). Retrieved from http://www.salon.com/2002/08/09/stigma/ on October 14, 2014. New York, NY: Salon Media Group Inc.

San Jose Mercury News, July 25, 2002. Spunky girl saved herself in escape from kidnappers. Beth Gillin, Ira Porter and Thomas J. Gibbons (reporters). San Jose, CA: San Jose Mercury News, p. A12.

Saturday Good Morning America, January 13, 2007. Kidnapped boys found: How police cracked the case. Kate Snow, Eric Horng, and Bill Weir (reporters). New York, NY: American Broadcasting Companies, Inc.

St. Louis Post-Dispatch, October 8, 2002. Report of missing boy sparks search in Washington County, authorities are treating case as an abduction. Tim Rowden (reporter), Davenport, IA: Lee Enterprises, p. B1.

St. Louis Post-Dispatch, January 10, 2007. Search goes on for missing boy: Case centers on white pickup seen speeding away near home of Ben Ownby, 13. Stephen Deere (reporter). Davenport, IA: Lee Enterprises, p. A1.

The Big Story with John Gibson, January 19, 2007. Interview with Linda Stasi. New York, NY: Fox News Network.

The Baltimore Sun, July 29, 2002. A 7-year-old from S.W. Philly. Retrieved from http://articles.baltimoresun.com/2002-07-29/news/0207290267_1_erica-pratt-samantha-duct-tape on November 20, 2014. Baltimore, MD: The Baltimore Sun.

The Big Story with John Gibson, February 1, 2007. Interview with Christopher Leonard. John Gibson (host). New York, NY: Fox News Network.

The Big Story with John Gibson, February 2, 2007. Big justice: Will Shawn Hornbeck's aid of Michael Devlin help or hurt prosecution, defense? John Gibson (host). New York, NY: Fox News Network.

The Early Show, July 24, 2002. Bill Colarulo, inspector with the Philadelphia Police Department, discusses Erica Pratt's escape from an abandoned house after she was abducted by two men. Russ Mitchell (co-host). New York, NY: CBS Worldwide Inc.

The Early Show, September 5, 2002. Michael Farber discusses the recovery of his son after the nine-year-old was kidnaped a week ago. Jay Clayson (co-host). New York, NY: CBS Worldwide Inc.

The Early Show, January 16, 2007. Criminal profiler Pat Brown speaks about using the Internet to track missing kids. Hannah Storm (anchor). New York, NY: CBS Worldwide Inc.

The Early Show, August 28, 2009. Maggie Rodriguez (reporter). New York, NY: CBS Worldwide Inc.

The Joy Behar Show, November 10, 2010. Elizabeth Smart's nightmare. Joy Behar (host). New York, NY: Turner Broadcasting System, Inc.

Time, July 26, 2002. Person of the week: Erica Pratt. Mark Coatney (reporter). Retrieved from http://content.time.com/time/nation/article/0,8599,331695,00.html on December 13, 2014. New York, NY: Time, Inc.

The New York Times, June 7, 2002. Slain girls' parents questioned on lifestyle. Michael Janofsky (reporter). Retrieved from http://www.nytimes.com/2002/06/07/us/slain-girl-s-parents-questioned-on-lifestyle.html on November 15, 2014. New York, NY: N.Y.P. Holdings, Inc.

The New York Times, July 25, 2002. Officers praise 7-year-old's courage in escape. Richard Jones (reporter). New York, NY: The New York Times Company, p. A10.

The New York Times, August 6, 2002. Pastor tells why abducted girls went on TV. Bill Carter (reporter). New York, NY: The New York Times Company, p. A12.

The New York Times, August 11, 2002. When rape victims speak out. New York, NY: The New York Times Company, p. 12.

The New York Times, October 2, 2002. Bush unveils upgrade of Amber Alert system. E. Bumiller (reporter). New York, NY: The New York Times Company, p. 21.

The New York Times, March 13, 2003. "Utah girl, 15, is found alive 9 months after kidnapping." Dean E. Murphy. Available at http://w.w.w. nytimes.com/2003/03/13/us/Utah-girl-15-is-found-alive-9-months-after-kidnapping.html

The New York Times, May 8, 2013. Before escape, fleeting clues to long ordeal. Trip Gabriel, Serge Kovaleski & Erica Goode (reporters). New York, NY: The New York Times Company, p. 1A.

The New York Times, May 8, 2013. Cleveland man charged with rape and kidnapping. Trip Gabriel, Serge F. Kovaleski, Steven Yaccino, and Erica Goode. Retrieved from http://www.nytimes.com/2013/05/09/us/cleveland-kidnapping.html?pagewanted=all&_r=0

The New York Times, May 9, 2013. Horrific details emerge as kidnapping suspect is charged in Cleveland. Trip Gabriel, Serge Kovaleski, Steven Yaccino & Erica Goode (reporters). New York, NY: The New York Times Company, p. 17

The New York Post, July 26, 2002. "Snatchers" snatched: Philly duo ran for it after girl's escape. Bill Hoffmann (reporter). New York, NY: N.Y.P. Holdings, Inc., p. 9.

The Oklahoman, January 20, 2007. No arrests have been made in the abduction of a 10-year-old from an Oklahoma Panhandle town. Chad Previch and Ron Jackson (reporters). Oklahoma City, OK: The Oklahoman, p. 1A.

The Oklahoman, January 21, 2007. 10-year-old victim used her foot to open the car door, escape. Chad Previch (reporter). Oklahoma City, OK: The Oklahoman, p. 1A.

The Pueblo Chieftain, January 20, 2012. Authorities call abducted girl a hero. Nick Bonham (reporter). Chieftain, CO: The Pueblo Chieftain & Star Journal Publishing Corp.

The Philadelphia Inquirer, January 24, 2002. At mystery's core, a young survivor; Before her abduction, Erica Pratt, 7, already had endured hard times in a turbulent neighborhood. Maria Panaritis, Jacqueline Soteropoulos and Ira Porter (reporters). Philadelphia, PA: Philadelphia Newspapers, LLC, p. B1.

The Philadelphia Inquirer, July 25, 2002. Phila. girl escapes abductors, brings hope to neighborhood. Acel Moore (reporter). Philadelphia, PA: Philadelphia Newspapers, LLC, p. A11.

The Today Show, August 7, 2007. Search for Madeleine McCann continues with few clues; FBI profiler Clint Van Zandt discusses issue. (Matt Lauer, host; Dawna Friesen, reporter). New York, NY: NBCUniversal.

The Today Show, August 10, 2007. Madeleine McCann's parents speak out about statements that they killed her. Keith Miller (reporter). New York, NY: NBCUniversal.

The Today Show, September 27, 2007. Possible sighting of Madeleine McCann turns out to be false; John Walsh and Ed Smart talk about missing children. Matt Lauer (host) and Stephanie Gosk (reporter). New York, NY: NBCUniversal.

The Washington Post, July 25, 2002. Abducted girl who escaped is hailed for her courage; Police seek two men suspected in kidnapping. Debbie Goldberg (reporter). Washington, DC: Washington Post Company, p. A2.

The Washington Post, August 6, 2002. The strength of a bond forged in crisis; For kidnapped teens, comfort and courage came from concern about the other. Laura Sessions Stepp (reporter). Washington, DC: Washington Post Company, p. C1.

The Washington Post, May 8, 2013. For 3 captive women, freedom at last. Manuel Roig-Franzia & Jerry Markon (reporters). Washington, DC: Washington Post Digital, p. A15.

The Washington Post, May 11, 2013. Cleveland suspect Ariel Castro's American dream darkened by allegations of violence. Manuel Roig-Franzia, Jerry Markon, and Luz Lazo. Retrieved from http://www.washingtonpost.com/national/cleveland-suspect-ariel-castros-american-dream-darkened-by-allegations-of-violence/2013/05/11/61302bd8-ba44-11e2-92f3-f291801936b8_story.html

USA Today, June 17, 2002. City 'unwavering' in search of girl. P. McMahon (reporter). McLean, VA: Gannett Company, Inc., p. 3A.

USA Today, June 30, 2002. Preventing child abductions. McLean, VA: Gannett Company, Inc., p. 10A.

USA Today, August 26, 2002. Abductions highlight another security threat. Strange (reporter). McLean, VA: Gannett Company, Inc., p. 13A.

USA Today, May 8, 2013. House of horrors; Disturbing tale of three abducted and abused over years emerges even as police delay "deep questioning' in Cleveland

kidnapping. Yamiche Alcindor and Gary Strauss (reporters). McLean, VA: Gannett Company, Inc., p. 1A.

USA Today, May 8, 2013. Police chief confirms chains found in abduction house. Yamiche Alcindor and Gary Strauss. Retrieved from http://www.usatoday.com/story/news/nation/2013/05/07/amanda-berry-missing-cleveland-brothers/2143227/

U.S. News & World Report, August 5, 2002. You don't mess with Erica Pratt. Justin Ewers (reporter). New York, NY: U.S. News & World Report LP, p. 6.

WJBF.com, July 1, 2014. North Augusta mother charged with unlawful conduct towards a child. Tonya Cullum (reporter). Retrieved from http://www.wjbf.com/story/25915218/north-augusta-mother-charged-with-unlawful-conduct-towards-a-child?clienttype=generic&mobilecgbypass on January 15, 1015.

World News Tonight with Diane Sawyer, May 8, 2013. Breaking free: The escape in Cleveland. David Muir (reporter). New York, NY: American Broadcasting Companies, Inc.

World News Tonight with Peter Jennings, March 13, 2003. Questions puzzling abduction case. Charles Gibson (reporter). New York, NY: American Broadcasting Companies, Inc.

World News Tonight with Peter Jennings, July 6, 2005. A closer look at repeat offenders. Charles Gibson (host). New York, NY: American Broadcasting Companies, Inc.

World News Tonight with Peter Jennings, January 15, 2007. A closer look: kidnap mystery. Charles Gibson (host). New York, NY: American Broadcasting Companies, Inc.

World News Saturday, January 13, 2007. Answered prayers; two lost boys found alive. Eric Horng (reporter). New York, NY: American Broadcasting Companies, Inc.

World News Sunday, January 14, 2007. Cracking the case: Missing boys lived as suspect's son. Barbara Pinto (reporter). New York, NY: American Broadcasting Companies, Inc.

World News Sunday, January 21, 2012. True grit: Saving herself. Matt Gutman (reporter). New York, NY: American Broadcasting Companies, Inc.

Timeline of Major Cases Prominently Featured in U.S. News Media

Etan Patz, 6 years old at time of abduction

Disappeared from his SoHo neighborhood in New York City on May 25, 1979. His parents had allowed him to walk the two blocks to his bus stop by himself for the first time. When he did not come home from school that afternoon, his parents called the police. Etan became one of the most famous missing children cases in history, and the day of his disappearance, May 25th, was designated National Missing Children's Day. His loss has been credited with sparking the contemporary missing children's movement and the milk-carton campaigns that began in the 1980s. Even though Etan's body was never found, he was declared legally dead in 2001. His case today remains unsolved.

Legal outcome: Jose Antonio Ramos, a convicted sex offender, was the prime suspect from the mid-1980s to 2012. He was not prosecuted in the case of Patz's murder but did serve a 20-year sentence for child molestation. In 2012, another suspect, deli worker Pedro Hernandez, confessed in a now-disputed video-taped testimony that he had lured Etan into the basement of a convenience store with the promise of a

soda and then strangled him. Hernandez's defense attorneys claim Hernandez has a mental disorder and a low I.Q., and that the confession was coerced. Hernandez's first murder trial ended in May 2015 in a mistrial when a single juror declined to convict Hernandez. A retrial has been set for 2016.

Adam Walsh, 6 years old at time of abduction
Abducted from a Sears department store on July 27, 1981, in Hollywood, Florida, when his mother walked a few aisles over and left him playing Atari video games with a several other boys. His decapitated head was found in Vero Beach canal 14 days later. Adam's murder help spur the formation of the National Center for Missing and Exploited Children, and his father, John Walsh, became a prominent victim's advocate and longtime host of the television show *America's Most Wanted*.

Perpetrator: in dispute, but police believe Ottis Toole, a convicted serial killer, kidnapped and murdered Adam. Toole confessed to the crimes but later retracted his statements. Due to a lack of evidence, Toole was never charged in the Walsh case, but died in prison in 1996 while serving time for other crimes.

Legal outcome: None. Police closed the Walsh case in 2008 and despite the lack of new evidence were convinced that Toole was guilty.

Elisabeth Fritzl, 18 years old at time of abduction
Lured by her father to his basement in Austria in 1984, held captive for 24 years and sexually assaulted. Bore eight children by her father, two of whom died as infants. Three of the children were held captive in the basement, while three of them were clandestinely brought to live in the house above with Josef Fritzl and his wife (Elizabeth's mother) Rosemarie.

Perpetrator: Josef Fritzl

Legal outcome: During the trial in March 2009, Josef Fritzl entered a plea of guilty on all charges of murder (in the case of one dead infant), rape, incest, kidnapping, false imprisonment, and slavery. Received sentence of life in prison without possibility of parole for 15 years. Elisabeth Fritzl provided 11 hours of video recorded testimony about her ordeal that was played to jurors before the plea of guilty.

Jaycee Lee Dugard, 11 years old at time of abduction

Abducted June 10, 1991, while walking home from school in South Lake Tahoe, California. Discovered alive on August 26, 2009, having spent more than 18 years in captivity and giving birth to two daughters, then aged 11 and 15, by her abductor.

Perpetrators: Husband and wife, Phillip Craig Garrido and Nancy Garrido.

Legal Outcome: Both perpetrators pleaded guilty to kidnapping and sexual assault charges. Phillip Garrido was sentenced to 431 years in prison, while Nancy Garrido was sentenced to 36 years to life in prison.

Natascha Kampusch, age 10 at time of abduction

Abducted on her way to school near her family's home in Vienna, Austria, on March 2, 1998, and held as prisoner for over eight years in a small cellar under her captor's garage. She was forced to live and sleep in the 54-square-foot dungeon, beaten severely, and raped. She escaped on August 23, 2006, while her abductor was distracted by a phone call.

Perpetrator: Wolfgang Přiklopil

Legal Outcome: None. After escaping a police chase, Přiklopil committed suicide by stepping in front of a moving train.

Danielle van Dam, 7 years old at time of abduction

Abducted at night from her bedroom in the Sabre Springs neighborhood of San Diego, California, on February 1, 2002. A search team found her partially decomposed body on February 27, 2002, near a trail in Dehesa, California.

Perpetrator: David Westerfield, 49, neighbor of van Dam family

Legal outcome: Convicted of kidnapping and murder. He was sentenced to death in 2003.

Elizabeth Smart, 14 years old at time of abduction

Abducted at night by knifepoint from her bedroom in the affluent Salt Lake City neighborhood of Federal Heights on June 2, 2002. Her 9-year-old sister, Mary-Katherine, shared a bedroom with Elizabeth and pretended to be sleeping but actually watched the abduction and provided details in the early hours of the next morning. Elizabeth was threatened

with her life, chained to a tree, and raped repeated during her captivity. She was found 9 months later in March 2002 in Sandy, Utah, when a passerby recognized her captor, Brian Mitchell, from an episode of *America's Most Wanted*.

Perpetrators: Brian Mitchell and Wanda Barzee

Legal outcome: Barzee pleaded guilty to assisted kidnapping of Smart and was sentenced to 15 years in prison. Mitchell was found guilty of kidnapping and sexual assault and was sentenced to two life-term sentences in federal prison.

Samantha Runnion, 5 years old at time of abduction

Abducted from outside her home in Stanton, California, in July 2002 by a man who asked for help finding his lost dog. Her body was found the next day in Cleveland National Forest, about 50 miles south of Stanton.

Perpetrator: Alejandro Avila, 27.

Legal outcome: Charged with murder in 2002 and sentenced to death in 2005.

Amanda Berry, Gina DeJesus and **Michelle Knight**, "The Cleveland Kidnappings"

Michelle Knight, 21 years old at time of abduction on August 21, 2002

Amanda Berry, 16 years old at time of abduction on April 21, 2003

Gina DeJesus, 14 years old at time of abduction on April 2, 2004

All three women were abducted by Ariel Castro between 2002 and 2004 and held captive for ten or more years in the Tremont neighborhood of Cleveland, Ohio. All three women had accepted rides from Castro who drove them home, restrained them with ropes and chains, and locked them in separate bedrooms. Police reports and victims' diary accounts reported that the women had endured years of torture, severe beatings, rape, sexual abuse, multiple forced pregnancies and miscarriages, starvation, and being forced to use plastic toilets that were rarely emptied. He forcibly impregnated Amanda Berry, and, under the threat of death, ordered Michelle Knight to help deliver the baby safely in a small plastic swimming pool inside the boarded-up home. On May 6, 2013, Berry discovered that Castro had left the interior door unlocked when he left the home. She kicked and screamed

through the exterior storm door until neighbors came to her aid. After alerting police, all three women escaped that day along with Berry's six-year-old daughter.

Perpetrator: Ariel Castro, 52 at the time of his arrest

Legal Outcome: In July of 2013, Castro was charged with 977 counts of kidnapping, rape, child endangerment, aggravated murder, and other charges. He was sentenced to life in prison plus 1,000 years without parole. One month into his sentence, he committed suicide by hanging himself with bedsheets in his prison cell.

Shawn Hornbeck, 11 years old at time of abduction

Abducted October 2, 2002, in Richwood, Missouri, at gunpoint while riding his bike to a friend's house. Discovered alive on January 12, 2007, by police in the apartment in which he had been held captive.

Perpetrator: Michael Devlin

Legal outcome: Pleaded guilty to dozens of counts of kidnapping, sexual assault, attempted murder, child pornography, and armed criminal action in the cases of both Shawn Hornbeck and Ben Ownby (see below) and is currently serving multiple life sentences.

Carlie Brucia, 11 years old at time of abduction

Abducted from a car wash near her home in Sarasota, Florida, on February 1, 2004. She was walking home from her friend's house. A video surveillance camera from the car wash's security system showed Carlie being approached by a man, who then grabbed her arm and led her away to a car. Her body was found five days later.

Perpetrator: Joseph P. Smith, 37, was on parole after having spent 13 months in custody for drug-related charges

Legal Outcome: In 2006, Joseph P. Smith was sentenced to death for the murder of Brucia, and to life in prison without parole for kidnapping and sexual assault.

Ben Ownby, 13 years old at time of abduction

Abducted while walking home from school in Beaufort, Missouri, on January 8, 2007. Found alive four days later in the same apartment as Shawn Hornbeck.

Perpetrator: Michael Devlin

Legal outcome: Pleaded guilty to dozens of counts of kidnapping, sexual assault, attempted murder, child pornography, and armed criminal action in the cases of both Shawn Hornbeck and Ben Ownby (see above) and is currently serving multiple life sentences.

Madeleine McCann, 3 years old at time of disappearance

Disappeared from her family's vacation home in Portugal on the night of May 3, 2007. The McCann family was on holiday from the UK where they reside. Madeleine was sleeping in the apartment with her siblings and a group of family friends while the children's' parents dined at a restaurant a few hundred feet away. The parents checked on the children throughout the night until 11:00 p.m., when they discovered Madeleine was missing. The McCanns were initially declared suspects in the disappearance of their daughter, but were later cleared in the case. As of February 2015, Madeleine remains missing and her case unsolved.

Perpetrator: Unknown

Legal outcome: Case Unsolved

Shasta Groene, 8 years old at the time of abduction

Abducted along with her brother, Dylan, from their home in Idaho in May, 2005, by a man who bludgeoned to death their mother, her boyfriend, and their 13-year-old brother. Held captive in multiple locations, sexually assaulted and tortured before being recovered alive seven weeks later on July 2, 2005, when a waitress recognized Shasta from news reports and "missing" posters and alerted police.

Perpetrator: Joseph E. Duncan, III

Legal outcome: Duncan pleaded guilty to federal and state charges against him and was sentenced to three consecutive federal life sentences for kidnapping Shasta Groene and for sexually abusing her and her brother, Dylan (see below). Shasta provided video recorded testimony about her abduction and the murder of her family, including having witnessed Dylan's murder that was played during sentencing.

Dylan Groene, 9 years old at the time of abduction

Abducted along with his sister, Shasta, from their home in Idaho in May, 2005, by a man who bludgeoned to death their mother, her boyfriend, and their 13-year-old brother. Held captive in multiple locations, sexually assaulted and tortured before being shot in the abdomen and head. His body was burned on a campfire for several days and discovered after Shasta was found alive and provided information that led police to the site of the crime.

Perpetrator: Joseph E. Duncan, III

Legal outcome: Duncan pleaded guilty to federal and state charges against him and was sentenced to three death sentences for kidnapping resulting in death, sexual exploitation of a child resulting in death, and use of a firearm in a violent crime resulting in death, all related to the death of Dylan Groene. Dylan's sister Shasta (see above) provided video recorded testimony about her abduction and the murder of her family, including having witnessed Dylan's murder that was played during sentencing.

References

Acosta-Alzuru, C., & Kreshel, P. J. (2002). "I'm an American girl ... whatever that 'means'": Girls consuming pleasant company's American girl identity." *Journal of Communication, 52* (1), 139–162.

Alter, J. (2002, July 29). Who's taking the kids? *Newsweek* Web Exclusive. Retrieved October 15, 2002, from http://www.newsweek.com

Althusser, L. (1971). Ideology and ideological state apparatuses. In L. Althusser (Ed.), *Lenin and philosophy and other essays*. New York: Monthly Review Press.

Ariés, P. (1962). *Centuries of childhood*. New York: Vintage.

Armstrong, C. L. (2013). *Media disparity: A gender battleground*. New York: Lexington Books.

Arthurs, J. (2003). *Sex and the city* and consumer culture: Remediating postfeminist drama. *Feminist Media Studies, 3* (1), 83–99.

Banet-Weiser, S. 2004. Girls rule! Gender, feminism, and Nickelodeon. *Critical Studies in Media Communication, 21* (2), 119–139.

Barthes, R. (1972). *Mythologies*. New York: The Noonday Press.

Benedict, H. (1992). *Virgin or vamp: How the press covers sex crimes*. New York: Oxford University Press.

Berlant, L. (1997). *The queen of America goes to Washington City*. Durham, NC: Duke University Press.

Bernstein, R. (2011). *Racial innocence: Performing childhood and race from slavery to civil rights*. New York: New York University Press.

Bignell, J. (1997). *Media semiotics: An introduction.* Manchester, UK: Manchester University Press.

Bissler, D. L., & Conners, J. L. (2012). *The harms of crime media: Essays on the perpetuation of racism, sexism and class stereotypes.* Jefferson, NC: McFarland.

Bray, A. (2009). Governing the gaze: Child sexual abuse moral panics and the post-feminist blindspot. *Feminist Media Studies, 9* (2), 173–191.

Bromley, D. G. (1991). The Satanic cult scare. *Society, 4,* 55–66.

Brongerson, E. (1984). Aggression against pedophiles. *International Journal of Law and Psychiatry, 7,* 79–87.

Brookfield, T. (2013). "No woman is an island: Heroes, heroines and power in the gendered world of lost." *The Journal of Popular Culture, 46* (2), p. 315–337.

Buckingham, D., & Bragg, S. (2007). *Young people, sex and the media: The facts of life?* London: Palgrave Macmillan.

Calvert, K. (1992). *Children in the house: The material culture of early childhood, 1600–1900.* Lebanon, NH: Northeastern University Press.

Cameron-Dow, J. (2009). The question of crime: How much does the public have a the right to know? *Pacific Journalism Review, 15* (2), 71–84.

Carter, C. (1998). When the "extraordinary" becomes the "ordinary": Everyday news of sexual violence. In C. Carter, G. Branston and S. Allan (Eds.), *News, gender and power* (pp. 219–232) New York: Routledge.

Cenite, M. (2005). The obligation to qualify speculation. *Journal of Mass Media Ethics, 20* (1), 43–61.

Chermak, S. M. (1995). *Victims in the news: Crime and the American news media.* Boulder, CO: Westview Press.

Chesney-Lind, M. (2010). *Fighting for girls: New perspectives on gender and violence.* Albany, NY: State University of New York Press.

Cohen, S. (1972). *Folk devils and moral panics,* London: MacGibbon and Kee.

Cohen, S. (1980). Footprints in the sand: A further report on criminology and the sociology of deviance in Britain. In M. Fitzgerald, G. McLennan, & J. Pawson, (Eds). *Crime and society: Readings in history and theory.* London: Routledge and Kegan Paul.

Cohen, S., & Young, J. (1981). *The manufacture of news: Deviance, social problems and the mass media.* London: Constable.

Connell, R. (2005). *Masculinities.* Cambridge: Polity Press.

Conrad, J. (1999). Lost innocent and sacrificial delegate: The JonBenet Ramsey Murder. *Childhood, 6* (3), 313–351.

Crary, D. (2002, July 19). Despite grim headlines, experts say abductions of children by strangers are rare and getting rarer. Associated Press, 1.

Currie, D., Kelly, D., & Pomerantz, S. (2009). *"Girl power": Girls reinventing girlhood.* New York: Peter Lang.

Denham, B. E. (2008). Folk devils, news icons and the construction of moral panics: Heroin chic and the amplification of drug threats in contemporary society. *Journalism Studies, 9* (6), 945–961.

Doyle, K., & Lacombe, D. (2000). Scapegoat in risk society: The case of pedophile/child pornographer Robin Sharpe. *Studies in Law, Politics, and Society, 20,* 183–206.

Durham, M. G. (2004). Constructing the "new ethnicities": Media, sexuality, the diaspora identity in the lives of Asian immigrant girls. *Critical Studies in Media Communication, 22* (2), 210–229.

Durham, M. G. (2011). Vicious assault shakes Texas town: The politics of gender violence in *The New York Times'* coverage of a schoolgirl's gang rape. Paper presented at AEJMC Conference, St. Louis, August 10–14, 2011.

Duvall, S. (2010). Perfect little feminists? Young girls in the U.S. interpret gender, violence and friendship in cartoons. *Journal of Children and Media, 4* (4), 402–417.

Faludi, S. (2007). *The terror dream: Myth and misogyny in an insecure America.* New York: Metropolitan Books.

Fass, P. (1997). *Kidnapped: Child abduction in America.* New York: Oxford University Press.

Fass, P. (2011). *Reinventing childhood after World War II.* Philadelphia: University of Pennsylvania Press.

Fishman, M. (1981). Crime waves as ideology. The social production of news: Mugging in the media. In S. Cohen & J. Young (Eds.), *The manufacture of news: Deviance, social problems and the mass media* (pp. 98–117). London: Constable.

Foucault, M. (1977). *The history of sexuality: An introduction, Volume I.* New York: Vintage Books.

Frank, R. (2003). These crowded circumstances: When pack journalists bash pack journalism. *Journalism, 4* (4), 441–458.

Friedersdorf, C. (2014, July 15). Working mom arrested for letting her 9-year-old play alone at park. *The Atlantic,* accessed January 2015 from http://www.theatlantic.com/national/archive/2014/07/arrested-for-letting-a-9-year-old-play-at-the-park-alone/374436/

Fullerton, R. S., & Patterson, M. J. (2006). Murder in our midst: Expanding coverage to include care and responsibility. *Journal of Mass Media Ethics, 21* (4), 304–321.

Fursich, E. (2009). In defense of textual analysis: Restoring a challenged method for journalism and media studies. *Journalism Studies, 10* (2), 238–252.

Gelman, D., et al. (1984, March 19). Stolen children. *Newsweek.* Available at http://www.newsweek.com/stolen-children-207018

Gerbner, G., Gross, L., Jackson-Beeck, M., Jeffries-Fox, S., & Signorielli, N. (1978). Cultural indicators violence profile no. 9. *Journal of Communication, 28* (3), 176–207.

Glasser, T. L., & Ettema, J. S. (2008). Ethics and eloquence in journalism. *Journalism Studies, 9* (4), 512–534.

Gonick, M. (2004). The mean girl crisis: Problematizing representations of girls' friendships. *Feminism and Psychology, 14* (3), 395–400.

Goode, E., & Ben-Yehuda, N. (1994). Moral panics: Culture, politics, and social construction. *Annual Review of Sociology, 20,* 149–171.

Gooren, J. C. W. (2011). Deciphering the ambiguous menace of sexuality for the inno-cence of childhood. *Critical Criminology, 18,* 1–14.

Gorelick, S. (1992). Cosmology of fear. *Media Studies Journal, 6,* 17–29.

Grabe, M. E. (1996). Tabloid and traditional television news magazine crime stories: Crime lessons and reaffirmation of social class distinctions. *Journalism & Mass Communication Quarterly, 73,* 926–946.

Gramsci, A. (1971). *Selections from the prison notebooks.* Quintin Hoare and Geoffrey Nowell Smith (Eds). New York: International Publishers.

Greer, C. (2003). *Sex crime and the media: Sex offending and the press in a divided society.* Cullompton: Willan.

Grewal, I. (2005). Transnational America: Race, gender and citizenship after 9/11. *Social Identities, 9,* 535–61.

Hains, R. (2012). *Growing up with girl power: Girlhood on screen and in everyday life.* New York: Peter Lang.

Hall, S. (1973). *Encoding and decoding in the television discourse.* Birmingham UK: Centre for Contemporary Cultural Studies.

Hall, S., Chritcher, C., Jefferson, T., Clarke, J., & Roberts, B. (1981). The social produc-tion of news: Mugging in the media. In S. Cohen & J. Young (Eds.), *The manufac-ture of news: Deviance, social problems and the mass media* (pp. 335–367). London: Constable.

Harper, K., Kaulis, Y., Lopez, V., & Scheiner, G., Eds. (2013). *Girls' sexualities and the media.* New York: Peter Lang.

Hartley, J. (1998). Juvenation: News, girls and power. In C. Carter, G. Branston, and S. Allan (Eds.), *News, gender and power* (pp. 47–70) New York: Routledge.

Higonnet, A. (1998). *Pictures of innocence: The history and crisis of ideal childhood.* New York: Thames and Hudson.

Holland, P. (2004). *Picturing childhood: The myth of the child in popular imagery.* London: I. B. Tauris.

Holt, K. (2012). Authentic journalism? A critical discussion about existential authentic-ity in journalism ethics. *Journal of Mass Media Ethics, 27* (2), 2–14.

Howard, J. W. III, & Prividera, L. C. (2004.) Rescuing patriarchy or saving "Jessica Lynch": The rhetorical construction of the American woman soldier, *Women and Language, 27* (2), 89–97.

Inness, S. A. (2004). *Action chicks: New images of tough women in popular culture.* New York: Palgrave Macmillan.

Jeffords, S. (1994). *Hard bodies: Hollywood masculinity in the Reagan Era.* New Brunswick, NJ: Rutgers University Press.

Jenks, C. (1992). *The sociology of childhood.* Aldershot, UK: Ashgate.

Kappeler, V., & Potter, G. W. 2005. *The mythology of crime and criminal justice.* 4th edition. Prospect Heights, IL: Waveland.

Kearney, M. C. (2006). *Girls make media.* New York: Routledge.

Kitzinger. J. (2004). *Framing abuse: Media influence and public understanding of sexual vio-lence against children.* London: Pluto Press.

Kurtz, H. (2002, July 27). Is the media blowing coverage of child abductions out of proportion? Transcript of *CNN Reliable Sources*, 1–4.

Lee, N. (2001). *Childhood and society*. Buckingham, UK: Open University Press.

Levine, J. (2002). *Harmful to minors: The perils of protecting children from sex*. Minneapolis: University of Minnesota Press.

Liebler, C. (2002). Tale of two cities: When missing girls are(n't) news. In D. Heider (Ed.) *Class and news*. (pp. 199–212). Lanham, MD: Rowman & Littlefield.

Leibler, C. (2010). Me(di)a culpa? The "missing white woman syndrome" and media self-critique. *Communication, Culture & Critique, 3* (4), 549–565.

Lule, J. (2002). Myth and terror on the editorial page: The *New York Times* responds to September 11, 2001. *Journalism & Mass Communication Quarterly, 79* (2), 275–293.

Lull, J. (2014). Hegemony. In G. Dines & J. Humez (Eds.). *Gender, race, and class in media: A critical reader*. Thousand Oaks, CA: Sage.

Malin, B. J. (2005). *American masculinity under Clinton: Popular media and the nineties "crisis of masculinity."* New York: Peter Lang.

Mankekar, P. (1997). To whom does Ameena belong: A feminist analysis of childhood and nationhood in contemporary India. *Feminist Review, 56*, 26–60.

Marcel, M. (2013). Victim gender in news coverage of the priest sex crisis by the *Boston Globe*. *Women's Studies in Communication, 36* (3), 288–311.

Mazzarella, S. (2005). *Girl wide web: Girls, the internet, and the negotiation of identity*. New York: Peter Lang.

Mazzarella, S. (2010). *Girl wide web 2.0: Revisiting girls, the internet, and the negotiation of identity*. New York: Peter Lang.

Mazzarella, S., & Pecora, N. (2007). Girls in crisis: Newspaper coverage of adolescent girls. *Journal of Communication Inquiry, 31* (1): 6–27.

McCaghy, C. H., & Capron, T. A. (1997). *Deviant behavior: Crime, conflict, and interest groups*. Boston: Allyn and Bacon.

McMahon, P. (2002, June 10). Utah's "worst nightmare." *USA Today*, p. 3A.

McMahon, P. (2002, June 17). City "unwavering" in search of girl. *USA Today*, p. 3A.

McRobbie, A. (1991). *Feminism and youth culture: From Jackie to just seventeen*. Boston: Unwin Hyman.

McRobbie, A., & Thornton, S. L. (1995). Rethinking "moral panic" for multi-mediated social worlds). *The British Journal of Sociology, 46* (4), 559–574

Meyers, M. (1997). *News coverage of violence against women: Engendering blame*. Thousand Oaks, CA: Sage.

Meyers, M. (2004). African women and violence: Gender, race and class in the news. *Critical Studies in Media Communication, 21* (2), 95–118.

Mokrzyckil, P. (2013/2014). "A flower smashed under a rock": Race, gender and innocence in American missing children cases, 1979–present. *Neoamericanist, 7* (1), accessed at http://www.neoamericanist.org/issues/issue/vol-7-no-1-fallwinter-201314

Morton, T. (2012). "Dirty little secret": Journalism, privacy and the case of Sharleen Spiteri. *Pacific Journalism Review, 18* (1), 46–69.

Moscowitz, D. (2014). *A culture of tough Jews: Rhetorical regeneration and the politics of identity.* New York: Peter Lang.

Moscowitz, L., & Duvall, S. (2011). "Every parent's worst nightmare": Myths of child abductions in U.S. news. *Journal of Children and Media 5,* (2): 147–63.

Murr, A. (2002, July 29). When kids go missing. *Newsweek,* 38.

National Center for Missing and Exploited Children. (2015, January 3). Retrieved from http://www.missingkids.com/NCMEC

National Criminal Justice Reference Service. (2015, January 3). Retrieved from https://www.ncjrs.gov

O'Hara, S. (2012). Monsters, playboys, virgins and whores: Rape myths in the news media's coverage of sexual violence. *Language & Literature, 21* (3), 247–259.

Ono, K. (2000). To be a vampire on *Buffy the Vampire Slayer*: Race and ("other") socially marginalizing positions on horror TV. Ed. Elyce Rae Helford. *Fantasy girls: Gender in the new universe of science fiction and fantasy television.* (pp. 163–186). Lanham, MD: Rowman and Littlefield.

Parameswaran, R. (1996). Coverage of "bride burning" in the *Dallas Observer*: A cultural analysis of the "other." *Frontiers: A Journal of Women Studies, 16* (2/3), 69–100.

Parameswaran, R. (2005). Journalism and feminist cultural studies: Retrieving the missing citizen lost in the female audience. *Popular Communication, 3* (3), 195–207.

Peraino, K. (2002, July 8). The plot thickens. *Newsweek,* 41.

Postman, N. (1994). *The disappearance of childhood.* New York: Vintage Books.

Potter, G. W., & Kappeler, V. E. (2006). *Constructing crime: Perspectives on making news and social problems.* Long Grove, IL: Waveland Press.

Preventing child abductions (2002, June 30). *USA Today,* p. 10A.

Pritchard, D., & Hughes, K. D. (1997). Patterns of deviance in crime news. *Journal of Communication, 47,* 49–67.

Prout, A. (2005). *The future of childhood.* London: Routledge.

Rakow, L. (2006). *Feminist communication theory.* Thousand Oaks, CA: Sage.

Reinarman C., & Levine, H. G. (1989). Crack attack: Politics and media in America's latest drug scare. In J. Best (Ed.) *Images of issues: Typifying contemporary social problems,* (pp. 15–37). Chicago: Aldine.

Rice, S., Hackett, H., Trafimow, D., Hunt, G., & Sandry, J. (2012). Damned if you do and damned if you don't: Assigning blame to victims regardless of their choice. *Social Science Journal, 49* (1), 5–8.

Robinson, E. (June 10, 2005). White women we love. *The Washington Post.* Retrieved October 15, 2014, from http://www.washingtonpost.com/wp-dyn/content/article/2005/06/09/AR2005060901729.html

Schor, J. B. (2004). *Born to buy: The commercialized child and the new consumer culture.* New York: Scribner.

Sheley, J. F., & Ashkins, C. D. (1981). Crime, crime news, and crime views. *Public Opinion Quarterly, 45,* 492–506.

Silverman, D., & Wilson, I. (2002). *Innocence betrayed: Paedophilia, the media & society.* Cambridge: Polity.

Steeves, H. L. (1987). Feminist theories and media studies. *Critical Studies in Mass Communication, 4* (2), 95–135

Steeves, H. L. (1997). *Gender violence and the press: The St. Kizito story.* Athens, OH: Ohio University Center for International Studies.

Stillman, S. (2007). "The missing white girl syndrome": Disappeared women and media activism. *Gender & Development, 15* (3), 491–502.

Taylor, R. (2009). Slain and slandered: A content analysis of the portrayal of femicide in crime news. *Homicide Studies, 13* (1), 21–49.

Tolan, M. (2006). Self-imposed media blackout: A case study. *Journal of Mass Media Ethics, 21* (4), 353–358.

Tuchman, G. (1976). Telling stories. *Journal of Communication, 26* (4), 93–97.

Tuchman, D., & Benet, J. (1978.) *Hearth and home: Images of women and the media.* New York: Oxford University Press.

Turner, G. (1999). Tabloidization, journalism and the possibility of critique. *International Journal of Cultural Studies, 2* (1), 59–77.

Vargas, L. (2009). *Latina teens, migration, and popular culture.* New York: Peter Lang.

van Zoonen, L. (1994). *Feminist media studies.* Thousand Oaks, CA: Sage.

Wannamaker, A. (2011). *Mediated boyhoods: Boys, teens, and young men in popular media and culture.* New York: Peter Lang.

Wanzo, R. (2008). The era of lost (white) girls: On body and event. *Differences, 19* (2): 99–126.

Watson, E. (2009). Pimps, wimps, studs, thugs and gentlemen: Essays on media images of masculinity. Jefferson, NC: McFarland.

Wilkinson, R. (1984). American tough: The tough-guy tradition and American character. Westport, CT: Greenwood.

Williams, K. V. (2012). *Gendered politics in the modern South: The Susan Smith case and the rise of a new sexism.* Baton Rouge: Louisiana University Press.

Wykes, M. (2001). *News, crime and culture.* London: Pluto Press.

Wyness, M. G. (2006). *Childhood and society: An introduction to the sociology of childhood.* Basingstoke, UK: Palgrave Macmillan.

Zgoba, K. M. (2004). Spin doctors and moral crusaders: The moral panic behind child-safety legislation. *British Journal of Social Work, 31,* 887–901.

Index

A

ABC News, 34, 42, 51, 59–60, 66–67, 75, 114
Activist-survivors, 124–125, 139
Advocacy, 138–139
Akers, Craig, 71, 131
Akers, Pam, 91–92, 131
Aliens, 103
Amber Alerts, 19, 29–31, 61, 110, 121
America's Most Wanted, 11
Anti-gay attitudes. *See* Homophobia
Armstrong, 13
Associated Press, 63, 67
Avengers, 103
Avila, Alejandro, 23

B

Barzee, Wanda, 23, 79
Beckham, David, 45
Behar, Joy, 93–94
Berlant, Lauren, 72
Bernstein, R., 55

Berry, Amanda, 1, 18, 94, 96, 102
 escape of, 99–101, 116–120
 lack of media attention to, 129
 marked as true "hero," 119–120
 physical bondage of, 116–120
 physical descriptions of, 116
Bignell, J., 6
Blaming, victim, 76–82, 96–97, 119–120, 139
Blitzer, Wolf, 119–120
Boston Globe, 64
Branson, Richard, 45
Brooks, Tamara, 102, 110–111
Brown, Aaron, 78, 81
Brown, Pat, 37, 41, 86
Brucia, Carlie, 1
Buffy the Vampire Slayer, 103
Bush, George W., 31

C

Carter, Cynthia, 8
Castro, Ariel, 96, 100, 117, 119

Catholic Church, 64–65
CBS Evening News, 28, 69
Cenite, M., 137
Charlie's Angels, 103
Child abductions
 advocacy and exploitation, 138–139
 construction of girlhood and, 11–14
 dungeon cases of, 120–124
 early theories on, 54–55
 international, 42–49, 129
 media attention during summer of
 2002, 21–50
 media attention on specific types of,
 1–4
 media ethics and, 134–138
 as modern morality play, 9–11
 panic over, 8–9, 127–128, 137
 sexual abuse as motive for, 15, 55–60,
 65–68, 73–74
 shifting conceptions of childhood,
 parenting, safety, and fear in light
 of, 139–141
 statistics on, 2–3, 138–139
Chitwood, Michael, 109
Clayson, Jane, 28
CNN, 79, 92, 102, 108–109, 116
Collins, Kevin, 139
Connell, R., 72–73
Cooksey, Donald, 66
Cooper, Anderson, 118–119
Cordova, Calysta, 102, 113–115
Couey, John, 41
Couric, Katie, 111
Crime
 calls for more legislation and harsher
 penalties for, 41–42
 modern morality play and, 9–11
 moral panics over, 8–9, 127–128, 137
 popularity of news about, 6–9
 shifting conceptions of childhood,
 parenting, safety, and fear in light
 of, 139–141
 signal, 135
Cullum, Tonya, 127
Culpability of victims, 119–120, 139

code of innocence and, 68–71
 in not escaping, 76–82
 victim blaming and, 76–82, 96–97
Curry, Ann, 39, 136

D

Dahler, Don, 133
Dateline, 101, 121
DeJesus, Gina, 1, 18, 96, 100, 116
 as not "hero" enough, 119–120
 physical bondage of, 116–120
Deseret News, 81, 83
Devlin, Michael
 abduction and abuse by, 64–65, 67,
 69–71, 133
 arrest of, 75–76
 Stockholm Syndrome in victim of, 85,
 89–92
 trial of, 73–74
Domestic violence, 86
Dugard, Jaycee Lee
 abduction and captivity of, 1, 16, 18,
 45–46, 76, 82, *88*, 96, 101
 activist stance taken by, 124
 lack of media attention to, 128–129
 neighbors and community of, 132–134
 Stockholm Syndrome in, 84, 86–87,
 92–93
Duncan, Joseph Edward, 39, 41, 62–63, 96
Dungeon cases, 120–124

E

Edmunds, Bret Michael, 25
Escape by survivors. *See also* Victims
 individual agency and, 78–79
 labeled tough girls, 103–106
 language used to describe, 107, 112,
 115–116
 narratives of, 99–103
 from physical constraints, 116–120
 physical strength used in, 106–113

by reaching out to family members, 120–124
speaking out and redefining toughness, 124–126
spunk and, 113–116
Ethics, journalism, 134–138
Ettema, J. S., 135
Evans, Kim, 131
Existential journalism, 136

F

Faludi, S., 50
Family values stories, 27–29
Farber, Nicolas, 52, 61
Fass, Paula, 1–2, 4, 10, 52, 56, 138
Feldman, Steven, 29
Female kidnap victims
girlhood and, 11–14
"Girl Power" movement and, 102
international, 42–49
socioeconomic class and, 23–26
tough girls in the media and popular culture and, 103–106, 122
Femininity. *See* Female kidnap victims; Girlhood, media construction of
Figueroa, LaToyia, 14
Filyaw, Vinson, 121
Fox News, 67–68, 70–71
Framing and myth in news narratives, 4–6
Frank, R., 136
Free range kid movement, 128, 140
Free Range Kids, 140
Friedersdorf, Conor, 140
Friesen, Dawna, 45, 48
Fritzl, Elisabeth, 1, 94–95, 96

G

Garcia, Jose, 113–114
Garrett, Brad, 133–134
Garrido, Phillip, 92–93

Gibson, Charlie, 34, 75, 79
Gibson, John, 67, 131–132
Girlhood, media construction of, 11–14, 22. *See also* Female kidnap victims
race and, 109–110
"spunk" and, 113–116
tough girls in popular culture and, 103–106, 122
"Girl Power" movement, 102
Glasser, T. L., 135
Good Morning America
coverage of abductions, 34, 38, 40, 53, 66–67, 70–71, 74, 82, 90
coverage of escapes, 107, 114
Gosk, Stephanie, 45
GraBbois, Stuart, 59–60
Grabe, M. E., 25
Grace, Nancy, 36, 38, 40, 82, 85, 89–90, 136
Graham, Marissa, 102, 111–113
Groene, Dylan, 22, 35, 50, 52
lack of media attention on, 62–63
media portrayals of, 35–36
news stories about family of, 36–42
Groene, Shasta, 22, 34–35, 49
media attention focused more on, 62–63
media portrayals of, 35–36
news stories about family of, 36–42

H

Hannity, Sean, 85–86
Harrell, Debra, 127
Harris, Dan, 114–115
Hartley, John, 12
Hearst, Patty, 84–85
Hemmer, Bill, 109
Herman, Richard, 89–90
Heyman, J. D., 84–85
Holloway, Natalie, 14
Holt, K., 136
Homophobia, 10–11, 54
predatory pedophilia and, 64–68

Hornbeck, Shawn, 1, 18, 45–46, 52
 codes of innocence applied to, 68–71
 criticisms of parents of, 130–132
 found by police, 76
 lack of media attention to, 63–64, 76,
 128
 lack of police attention to, 129
 media portrayal of, 33
 neighbors and community of,
 132–134
 sexual abuse of, 65–68, 73–74
 Stockholm Syndrome in, 85, 89–92
 victim blaming against, 82
Horng, Eric, 66, 131
Howard, J. W. III, 52
Huncovosky, Jackie, 66
Huott, Marla, 30

I

Ifil, Gwen, 13
Individual agency, 78–79
Inness, Sherry, 105, 122
Innocence, codes of, 68–71
International abductions, 42–49, 129
Inwood, Jennifer, 37

J

Joyner, Sheila, 21
Juvenation, 12–13

K

Kach, Tanya, 16
Kampusch, Natascha, 1, 102, 123–124
Karim, Reef, 87
Karlinsky, Neal, 39, 41
Keilar, Brianna, 84
Kelly, Megyn, 82
Kidnapped: Child Abduction in America, 1, 10

Kidnapping. *See* Child abductions
King, Larry, 84
Klaas, Marc, 130
Klaas, Polly, 139
Knight, Michelle
 abduction and captivity of, 1, 16, 18,
 45, 73, 96, 100, 116
 activist stance taken by, 124, 139
 lack of media attention to, 128–129
 as not "hero" enough, 119–120
 physical bondage of, 116–120
 on psychological bondage, 125
Kosinski, Michelle, 44

L

La Femme Nikita, 103
Larry King Live, 33
Larson, John, 39
Lauer, Matt, 46, 48, 130–131
Law & Order, 11
Lederle, Rita, 133
Leonard, Christopher, 67
Levine, Judith, 15
Lewis, George, 46
Lexis-Nexis, 17, 63
Lindbergh, Charles, 10
Loeb-Leopold case, 10
Lunsford, Jessica, 41

M

Male kidnap victims, 33, 35, 50, 51–53
 anti-gay bias and predatory
 pedophilia surrounding coverage
 of, 64–68
 codes of innocence and culpability of,
 68–71
 historical significance of early, 53–58
 as invisible to the media, 61–64
Marcel, M., 64
Marris, Jacqueline, 102, 110–111

Marshall, Bethany, 85
Masculinity. *See also* Male kidnap victims
 cultural anxiety of the 2000s and,
 72–73
 media construction of, 14–15
 patriotism and, 52–53
 toughness associated with, 113–116
McCann, Gerry, 44–45, 47, 49
McCann, Kate, 44–46
McCann, Madeleine, 1, 14, 22, 34, *43*
 media attention on, 129
 parents' media campaign after
 abduction of, 44–45
 parents suspected/blamed for
 abduction of, 42–44, 47–48
McFadden, Cynthia, 81
McRobbie, A., 9
Meanings of child abductions, 2
Media
 advocacy and exploitation of child
 abductions, 138–139
 attention on specific types of child
 abductions, 1–4, 22–24
 boy victims ignored by, 61–64
 construction of girlhood in, 11–14, 22
 construction of idea family, 130–132
 construction of masculinity, 14–15
 coverage of sexual crimes and victim
 blaming by, 77–82
 coverage of toughness, 106–113
 ethics in mediated digital age,
 134–138
 exaggeration of crime waves, 6–9
 framing and myth in news, 4–6
 implications of victim (in)visibility in,
 128–129
 judging of heroic neighbors and
 classed communities, 132–134
 moral panics created by, 8–9
 mythic narratives dominating post
 9-11 culture and, 27–34
 patriotism used by, 31, 38–39
 power and commercial, 5–6
 profit-seeking by, 6
 research approach, 16–17

 shifting conceptions of childhood,
 parenting, safety, and fear in light
 of, 139–141
 storytelling language used by, 107
 tough girls in, 103–106
Meitiv, Danielle, 141
Meserve, Jeanne, 89
Meyers, M., 26, 86–88
Miller, John, 55
Miller, Keith, 47
Missing Children's Day, 53
Missing White Woman Syndrome
 (MWWS), 13–14, 17, 49–50
Mitchell, Brian, 23, 32, 79, 81, 83
Modern morality play, 9–11
Mokrzyckil, P., 11, 54, 58–59
Moral panics, 8–9, 127–128, 137
Moran, Terry, 99
Mullenberg, Jessyca, 139
Murr, A., 21

N

National Center for Missing and
 Exploited Children, 2, 56
National Criminal Justice Reference
 Service, 2
Nationalism, 31, 38–39
 boys as symbols of, 52–53
 built through international abduction
 cases, 42–49
NBC News, 46–49
Newsweek, 58
New York Times, 108–109
Nightline, 99
Nuclear families, 10–11, 28, 129

O

Okwu, Michael, 39
On the Record with Greta Van Susteren, 69
Oprah, 131

O'Reilly, Bill, 36, 65, 67, 70, 90–91, 131, 136
Ownby, Ben, 18, 52, 132
 codes of innocence applied to, 68–71
 found by police, 75–76
 lack of media attention on, 63–64
 sexual abuse of, 65–68

P

Panics, moral, 8–9, 127–128, 137
Parameswaran, R., 16
Parental kidnapping, 61–62
 nuclear families and, 10–11
 statistics on, 3, 31–33
Parents
 criticisms of lifestyles of, 29–30, 33, 36
 media construction of the ideal family
 and, 130–132
 power of higher socioeconomic class,
 44–45, 83, 108
 viewed as expert victim advocates,
 130–131
Parnell, Kenneth, 55
Patriotism, 31, 38–39
 boys as symbols of, 52–53
Patterson, Alexis, 26
Patz, Etan, 2, 10, 141
 early theories about abduction of, 54–55
 as first significant abduction story,
 51–52
 historical significance of case of, 53–58
 symbolism of, 71–72
 worries over predatory pedophilia
 after abduction of, 58–60
Patz, Julie, 54–55
Patz, Stan, 57
Pedophilia
 anti-gay bias and predatory, 64–68
 Catholic Church and, 64–65
 panic over, 15, 57
 predatory, 58–60
Performance, toughness as, 103–104
Philadelphia Examiner, 108
Politics of shame, 71–74

Post 9–11 culture, 27–34
Powerpuff Girls, The, 103
Pratt, Derrick, 115–116
Pratt, Erica, 102, 106–111, 125–126
Predatory homosexuality, 58–60
Priklopil, Wolgang, 123–124
Prividera, L. C., 52
Psychological bondage, 125–126
 Stockholm Syndrome and, 83–94

R

Race of victims and suspects, 26, 46–47
 Missing White Woman Syndrome
 (MWWS) and, 13–14, 17, 49–50
 tough girls and, 109–110
Ramos, Jose, 57, 59–60
Ramsey, John, 44
Ramsey, JonBenet, 13, 44
Ramsey, Patricia, 44
Rankin, Michael, 114
Reagan revolution, 72
Reavy, Pat, 81, 83
Ricci, Richard Albert, 23, 25
Richards, Rick Charles, 134
Rivera, Geraldo, 68, 91
Robach, Amy, 47–48
Roberts, Robin, 38, 73–75, 136
Robinson, E., 13
Romer, Bill, 133
Rose, Debra, 61
Ross, Charley, 2, 57
Rowling, J. K., 45
Runnion, Samantha, 1, 17, 22–23, 108
 kidnapper of, 23

S

Salon, 111
Sandell, Clayton, 114
Sawyer, Diane, 40, 117
Schadler, Jay, 51, 55, 59, 72
Sexual abuse, 15, 55–60

of male kidnap victims, 65–68, 73–74
media ethics and reporting of, 136
shame associated with, 111
Stockholm Syndrome and, 85
Shame, politics of, 71–74
Sherman, Scott, 73–74
Shoaf, Elizabeth, 102, 121–122
60 Minutes, 59
Skenazy, Lenore, 140–141
Smart, Andrew, 28
Smart, Doratha, 29
Smart, Ed, *80,* 83, 108, 130
Smart, Elizabeth, 1, 14, 17–18, 22, *27,* 46,
 49, *73,* 76, *80,* 101
 activist stance taken by, 124, 139
 family values stories and, 27–29
 individual agency and, 78–79
 kidnapper of, 23
 media portrayals of, 33, 128–129
 neighborhood of, 30
 questions regarding captivity of, 79–81
 recovery by police, 79
 socioeconomic class of, 24–25
 Stockholm Syndrome in, 83, 93–94
 "stranger danger" theme and, 32
Smart, Lois, 28, *80*
Smart, Mary Katherine, 28
Smart, Tom, 32
Snow, Kate, 66, 131
Social experience of child abductions, 2
Socioeconomic class of victims and
 suspects, 23–26, 128–129
 media judging of, 132–134
St. Louis Post-Dispatch, 63, 64
Stasi, Linda, 132
Stayner, Steven, 54–57, 73
Stockholm Syndrome, 83–94
Storm, Hannah, 90
"Stranger danger" myth, 11, 18, 26–27,
 137–138
 media use of, 31–33
 race and, 46–47
 used to link cases together, 34
Summer of child abductions (SOCA),
 21–22

boy victims during, 61
legacy of, 34–42
legacy of lost white girls and
 implications for missing children,
 49–50
mythic narratives dominating post
 9–11 cultural climate of, 27–34
race, class, and gender defining
 victims and suspects in, 23–26
Survivors. *See* Escape by survivors
Suspects, abduction, 23–26
 race of, 46–47
Swanson, David, 120

T

Technology-assisted escapes, 121–124
Thornton, S. L., 9
Time, 107
Today Show, The, 47, 130–131
Torres, Sue, 38
Torture, 95–96
Tough girls, 103–106, 122
 media stories about, 106–113
 "spunk" and softness in, 113–116
 victims speaking out and redefining,
 124–126
Tuchman, G., 6
Turner, G., 135
Turner, Jahi, 26, 61
20/20, 51, 71, 73–74

U

USA Today, 31, 101, 117

V

Van Dam, Danielle, 1, 17, 22, *30,* 108
 kidnapper of, 23
 news stories about family of, 29–30,
 33, 36

Van Zandt, Clint, 46–48
Vargas, Elizabeth, 139
Velez-Mitchell, Jane, 86–87, 93
Victims. *See also* Escape by survivors;
 Female kidnap victims; Male
 kidnap victims
attention on higher socioeconomic
 class, 23–26, 128–129
blaming, 76–82, 96–97, 119–120, 139
codes of innocence and culpability of,
 68–71
culpability of, 68–71, 76–82, 119–120,
 139
girlhood and, 11–14, 42–49
implications of (in)visibility of,
 128–129
individual agency of, 78–79
linked together by the media, 34–35
Missing White Woman Syndrome
 (MWWS) and, 13–14, 17, 49–50
photos on milk cartons, 52
physical bondage of, 116–120
politics of shame and advocacy for,
 71–74
race, class, and gender defining,
 23–26, 46, 49–50, 132–134
speaking out and redefining
 toughness, 124–126
Stockholm Syndrome in, 83–94
torture of, 95–96
Viera, Meredith, 48
Villapando, Efrin, 114

Weir, Bill, 133
Westerfield, David, 23, 29
Weston, Beatrice, 95–96
Weston, Linda Ann, 96
White, Timothy, 55, 57
Whitfield, Fredricka, 37
Wilkinson, Rupert, 104
Winfrey, Oprah, 131
Wolfinger, Ben, 38, 40
World News Tonight, 79

X

Xena: Warrior Princess, 103

Z

Zahn, Paul, 81

W

Walsh, Adam, 2, 10, 53, 73, 139
Walsh, John, 33, 42, 56, 130
Wanzo, Rachel, 13–14
"War on Drugs," 8–9
Washington Post, 116
Watson, Clay, 83–84
Watson, Rocky, 37
Weaver, Sigourney, 103

mediated youth

Sharon R. Mazzarella
General Editor

Grounded in cultural studies, books in this series will study the cultures, artifacts, and media of children, tweens, teens, and college-aged youth. Whether studying television, popular music, fashion, sports, toys, the Internet, self-publishing, leisure, clubs, school, cultures/activities, film, dance, language, tie-in merchandising, concerts, subcultures, or other forms of popular culture, books in this series go beyond the dominant paradigm of traditional scholarship on the effects of media/culture on youth. Instead, authors endeavor to understand the complex relationship between youth and popular culture. Relevant studies would include, but are not limited to studies of how youth negotiate their way through the maze of corporately-produced mass culture; how they themselves have become cultural producers; how youth create "safe spaces" for themselves within the broader culture; the political economy of youth culture industries; the representational politics inherent in mediated coverage and portrayals of youth; and so on. Books that provide a forum for the "voices" of the young are particularly encouraged. The source of such voices can range from in-depth interviews and other ethnographic studies to textual analyses of cultural artifacts created by youth.

For further information about the series and submitting manuscripts, please contact:

SHARON R. MAZZARELLA
School of Communication Studies
James Madison University
Harrisonburg, VA 22807

To order other books in this series, please contact our Customer Service Department at:

(800) 770-LANG (within the U.S.)
(212) 647-7706 (outside the U.S.)
(212) 647-7707 FAX

Or browse online by series at WWW.PETERLANG.COM